The Complete Book of Decorative Painting

The *Complete* Book of — *Decorative* PAINTING

Tera Leigh

David & Charles

about the author

Tera Leigh is an artist and author living in California. She is the founder of ToleNet, the first Internet resource on decorative painting, and has been active in the decorative painting industry since 1995. Tera is a columnist for PaintWorks and Decorative Artist's Workbook magazines, and has had her original designs published in many painting and home décor magazines. She is the cocreator of Paintability, manufactured by Delta Technical Coatings, which is a line of products to help aspiring artists learn to paint.

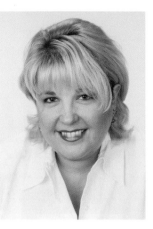

A DAVID & CHARLES BOOK

First published in the UK in 2001
First published in the USA in 2001 by North Light Books, Cincinnati, Ohio

Copyright © Tera Leigh 2001

Tera Leigh has asserted her right to be identified as author of this work in accordance with the Copyright, Designs and Patents Act, 1988.

A catalogue record for this book is available from the British Library.

ISBN 0 7153 1248 0

Printed in China by Leefung-Asco Printers for David & Charles
Brunel House Newton Abbot Devon

Editors: Heather Dakota and Maureen Mahany Berger
Designer: Brian Roeth
Page Layout: Kathy Gardner
Production Coordinator: Sara Dumford
Photographer: Christine Polomsky

METRIC CONVERSION CHART

TO CONVERT	TO	MULTIPLY BY
Inches	Centimeters	2.54
Centimeters	Inches	0.4
Feet	Centimeters	30.5
Centimeters	Feet	0.03
Yards	Meters	0.9
Meters	Yards	1.1
Sq. Inches	Sq. Centimeters	6.45
Sq. Centimeters	Sq. Inches	0.16
Sq. Feet	Sq. Meters	0.09
Sq. Meters	Sq. Feet	10.8
Sq. Yards	Sq. Meters	0.8
Sq. Meters	Sq. Yards	1.2
Pounds	Kilograms	0.45
Kilograms	Pounds	2.2
Ounces	Grams	28.4
Grams	Ounces	0.04

acknowledgments

Mushy stuff: This book would not have come together if not for the unfailing encouragement and support of Ken Mugrage, my husband and best friend. When I didn't believe in myself, you were there telling me I could live my dreams. What can I say, except, "Thank you for not divorcing me yet!"

When I entered the painting industry, four women went out of their way to help me learn the ropes, answer my questions and give me their time and valuable opinions. Susie Wolfe, Doxie Keller, Jean Watkins and Priscilla Hauser—I am humbled by your generosity, awed by your talent and grateful for the blessing of having you as a part of my life.

I owe a great debt to my family for their support. To my parents, Marie and Curt Gemmil; and my sister and brother and their families--Tonya, Bob and Natasha Mills, and Curtis, Dolores and Madison Rose Gemmil. They have offered encouragement when others would have ridiculed my dreams, support when I was cranky over deadlines and lack of sleep, and unconditional love always. When I married, I was welcomed with open arms into the terrific family of Ellen and Bill Mugrage, Bill Mugrage, Jr. and Deanna, Nicholas and LaDena Parks. I am truly blessed.

To the girly-girls of North Light Books: My sincerest thanks go to my editor, Heather Dakota, who made the biggest challenge of my life a whole lot of fun. Heather, your wild spirit and towering talent is a never-ending source of inspiration to me. Christine Polomsky, I bow at your fabulous feet. Thank you for making my work look so good through the photography on these pages. Girl, you ROCK! I am grateful to Maureen Mahany Berger for pinch-hitting, editorially speaking, to get this book to print. Thanks also to Sally Finnegan and Kathy Kipp of North Light Books, and Anne Hevener of *Decorative Artist's Workbook*. Cincinnati is a little slice of heaven with you in it. (Except for that chili!)

DEDICATION

This book is dedicated to all the artists who have been members of the ToleNet mailing list over the years. In 1995, I started a mailing list on the Internet with seven painters. By 2000, it had grown to over two thousand painters in eighteen countries. Although I am no longer working with ToleNet, my experiences with the group changed my life forever. Most of what I know about painting today was absorbed from five years of conversing with some of the most knowledgeable painters in the industry. The generosity, love and caring of the participants on the ToleNet mailing list is a tribute to the loving heart of a true artist.

table of contents

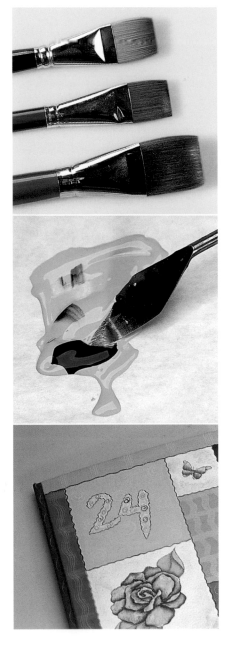

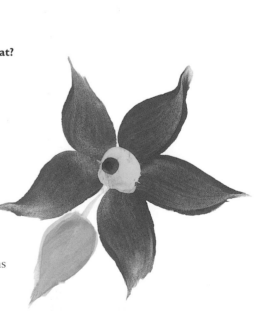

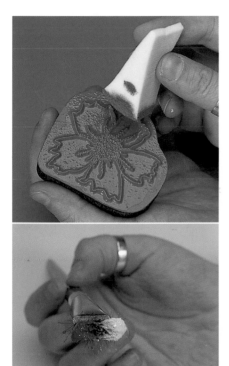
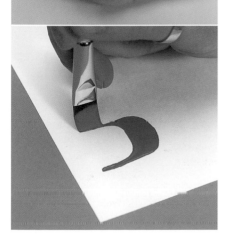

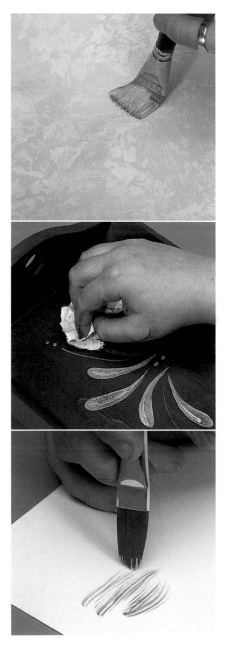

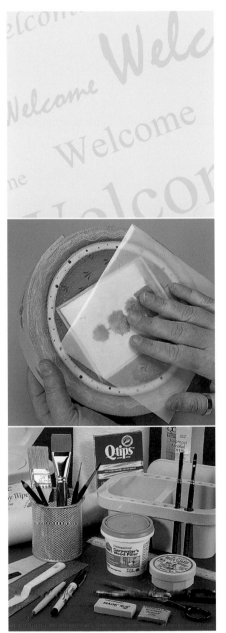

introduction

WHAT IS DECORATIVE PAINTING?

Decorative painting is a term that describes a broad range of painting styles and techniques. When pressed for a definition, I believe that it is easiest to explain that decorative painting is a folk art based upon a teachable method of strokes and techniques. Decorative painting is, at best, an umbrella term under which specific regional techniques, such as Bauernmalerei from Austria, or Russian Zhostovo, and more recently-evolved techniques are included.

Because of its nature as an accumulated body of knowledge passed down within families and communities, decorative painting is considered a folk art or craft. It is distinguished from fine art, which is said to be inspired by God or a result of natural talent. That is not to say that decorative artists do not have natural talent! Decorative art is taught with patterns and step-by-step techniques that allow us to copy other designs as we learn. For that reason, it does not have the wholly original nature or emphasis of fine art.

Decorative painting techniques have been a part of most cultures throughout the ages. For example, it is said that servants of European nobility used paint to replicate the fine materials and carvings that they could not afford in their own homes. There are many examples of ancient Egyptian paintings in tombs and public buildings. In North America, decorative painting has been driven by its immigrant roots, and much of modern decorative painting is a melting pot created by the mixing of regional and global techniques, as well as by influences of specific artists, the availability of books and modern painting products.

Prior to the introduction of painting books in the 1970s, if you could find someone to teach this form of painting, you would have most likely learned a single technique, such as rosemaling, Bauernmalerei or one of the Colonial-period painting techniques based upon

historic patterns. Rarely would you find a teacher that could teach decorative painting (drawn from a variety of techniques, products, surfaces and styles) as it is taught today. What you learned would depend on the influence and teachings of the settlers in that area. An example of this is the primarily German influence in the Pennsylvania Dutch area of the United States.

Today, artists have the opportunity to learn from other artists around the world. There are books with step-by-step photographs, videos and conventions that allow us to learn any technique we wish. As a result, artists today tend to be influenced by many different styles of painting, and, doing what artists do best, we tend to take the best of each and use it in our own art. For that reason, we see a blurring of the line in decorative painting and it is sometimes hard to define a piece as belonging to a specific genre. For example, although Zhostovo is a Russian art form, American artist Priscilla Hauser and Canadian artist Heather Redick are among those who teach it.

Happily, decorative painting still flourishes in many parts of the world. Hindeloopen, in the Netherlands, is a small town that still produces the folk art for which it is known. Artists in Zhostovo, Russia still produce their own brand of folk art, even though it is no longer in government-owned factories.

Another distinction that separates decorative painting from fine art painting is that it generally adorns useful surfaces, such as furniture or walls. As the term *decorating* implies, its pupose is to decorate and beautify. My husband likes to tell guests in our home that decorative painting involves the painting of anything that slows down long enough for me to take a brush to it! Decorative painting is an art form of beautification and embellishment.

You may also hear the term *tole painting* used interchangeably with *decorative painting*. Although tole historically refers to painting on

metal or tin, it has evolved through common usage to also refer to other forms of decorative painting. Technically, tole painting refers to a very specific technique of painting on metal and then coating it with multiple layers of lacquer.

ART VS. CRAFT

There are some who look down on decorative painting because many artists begin by using patterns created by other artists. Detractors of the art form like to say that fine art is wholly original, and decorative art is merely a copycat medium for people who are not talented enough to do original work. To me, this is nonsense. I don't buy into the idea that an art form based upon teachable techniques somehow lessens the value of decorative painting as a whole.

Many fine artists work from photographs and draw basic sketches on their canvas before beginning to work. Are fine artists lesser artists than their predecessors because they use tube paints and don't go into the forests to forage for plants to use in creating their pigments? Every art form has developed as our ability to communicate has increased and as manufacturers have developed products that make painting easier. To say that decorative artists aren't "real" artists because they learn their art form in informal settings and work on usable surfaces rather than canvas makes no sense.

No painter invented a rose, yet millions of fine artists paint roses. Originality is not what makes art valuable. It is the heart and spirit behind the work that determines its value. No two people paint the same thing in the same way, even if they are working from the same picture or pattern.

Decorative painting is a teachable art form based upon specific strokes and techniques. That means that anyone who can hold a paintbrush and has enough tenacity can learn to paint. It would be a won-

derful world if all of us had been given the opportunity to learn art in school, but most of us were not given that privilege. In the United States, art is being removed from many school curricula due to lack of funding. That makes decorative painting techniques more important than ever because anything that gives people the opportunity to experience the sheer joy of painting can be nothing but positive.

WHAT THIS BOOK CAN DO FOR YOU

It is my dream that this book will sit on your painting or crafting table and end up dog-eared, spattered with paint and well used. Although you can sit down and read it from cover to cover, it is intended to be a reference book to help you understand a term or technique as you need it—as a sort of portable teacher or painting helper.

When I began decorative painting, I was often frustrated by books that used terminology without further explanation and, worse, that terminology seemed to be regional and multiple terms often described the same technique. Decorative painting is an important and emerging art form all over the world. As a result, there is no standard for the terminology used as each regional folk art brings its own terms into the mix. This book is meant to be used as a tool. Keep it handy, use it when necessary and hopefully your journey as a painter will be easier and less frustrating than my own.

If I could give you one piece of advice as an artist, it would be this: relax! As you read this book, you will find that we have tried to show you multiple ways to accomplish many of the techniques. As Priscilla Hauser, First Lady of Decorative Painting in America, often says about painting, "There are many ways of right!" If there were only one way to accomplish a technique, painting would be a science, not an art form. This book is meant to show you how to accomplish the basic techniques you need as a decorative painter. I hope that you test them, try variations, discard what doesn't work for you and gain the confidence to know that whatever works best for you *is* right.

Decorative Painting Terms

A

Acrylic paint: A premixed water-based paint that dries quickly and requires only soap and water to clean up. The pigment is carried in an acrylic polymer binder.

Acrylic polymer: A synthetic resin that makes up the base of acrylic paints and mediums.

Alkyds: Pigments bound in a synthetic resin. They are much slower-drying than acrylic paints, but dry faster than oil paints.

Antiquing: The application of a glaze of color to darken the surface and create the appearance of age.

B

Back-to-back floats (also called flip floats or reverse floats): Two lines are side-loaded so that the dark edges of the side loads meet in the middle and the water edge of the brush is toward the outside on both sides.

Basecoat or basecoating: A smooth, even coat of paint that is the base of your design. This may refer to an even coat of one color all over the surface, or multiple colors applied as "coloring book painting" before applying details.

Binder: An agent in paints that holds the various ingredients together so that they do not separate on the surface.

Blend or blending: Using your brush to apply one color over another for a gradual transition from one color to the next.

Blot: Removing excess moisture with a towel or other absorbent material by gently laying it over the surface and then lifting.

Bristles: The hair or filament portion of the brush.

Brush basin (see Water basin).

Brush mixing: Mixing paint on a palette with a brush for smaller quantities.

C

Cast shadow: A shadow created when one design element blocks the light from another.

Chisel edge: The very tip of the bristles on a brush.

Coloring book painting: Filling in the outlined shape of a pattern in solid colors before applying details.

Complementary colors: Colors that are opposite each other on the color wheel.

Consistency: The texture of paint—thick, thin, creamy, inklike, and so on.

Crackle: A technique used to simulate old, cracked paint by applying a medium or crackling agent over a basecoat. Once dried, a secondary color is applied to enhance the crackle appearance.

Cure: The time in which paint and mediums go through the chemical process to thoroughly set and dry.

D

Dirty brush painting: Using a brush that has been wiped clean of paint—but not thoroughly cleaned with water or thinner—before continuing to paint with the next color.

Distressing: Roughing up or damaging wood to give it the appearance of age and use.

Dolly Parton hearts: Dot hearts are formed by dipping your brush handle or stylus into a fresh puddle of paint, painting two dots side by side, and pulling a line down on an angle from each dot to form the pointed "V" of the heart.

Double load: A brush loaded with two colors of paint, one on each corner.

Dressing a brush: To load your brush with paint or another medium.

Drybrushing: Applying paint with a brush that has a small amount of undiluted paint in its bristles.

Dry-it board: A board with multiple points sticking up from the surface. It holds surfaces that are wet with paint or varnish and lets them dry without sticking.

E

Extender: A medium added to paint to lengthen the open time before the paint sets up.

F

Faux finishes: Special painting effects that simulate natural materials such as marble, wood grain, and so on.

Ferrule: The metal or plastic section of a brush that holds the bristles in place.

Flip float (see Back-to-back floats)

Fly specking (see Spattering).

Force dry: To speed the drying process of your paint by using a hair dryer or oven.

Freehand painting: To paint without the use of a pattern.

Fully loaded: A brush that is completely filled with paint or medium.

G

Gesso: A tinted acrylic primer.

Glaze: A thin, transparent wash of color that may be created by adding water or medium to paint.

Gold leafing: Gold or metal composition pressed into thin sheets. It is applied to surfaces over a special adhesive.

Gouache: An opaque form of watercolor.

Graphite paper: Transfer paper that is used to trace a pattern to the surface.

H

Highlight: To lighten a specific area of a painting through side loading, drybrushing or painting. An area that is highlighted will appear to be higher and closer to the foreground because it represents reflected light.

Hue: The name of a color, e.g., red or yellow.

I

Inklike: To thin paint with water or medium to the consistency of ink.

Intensity: Brightness or dullness of color.

L

Line drawing: The pattern in a painting book or pattern from which you trace in order to transfer the design to your painting surface.

Line or linework: Details applied using a liner brush that has been loaded with paint thinned with water or another medium.

M

Medium: A product added to the paint to change the physical properties of the paint, e.g., used to thin or thicken, slow the drying time, and so on.

Metal primer: A rust inhibitor that is applied to a metal surface to provide "tooth," which allows the paint to adhere to the surface.

Monochromatic: A color scheme comprised of multiple shades of a single color.

Mop or mopping: Lightly brushing color with a large, loose-bristled brush to soften or blend the paint.

O

Oil paint: Paint made from pigment in an oil base. It has a very slow drying time.

Opaque: Paint coverage that does not allow light to shine through.

Open time: The period of time in which the paint remains workable and movable on the surface before it begins to dry and set up.

Outlining: Painting the outline of a design with a thin line of paint using a liner or small round brush.

P

Palette: A flat, nonporous surface that is used to hold and mix colors while working with them.

Palette knife: A plastic or metal knife used to work with and mix paints.

Pat blend: Blending colors together using light tapping strokes.

Pen and ink: Washes of color are applied to a surface and the details are applied using pen and ink.

Pickle or pickling: Applying thin washes of light-colored paint that allow the wood grain to show through.

Pigment: Raw material used to add color to paint and other colored materials.

Prepping surface: Preparing the surface for painting. It generally involves cleaning, sanding and sealing.

Primary colors: Red, yellow and blue—colors that cannot be mixed by combining other colors.

Porous: Surfaces that will absorb moisture.

R

Retarder: Medium used to extend the open time of paint. Also called an "extender."

S

Sandpaper: Paper with a gritty surface that is used to smooth a surface before and after sealing and painting.

Scumbling (also called slip-slap stroke): A loose back-and-forth type of X-style stroking, that literally slaps the paint onto the surface. Your wrist should constantly be moving in different directions so there is no set pattern to your strokes.

Seal or sealer: A liquid protective coat that is applied prior to painting to protect the surface from outside sources and prevent moisture in the surface from leaking out into the paint.

Secondary colors: Green, orange, and violet—the colors that are created by mixing two primary colors.

Shade: Color with black added to it to create a darker version of the original color.

Shading: To darken a specific area of the painting by side loading, drybrushing, painting or another method. Used to recess an area, to creating the illusion of depth.

Shadow: Dark areas where the light source is blocked, e.g., where one petal of a flower overlaps another, creating a shadow.

Side loading (also called floating or floated color): Painting technique accomplished by loading one side of your brush with paint, then blending on a palette. The paint should stay mostly on one side and gradually blend to water on the other side of the brush.

Spattering: A random spray of paint created by running your finger through a paint-loaded toothbrush, or tapping the ferrule of a loaded brush across another brush.

Sta-Wet palette: A palette with a large sponge and special water-soaked paper used for keeping paints damp and workable longer.

Smoking: A faux finish used to create a marble effect. It is created by moving the smoke from a candle across a surface dampened with a medium that allows the smoke to stick to it.

Stippling: A texturing technique that is accomplished by pouncing your bristles up and down on your surface. Generally, very little paint is used on the brush for stippling.

Soup dots: Dots made with a brush handle or stylus using paint that has been thinned with water to a souplike consistency.

Sponging: Using a sponge as a paint application tool to dab or pounce paint onto a surface.

Stain: A thin glaze of paint applied to raw wood to color the surface without covering the pattern of the grain.

Strokework: A teachable technique for brush control using specific brushstrokes. Strokes are combined to create patterns and designs.

Stylus: A tool with a dull metal point on one or both ends that is used to transfer patterns or to make decorative dots.

Super Chacopaper: Water-soluble transfer paper used to apply patterns to the surface.

T

Tacking: To remove sanding residue from your surface.

Tack cloth: A special cloth with a resin base that lifts and holds dust and sanding residue from wood surfaces.

Tannin blocker: A product used to seal your wood specifically to prevent the tannin or pitch and knots from seeping up through sealer and paint to discolor surface.

Tertiary colors: A primary and secondary color mixed together. For example, yellow and green mixed together make yellow-green.

Tint: Color with white added to it to create a lighter and brighter version of the original color.

Technical pen: A pen created for use by architects and draftsmen for precise linework. Artists use it for the same purpose.

Theorem painting: Historical painting method using a series of stencils called "theorems."

Tole: A term derived from a French word referring to painting on thin metal, which was then layered with shiny lacquer. Today the term has evolved to refer to decorative painting on any surface.

Tone: Color with gray added to it in order to create a duller version of the original color.

Tooth: Refers to the texture of the surface that allows the paint to adhere.

Tracing: A pattern that has been transferred to tracing paper.

Tracing paper: Translucent paper onto which line drawings are traced. It is used with transfer paper to transfer a pattern onto the surface for painting.

Translucent: Allows light to pass through in a diffuse manner.

Transparent color or wash: Paint that has been diluted with water or another medium, allowing the paint or surface below to show through.

Trompe l'oeil: A French term referring to a form of painting that "fools the eye." The focus of the painting is on the scale and dimension, creating realistic optical illusions from certain angles.

U

Undercoat: A preliminary basecoat used to enhance the coverage. Undercoating is often used over a dark surface so that color painted over an undercoat will appear vibrant.

V

Value: The lightness or darkness of a color on the gray scale.

Varnish: A sealant applied to protect a painted or finished surface.

W

Walking out color: Extending the width of a side load using a series of strokes out from the original side-loaded line. By slowly widening the darkened area, the paint is walked out.

Wash (see Transparent color).

Water basin (also called a Brush basin): A tub used to clean brushes, usually made of plastic or glass. Some have multiple sections for cleaning and rinsing brushes. Some have ridges at the bottom to clean paint out of the ferrule.

Wet-on-wet: The application of paint onto an already wet paint. This is used to create a very blended look.

Wet sand: A sanding technique used to smooth the finish of varnish. After applying several coats of varnish, sand with water and liquid soap to remove brush lines, bubbles, and so on. Dry thoroughly and apply more varnish.

materials & supplies

What do I need and what do they do?

One of the joys of being a decorative artist today is that products developed specifically for decorative painting are making it easier than ever to get the effects you want! However, the large number of products can be a bit confusing for a new painter. In this chapter, I'll give you an overview of the major product categories and, when appropriate, explain the difference between similar or competing products.

Paint

Broken down into its most basic elements, paint is simply a pigment or coloring additive that is mixed with a "vehicle" or product that makes the paint liquid or movable. Some paints also include a "binder," which binds the pigment and vehicle together, and other additives that affect the paint's finish and drying time. Decorative artists work with a variety of paint types, with acrylic, oil and gouache being the most popular. The primary difference among these paints is the binders and additives that have been used, which affects the outcome you get using them.

As a rule, you should not mix acrylic, oil and gouache paints in the same project. However, as the saying goes, rules are made to be broken, and some artists have developed techniques that involve glazes and various

techniques that mix mediums. In those cases, you should follow the artist's advice regarding that technique to achieve the results indicated. Since their introduction in the 1970s, many companies have begun to manufacture acrylic paint for artists. When choosing a paint, look for a good quality paint with enough pigment to provide adequate coverage. (It isn't a bargain if it takes an entire bottle to basecoat a small piece, so beware of cheap paint!) Good quality acrylic paint should also be labeled as nontoxic.

Included in this book are paints by Delta, DecoArt, 1837 Legacy, Plaid and Daler-Rowney. Acrylic paints are available in tubes and bottles. To choose a paint, try various brands to determine the qualities you like best. For example, Delta Technical Coatings, Inc. makes Ceramcoat, a creamy, thin paint that is excellent for crafting and basic painting techniques. Plaid's FolkArt paint is a thicker paint that is excellent for more advanced techniques, such as Zhostovo, and for strokework that requires a heavier paint. DecoArt's Americana is a very consistent paint that is thicker than Ceramcoat but not quite as thick as FolkArt. All of the brands shown on these pages are of excellent quality. Your choice then becomes one of personal preference as to thickness and coverage.

tera tip

Since we are discussing so many products, I will offer one word of advice. Until you become experienced with painting and the results of various products, I recommend that you not mix brands. It is not uncommon for a project to call for a sealer by one company, paint by another, specialty products from another and varnish from yet another company. In my years with ToleNet, I found that one of the most common causes of problems like peeling, lifting or bubbling of paint was mixing brands. If you stick to the same brand throughout one piece, you lessen the likelihood of this happening. Once you have tried various brands and become more familiar with the way they work, you will be more willing to risk incompatibility.

ACRYLIC PAINT

Decorative painters have a wide variety of manufacturers to choose from when buying acrylic paint. Each paint has its unique characteristics. It is a good idea to try different brands to determine which works best for you and your style of decorative painting.

Jo Sonja's Acrylic Gouache is a marriage between acrylic paint and traditional gouache. Several fine art companies also make gouache. If you are interested in trying them, look in an art supply store or the fine art section of a craft chain.

Many artists with an oil-painting background find the thicker tube acrylic paint easier to control. There are several brands on the market. If this sounds like something that would help your painting, you should try several brands to get the right one for you.

Acrylic paints are essentially a liquid form of plastic. Because they are termed "water-based," they thin when water is added and dry quickly. You will get the best results if you paint in a cool, damp place. If you use air conditioning or a fan, try to position your palette where the air doesn't blow across it. Many artists in warmer and drier climates put ice in their water bins (a trick I learned from Priscilla Hauser), use wet palettes and keep cool humidifiers in their painting studios.

tera tip

All of the manufacturers offer conversion charts to convert a color name in one brand to their brand. You will also find books that offer this for all brands. Keep in mind that the conversion will tell you an approximate equivalent based upon the color. However, it may react differently when it is mixed with other colors or thinned to a wash because the formula for the color will differ for each manufacturer.

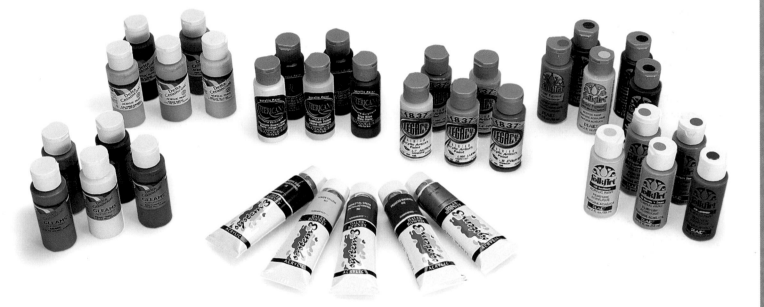

tera tip

Keep an open mind about products. You may find that what you like when you begin painting changes as you gain more experience.

ACRYLIC PAINT, *continued*

Tube acrylics are thicker and generally more opaque. Many artists like working with tube paints because they find it easier to control the consistency when starting with a thick product (much like oil paint) and working it down to a thin consistency using other mediums.

Gouache is an opaque watercolor made with gum arabic as the binder and chalk to increase its opacity. Gum arabic remains water-soluble after it dries, so it is easy to lift colors if you are layering paint onto a piece. In the 1980s, Chroma developed Jo Sonja's gouache using acrylic resin as the binder and creating a marriage between traditional gouache and acrylic paint. This means that Jo Sonja paints do not lift because they dry like an acrylic-based paint, but they have the intensity of a water-color. Jo Sonja paints come in tubes and are thicker than most bottle paints.

The decorative artists of the 1970s and earlier learned to paint with oil paint because that was all that was available. Many artists prefer the opacity, versatility and durability oil paints provide. The downside to using oil paints has been the toxicity of some of the paints and many of the mediums. Manufacturers have responded to these problems, however, and have developed new products over the last few years. In addition, low-odor products have been developed in response to artists who suffer from allergies.

OIL PAINT

Oil paints fell out of favor with many painters after the development of nontoxic alternatives. Oil paint manufacturers have responded by creating safer alternatives, and oil is beginning to regain its popularity among decorative artists. An excellent alternative to traditional oil paint, most water-based oil paints have little or no odor.

Oil paints are used with a variety of mediums that enable artists to get the effects they want. Linseed and poppy oils are commonly used to thin or dilute the color of the paint. Oils in the paint also slow drying time. These products can be used in combination with turpentine or thinner to create a glaze. Thinners and turpentine are also used to change the consistency of the paint to the artist's specifications.

Alkyds fall between an oil and acrylic paint. They contain the oil or petroleum-based products found in oil paints and are combined with ingredients that help them dry significantly faster than traditional oil paints. Many alkyds can be mixed with oil paints made by the same manufacturer. Mixing alkyds with oil paints will make the oil paints dry faster.

In addition to alkyds, water-based oil paints are now available. These paints have gained popularity because of the low- or no-odor properties of the mediums that go with them. Some of these paints are also advertised as nontoxic. Be sure to check the label and read the materials that come with your paints before starting to work with them.

SPECIALTY PAINT

More specialty paints come on the market every year as manufacturers respond to the special needs of artists who concentrate their work on specific surfaces. DecoArt's wonderful Patio Paint created for outdoor use on patios, cement, etc., includes its own sealing agent so you don't have to worry about surface preparation except to clean and dry the surface.

Paper paints are archival, so they will not cause the paper to break down over time. This is important for artists using the products for scrapbooks or historical purposes. If the paper is stored properly, these products will not break down or damage the paper or other materials stored against them.

Neither oil nor acrylic, Genesis calls its paint a "heat-set artist oil." This means that it doesn't dry until heated to 265° F. You can do this with a special heat gun or dryer, or in your oven. It has the buttery feel of an oil paint and doesn't dry until heat-set, so it can be left on your palette and will not go to waste because of curing. The product is also "thixotropic" which means it may be thick in the jar but becomes soft and malleable as you mix or work with it. The product's base is a synthetic polymer. The paint is odor-free and AP nontoxic.

All of the major manufacturers

now make glass paints. These paints are as varied as the companies that produce them. Some are heat-set; others air-dry. Some are permanent; others may be peeled off and used again or thrown away. This kind of variety gives you the opportunity to get the exact finished product you desire because you begin with the right product for the job.

Be sure to read labels and all available instructions before beginning to work with a specialty paint. Many require several steps. Remember, these products tend to be developed specifically for surfaces to which traditional paint will not adhere. For this reason, using the product as directed is important to guarantee the desired results.

Savvy manufacturers have begun to create products for specific surfaces to make it easier for artists to get the results they desire. Here are different brands of metal paints.

Rapidly gaining in popularity among decorative painters are Genesis paints. These paints do not dry until heat set and have the consistency of traditional oil paints.

Glass paints are becoming very popular. A variety of brands and products currently available make it fun to create small or large pieces that look like stained glass.

Brushes

Many painters do not fully appreciate the impact the quality of their brushes has on their work. I believe that one of the greatest disservices a teacher can do to beginning painters is to give them "student grade" or lesser-quality brushes because they are less expensive. An experienced painter may be able to get a good result from a badly made brush because she knows more about brush control and the properties of brush styles. Beginners, however, may become discouraged when they cannot achieve the results they desire. This may not be because they lack skill, but because they are using poorly made brushes.

There are few standards in brush making and labeling laws about brush content. This makes it a challenge for any artist to acquire good quality brushes. The price of a brush is not a guarantee of its quality. You will need to familiarize yourself with brand names, brush categories and hair types. From there, you will need to experiment to find your own preferences as to handle size, how much moisture the hair or bristle type holds and other variables.

PARTS OF THE BRUSH

There are three main components of a brush: (1) the bristles or hair, which I generically refer to as filaments in this chapter, unless specifically addressing a type of bristle or hair; (2) the ferrule, which is usually a metal casing, that fastens the bristles or hair to the handle; and (3) the handle. It is important to note that brush sizes vary by manufacturer, and a no. 6 round by one manufacturer may be a completely different size by another.

See page 146 for a detailed explanation of the chisel edge and the movements of the brush.

Chisel: The very tip of the bristles. When you hold a flat brush on the chisel edge, the tips of the filaments barely touch the surface.

Flat: To apply downward pressure to the flat sides of the filament. It can also refer to the flat sides of the filaments.

Point: The tip of a round brush.

Snap: The speed and extent to which a brush returns to its natural shape when loaded with paint or rinsed. The amount of snap in a brush is a matter of personal preference. Some brushes have too much snap and are difficult to control, while others do not have enough snap.

tera tip

New painters tend to purchase all their brushes from the same manufacturer, and authors will recommend a single manufacturer simply to make it easier for their readers to find the brushes. I have found that more experienced artists use brushes from many lines, having a favorite brand for different brush categories. Try different brushes whenever possible to learn what works best for you.

THE PROTECTIVE SLEEVE ON NEW BRUSHES

There is always a protective cap on a new brush. Most brushes ship with this plastic tube-shaped protective cap. This cap should be removed and thrown away. When you purchase a brush, make sure that the cap has not been removed and then placed back on the brush, trapping the filaments between the ferrule and the cap. The manufacturer applies a sizing solution to the filaments before shipping to keep them in shape and to prevent breakage of the hairs. Gently working the filaments between your fingers or rinsing the brush will remove the sizing. You can then examine the shape and quality of the filament.

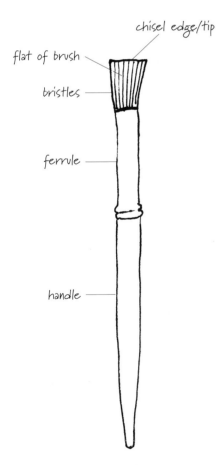

chisel edge/tip
flat of brush
bristles
ferrule
handle

Brushes, continued

STORING YOUR BRUSHES

Store your brushes to protect the filaments. If you use a cup or bin, the filaments should be pointed upward with the handle downward. Storing a brush with the filaments against a surface will bend or break them, often causing irreparable damage. Storing the brushes upright can mean that the bristles will get dusty if not used often. In this case, you may want to get a storage case with a lid wide enough not to touch the brushes.

Some artists prefer to store their brushes flat because they feel that it is better for the ferrule not to have moisture running down the filaments after washing. The brush manufacturers I spoke with said that if the brush is blotted after washing, storing the brush with the filaments up should not damage the glue in the ferrule. If you store your brushes flat, be sure to anchor the handles so they will not shift in the case and damage the filaments. Use the storage method you feel is most appropriate for your circumstances.

HAIR AND BRISTLES

The most important component of the brush is the type of bristle or hair used. Unfortunately, hair, bristle or filament names are often misleading. For example, camel hair is not used in "camel" brushes, and sable brushes are made from the hair of animals in the weasel family. It is also confusing when many manufacturers use filament names, such as Kolinsky, as brand names.

You can generally categorize brushes by their filaments as either natural animal hair or synthetic. Animal hairs used in brush making include Kolinsky, weasel, squirrel, badger, ox, pony and goat. Most animal hair brushes are made from combinations of these hairs. The hair comes from the animal's tail, and the quality of the brush depends on the

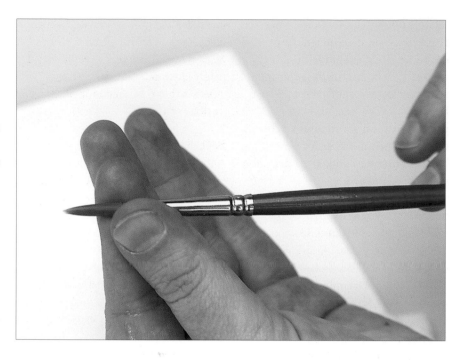

quality of the hair used.

Kolinsky mink fur is considered to be the best hair available for artist brushes. The quality of Kolinsky brushes, however, varies widely. Just because a brush says "Kolinsky" does not mean it will be the finest quality. You will need to learn the feel of a quality brush by experience. Most oil and acrylic brushes are made with weasel or a combination of weasel and other hair. This makes a hardier brush that can handle rougher surfaces and the harsh chemicals used in many of the products.

Synthetic brushes, also known as Taklon, were originally produced for wig making. Prior to that, nylon or polyester filaments were used only for making housepainting brushes. When manufacturers made a finer filament for wigs, brush manufacturers began to incorporate them for use in the arts. Synthetic filaments may be dyed and mixed with natural hairs.

The most popular brushes for decorative painters are synthetic and synthetic/animal hair mixes. For humane reasons, some artists do not feel comfortable using animal hair, so they choose synthetic brushes. In the end,

as you will find with most product choices in painting, what works best for you will largely be a matter of personal preference.

tera tip

There are a few guidelines to help you when choosing a brush:

• The thicker the paint or product you are using, the stiffer and shorter the bristles should be. Thinner products should be applied with softer bristle brushes because they will not create lines or textures in the paint.

• Purchase the best brush you can afford. The quality of your results will largely be affected by the quality of your tools, and no tool is more important to a painter than her brushes.

• You should have a separate set of brushes for use with oil paints if you also use water-based paints.

FERRULE

Brush sizes are determined by the size of the ferrule. One of the most common reasons for the differences in sizing between manufacturers is that the metal tubing used to make the ferrules varies from country to country, as do the measurement systems. There is no international standard for sizing brushes.

Ferrules are either flat or round on the side where the filaments emerge. Filaments are glued into place, bonding them to the metal ferrule. Most brushes come with a nickel-plated, copper, brass or aluminum ferrule. Another popular ferrule material is a quill from a duck, goose or turkey feather. These brushes tend to be more expensive than their metal counterparts.

Bristles are glued into the ferrule at one end, and the handle is glued into the other. The ferrule is then crimped at one end to hold the hair and may be crimped at the other end to fasten it to the handle. A double crimp is considered to be more durable and, therefore, preferable.

HANDLE

Craft brushes have shorter handles than fine art brushes, but they are otherwise made in the same manner. When working at an easel, it is easier to use a longer-handled brush. However, decorative artists work close to their surfaces, so they usually find shorter-handled brushes easier to use.

The diameter of a brush handle depends on the manufacturer and brush style. Some people with hand problems or arthritis may find wider handles easier to use. The brush should be easy to hold and feel well balanced in your hand. If the brush is not weighted evenly, it will be more difficult to hold upright and your hand will fatigue more quickly. Most brush handles are made from hardwoods and are painted and varnished for longer wear.

BRUSH SHAPES

As mentioned above, ferrules are either flat or round on the filament side. Brushes can be categorized by their ferrule shapes.

Flat Ferrule Brushes

Flat: Includes angle brushes, shaders, wash or glaze brushes and blenders (sharp corner or angular brushes).

Filbert or cat tongue: Similar to the flat brush but edges are rounded.

Rake or comb: Similar to the flat brush but the edges are thinned so that relatively few filaments are the full length.

Mop: Rounded full brush, much like a cosmetic brush.

Fan brushes: As the name suggests, the filaments are angled into a fan shape.

Round Ferrule Brushes

Round: Has a full load of bristles that tapers to a point at the tip.

Liners, scrollers, scripts and spotters: Similar to the round brush but they have fewer hairs and a sharper point at the tip.

Stippler: The tip may be blunt or pointed. Generally, stiffer filaments are used in making this brush.

tera tip

The sponge from a small sponge hair roller can be slipped over a brush handle to widen it and make it more comfortable to grip. You can also use pencil grips to make holding the brush more comfortable.

Brushes, *continued*

FLAT

Flat brushes are the most popular shaped brush for decorative painters. Note the difference in sizes and brands. This is due to a lack of industry standards in brush sizing. You must choose the brands and sizes that work best for you. Flat brushes are excellent for basecoating, floating and sideloading color. See pages 83-85 and 93-100 for detailed explanations of these techniques.

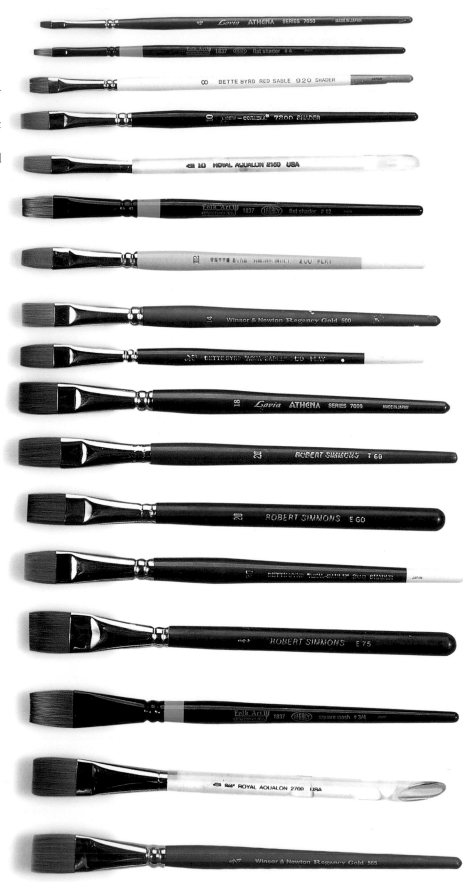

ROUND

Round brushes vary greatly in size, fullness and length of bristles. They are excellent for strokework and detail painting. Again, choose the brushes that work best for you.

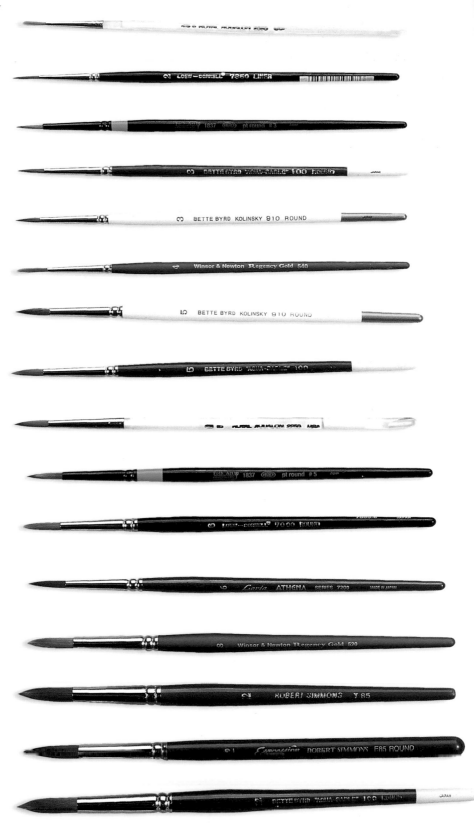

Brushes, *continued*

LINER

Liner brushes are used for detail painting, such as vines, cross-hatching and other linework techniques. Included in the liner category are scrollers, scripts and some round brushes. See pages 209-210 for learning how to use a liner brush.

FILBERT

This is similar to a flat brush but it has rounded edges. This brush is a favorite for basecoating, floating and creating leaves.

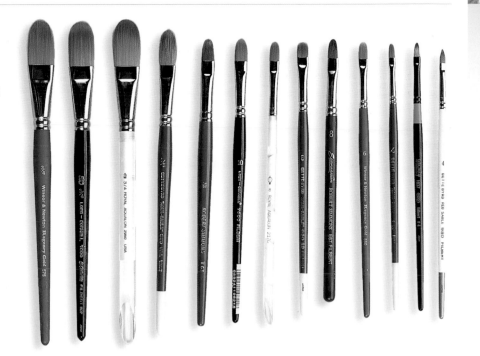

ANGLE SHADER

A variation on the flat brush, angles have bristles arranged at an angle to the ferrule. Many painters prefer this brush for small, tight areas. Some painters prefer it for floating and side-loading color because the short hairs hold less water.

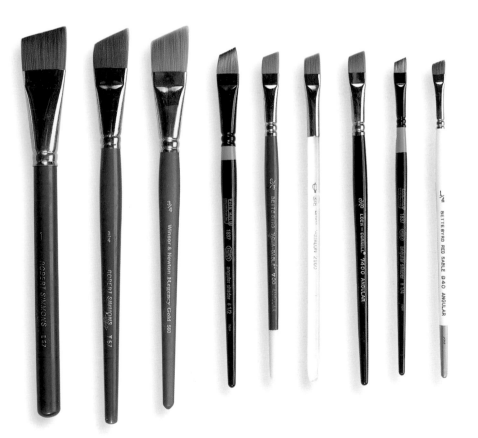

Specialty Brushes

DAGGER OR STRIPER

This angled brush produces beautiful lines and ribbon effects. Despite its odd looks, once mastered, this is an excellent tool to have in your brush box.

TRIANGLE, MIRACLE, WEDGE OR FEATHER

A brush with many names, this tool is primarily used for fur and textured effects. It can also be used for creating leaves.

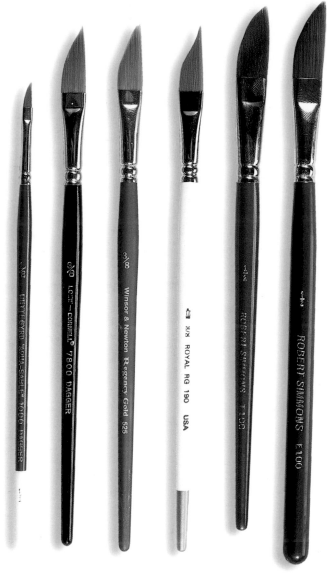

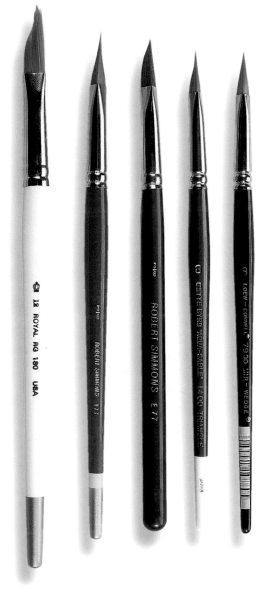

RAKE OR COMB

These brushes can be confusing because each manufacturer uses a slightly different name. It is a flat brush with the tips of the bristles thinned. The brush is loaded like a liner brush with an inky consistency paint and will produce the effects of hair, fur or parallel lines to be used in texture or patterns. See page 206 for its uses.

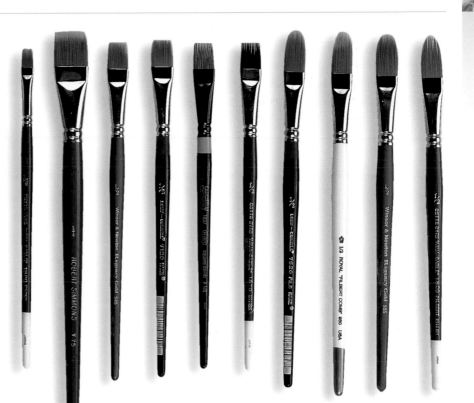

DEERFOOT STIPPLER

This group of stippler brushes includes both flat and round ferrule brushes with a fat, blunt end. This brush is primarily used to produce the effect of foliage or short fur.

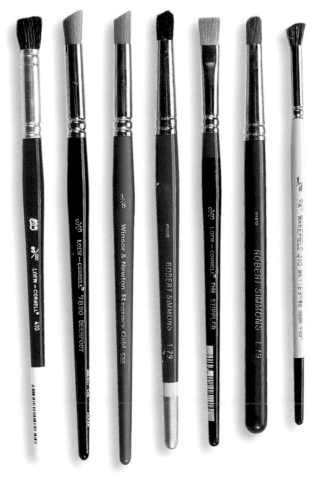

Specialty Brushes, *continued*

FAN

Fan brushes have a multitude of uses for the decorative painter. The stiffer camel versions are commonly used in oil painting to produce foliage and fur. The softer versions can be used to blend colors. The brush is also an excellent tool for spattering paint. See page 200 for this technique.

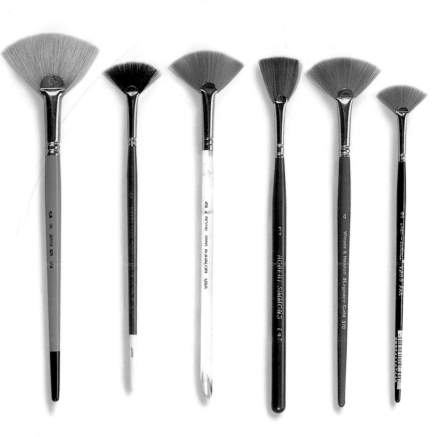

MOP

New painters often comment upon this brush's similarity to a cosmetic brush. Like its cosmetic counterpart, the mop is used to blend and soften color. It can also be used to apply color or varnish.

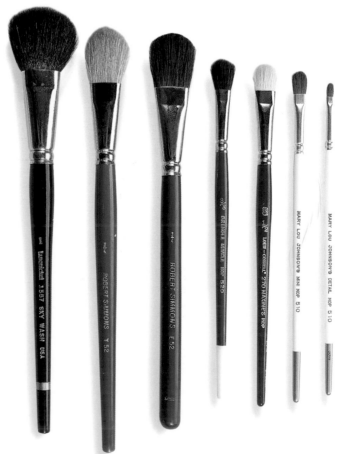

EXTENDED BRISTLE

Whether you like painting with these or not is a matter of personal preference. The extended bristles hold more water and pigment, which means you will get a longer stroke with the extended bristle brush.

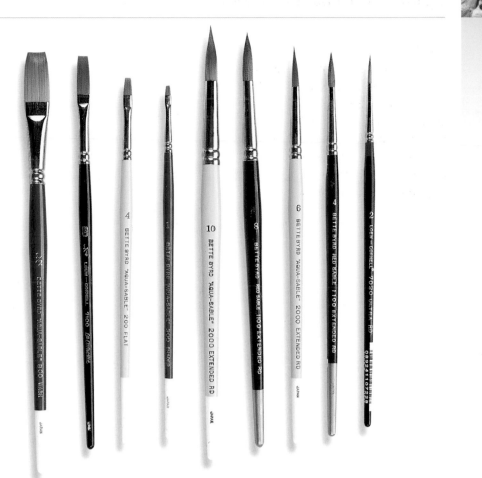

BLENDER

A variation on the blunt end stippler brushes, the blenders are rounded at the tip and produce a softer stippling effect. They can be used to blend colors as well.

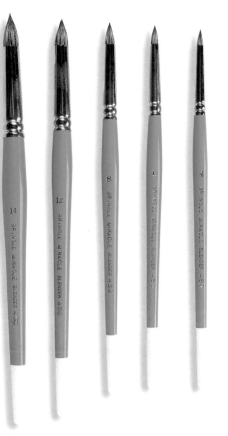

Specialty Brushes, *continued*

ONE-STROKE

Many artists are now developing their
own brush lines to help painters learn
specific techniques. This is the case
with Donna Dewberry's One-Stroke
brushes and teaching guides produced
by Plaid Enterprises. See pages 120-
127 for more information on the
One-Stroke technique.

FOR FABRIC PAINTING

Separate brushes are suggested for use on fabric because the fibers in the fabric respond best to a stiffer bristle that can work the paint or dye into the surface. Nylon brushes will stand up to the greater wear and tear of scrubbing that is required with painting on this surface.

FOR OIL PAINTING

Oil painting requires its own set of brushes. Shown here are a few of the extended-handle brushes used for painting on canvas. The handle extension makes it much easier to paint using an easel. The stiffer bristles allow you to work the paint into the canvas fibers without damaging the brush.

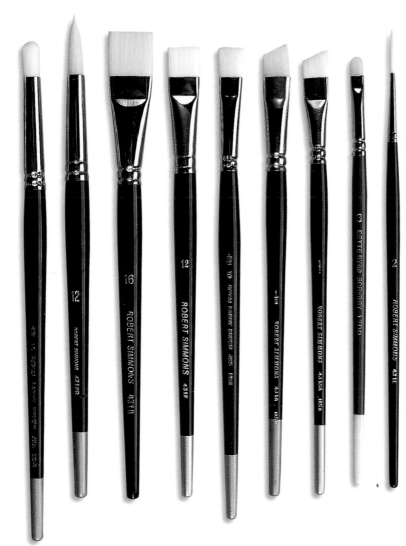

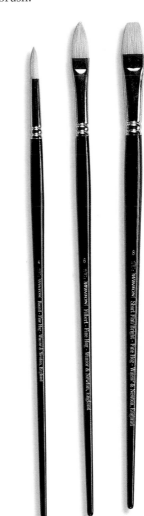

Specialty Brushes, *continued*

VARNISHING OR WASH

A large, fuller version of a flat brush, the wash is used to glaze in a "wash" of color into a larger area. This brush can be used for basecoating, blending and varnishing. If you use a specific brush for varnishing, use it for that purpose only.

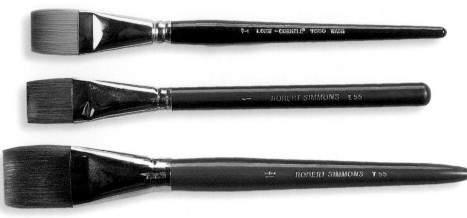

TECHNIQUE TOOLS

More and more specialty tools are being produced for the decorative painting industry to help you get better results. Shown here are a spattering tool, a wipe-out tool, a foam brush and a stenciling brush.

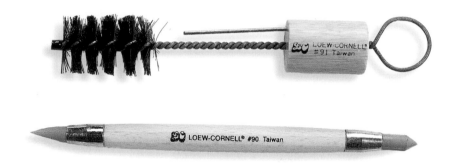

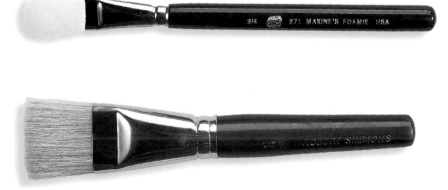

Caring for Your Brushes

With proper care, many artists keep their brushes for years. I must confess that I am very tough on my brushes. For that reason, I have learned some basics that help.

Do not leave brushes soaking in a fluid above the ferrule level. Moisture can cause the wood to swell which, in turn, may cause the wood to crack or ferrule to loosen. Rinse your brush and then remove it from the water immediately. If you want to soak the bristles, keep the fluid level below the ferrule when possible.

Do not allow paint to dry on the bristles. There may be times when you cannot immediately clean your brush thoroughly, for example, after a seminar or class. On these occasions, rinse your brush, work a paint retarder or brush cleaner into the filaments and then wrap it with foil or plastic until you can properly clean it.

Finer natural hair brushes need gentler care than those with the more durable bristle filaments. These softer brushes (such as pure sable brushes) have a greater tendency to split, as human hair splits when not properly cared for. Avoid using the ridges in brush bins for this style of brush. Rinse it by tapping the ferrule against the side of the brush basin or water jar so that the percussion knocks the paint away from the bristles.

With all brushes, be sure to blot water from the brush after rinsing and before storing it so that excess water does not run down and sit in the ferrule, which can loosen the glue. It is also a good habit to blot water from the ferrule each time you rinse since water dripping down the ferrule can ruin a perfectly good stroke!

tera tip

Some "baby wipe" products contain alcohol and can be used to remove paint from your hands, clothes and brush handles. Be sure to read the label. Plaid Enterprises has develped a "wipe" product just for painters.

tera tip

Before using water or brush cleaning fluid, wipe as much of the product as possible out of the brush on a smooth cloth or towel. If you are working with a water-based product, the next step is to rinse your brush by gently tapping the handle of the brush against the side of the basin. If appropriate, you can gently rake the brush across the ridges at the bottom of the basin. If not, tap the brush against the side of the brush basin to knock paint away from the filaments. Repeat until the brush is clear of paint. If you see residual color coming off the brush when you blot it on your towel, repeat the cleaning process until the water coming off the brush is clear. Dry the ferrule and handle after rinsing.

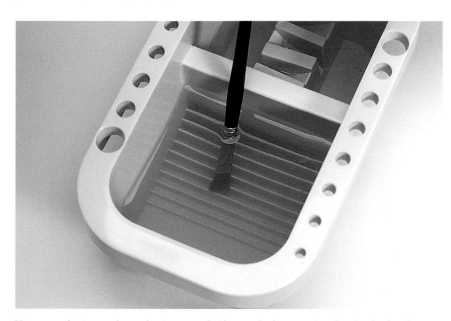

Your water basin may have plastic or metal ridges at the bottom. Gently rake the ferrule across these ridges to clean product from the filaments. These ridges may damage more fragile filaments, so if you use the ridges, do not rake back and forth—move the brush in one direction only. Some brush basins have an angled set of ridges that make it impossible for you to rake back and forth in order to lessen the possibility of damage to your brushes.

Caring for Your Brushes, continued

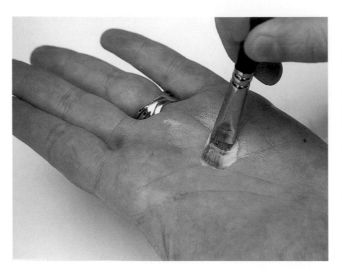

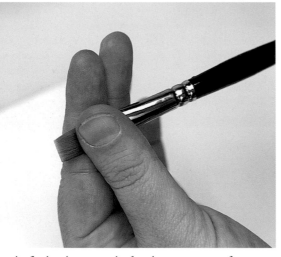

To reshape the flat brush, start at the ferrule, squeeze your fingers gently and flatten the brush to its original shape.

For a deeper cleaning when you are finished with your project, or if you are using a product that is not water-based, use a brush cleaner appropriate for the product and brush you are using. If the product is non-toxic, pour a small amount into the palm of your hand and gently work the bristles back and forth, moving them in their natural direction. Avoid splaying the bristles by roughly twisting and turning them, which may damage the brush. Rinse the product from the brush, and remove excess moisture by wiping it across a smooth cloth or towel.

Some artists like to leave retarder or a small amount of brush cleaner in their brush between uses to help maintain its shape. Be sure to read the brush cleaner guidelines to make sure this will not damage the brush, and, of course, rinse well before you use it again.

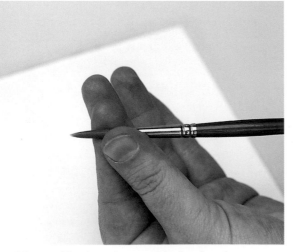

To reshape the round brush, again start at the ferrule and create a round pointed tip on the brush with your fingers.

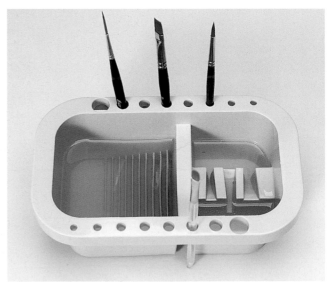

Set the brush in a basin hole to let it dry.

Repairing Damaged Brushes

Many painters are taught to rinse their brushes often to avoid allowing paint to creep up into the ferrule, but the purpose of a brush is to distribute paint. As long as it is properly cared for and paint is not allowed to dry in the brush, allowing paint to be distributed throughout the bristles and up into the ferrule will not harm a quality brush. Many techniques cannot be executed unless the brush is fully loaded to the ferrule. To prevent damage, simply watch that you do not allow the paint to dry before rinsing properly.

If the worst happens and your brush is damaged, sometimes there is help! Before you have given up hope and are ready to throw the brush away, try these emergency fixes. If they don't work, you haven't lost anything since you were going to throw the brush away anyway.

Pour a small amount of rubbing alcohol or vodka into the center of your palm, and gently rub it into the dried paint. This may take several applications. Work brush cleaner or Murphy's Oil Soap into the bristles and then wrap the brush in foil or plastic wrap for one to eight hours. Rinse as usual.

GUARANTEES

Most major manufacturers guarantee their brushes. If you have a problem with a brush, contact the manufacturer via its toll-free number or Web site. Follow the instructions for returning the brush to get a replacement if it falls within the return guidelines. If you do not know who the manufacturer is, contact the company from which you purchased the brush.

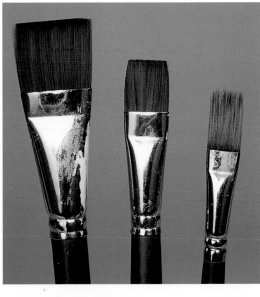

These brushes are in the beginning stages of damage due to dry paint. If they are not properly cleaned, the paint will build up and ultimately ruin the brushes.

Rubbing alcohol will dissolve most acrylic paints. Gently work it into the bristles to avoid further damage, then rinse thoroughly and follow the steps on page 38 for reshaping and drying.

 tera tip

If you have stored your brushes upside down or left them sitting in water and the bristles are now bent, try briefly dipping the bristles into boiling water. This seems to work best on mixed hair brushes.

If the filaments on a natural hair brush are split, some artists recommend using human hair products for split ends to restore the tips.

Surfaces

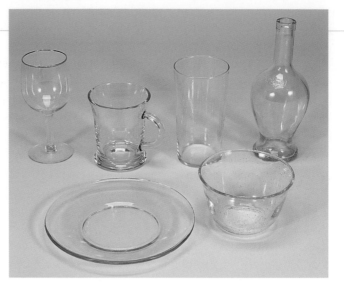

GLASS

Manufacturers have recently developed new paints to use on this very popular surface. See page 76 for more details.

SLATE

See page 76 for more details on working with slate.

PORCELAIN

Porcelain is becoming a popular painting surface. See page 75 for more details.

WOOD

Wood is a common painting surface for decorative painters. See pages 71-74 for detailed instructions for working on wood.

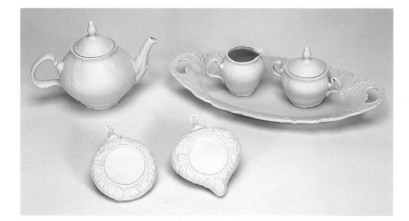

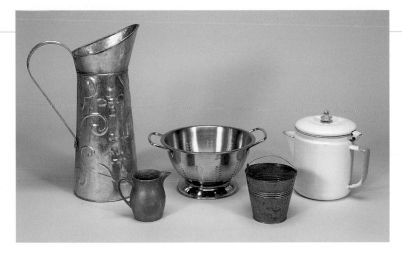

METAL
Metal requires special paints to keep it from rusting. See page 77 for detailed instructions.

FABRIC
See page 78 for more details on working with fabric.

CANVAS
See page 80 for more details on working with canvas.

PAPIER MÂCHÉ
See page 81 for more details on working with papier mâché.

Wet Palette

No matter what kind of paint you use, you will need to work from a palette. You may want to try several palettes to find which works best for your painting style. Many artists like simple Styrofoam plates, Styrofoam meat trays (which may be purchased from discount supply stores), deli paper or wax palette pads because they are disposable. Some artists prefer to use glass or acrylic palettes that enable them to rinse wet paint or peel the dried paint off the palette and reuse it over and over again. A third category of palettes lies in between—wet palettes allow the artist to store paint for longer periods and the paper may be rinsed and reused several times before throwing it out. Artists in drier climates often choose deli paper and wet palettes because they help to keep the paints damp and cool.

Masterson's Sta-Wet palette is a great addition to your painting supplies. It keeps your acrylic paints from drying out and they remain fresh for several days of painting.

A deli paper palette is sometimes called the "Arizona Palette." This palette is created by placing damp paper towels between two sheets of deli paper. The slight wax on the deli paper prevents the water from seeping up and diluting the paint.

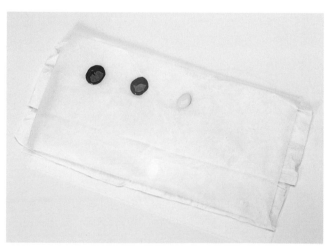

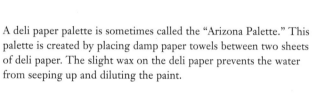

Wax palette pads can be used alone or with another palette as a place to blend paint. The wax surface of the pad makes it easier to blend paint because it doesn't absorb the paint, water or mediums.

SETTING UP A MASTERSON STA-WET PALETTE

Setting up a Masterson Sta-Wet palette correctly is crucial to its effectiveness. Shown here is the wet palette sponge loaded with water. In this photo, I am holding the palette at a slight angle so that you can see the amount of water a fully loaded palette needs to do its job correctly.

Presoak the paper for the palette. Then lay it on top of the sponge.

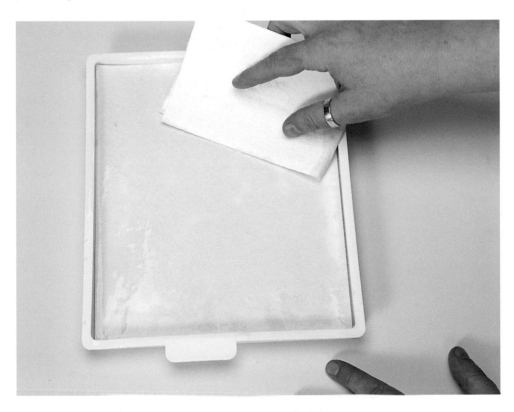

With a soft, absorbent cloth, wipe the moisture off the top of the paper. It is important that the top of the paper be dry, or the water will seep into the paint and dilute it.

CHAPTER ONE

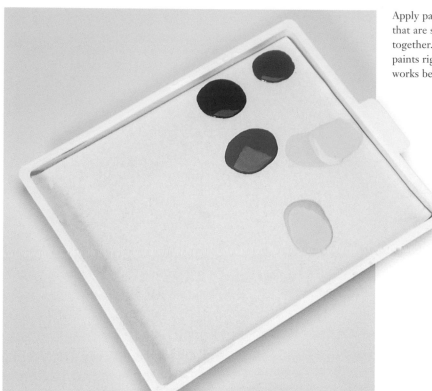

Apply paint to the palette in small puddles that are spaced so the paint will not run together. Some teachers suggest placing the paints right next to each other. See what works best for you.

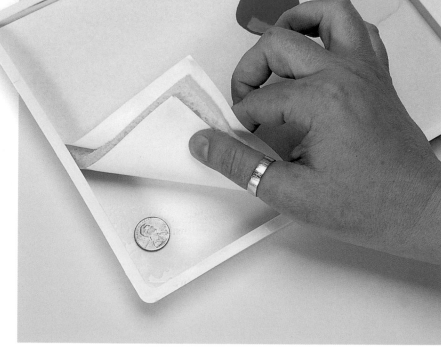

To prevent mildew in your wet palette, place a penny under your sponge.

Water Basin

Different styles of water basins are available for painters. Each manufacturer tailors its basin to specific needs, and you will find that you like some basins better than others. Some, like the Masterson Rinse Well, provide fresh water at the press of a button. Other basins have dual containers so you can rinse your brush in one side and have fresh water available for floating color and creating washes in the other side. Some basins have ridges or wire grates at the bottom for you to pull your brush bristles across to help clean paint between the filaments.

The differences between what the basins provide and what you prefer will ultimately be based on the way that you paint. Many artists, including myself, use more than one basin while painting. I use a lot of paint in my brush, so I use one basin for cleaning and rinsing, and a separate, smaller water jar to create glazes, lining, etc.

A great debate among painters is how often to change your water. If you use multiple containers, you will need to change your water less often. However, it is important to understand that if you are cleaning your brushes with dirty water, dirty water (with paint in it) is drying on your brushes. This will create a buildup on your brushes and ruin them. If you don't change your water often, you will need to deep clean your brushes with a brush cleaner at the end of each painting session.

Other Supplies

Artists use many supplies during the painting process. As decorative painting has developed, manufacturers have created more and more products to help make it easier for us to achieve the looks we want. Artists have had to learn to adapt their techniques to accommodate these new products. Here are some of the most common products used by decorative painters.

When you are working from a pattern, tracing paper, graphite paper or Chacopaper, pencils and a stylus are commonly used to trace the design from the original pattern and then apply it to the surface of your project. See chapter four for information on transferring a pattern.

Specialty products, such as sponges, paint rollers and lining tips, are items you will pick up as you begin to do more painting and want to create special effects, such as faux finishes. These products are shown throughout the book with explanations on how they are used and how to choose the right tool for the effect you wish to achieve.

STYLUS
The stylus is used as a painting tool and to transfer patterns to surfaces. It is wonderful for creating small dots.

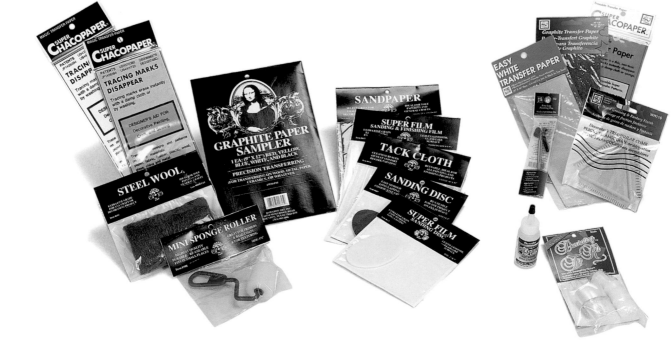

TRACING PAPER AND SANDING SUPPLIES
Other staples for your painting setup include graphite, Chacopaper, sanding products, rollers and finishing tools. There are more supplies that you'll need that are common household items, such as paper towels, Q-tips, pencils, erasers and several kinds of tape, such as Scotch Magic brand and masking tape.

PAINT SAVERS

These sealed containers are perfect to hold mixes and washes used throughout a painting project. With these, you won't need to remix colors in order to replicate a color exactly.

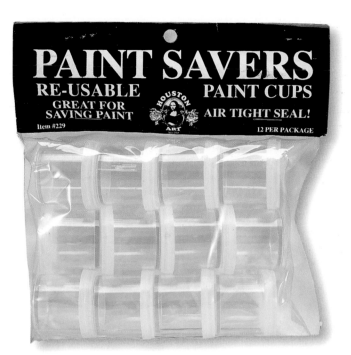

PALETTE KNIFE

Palette knives are available in plastic or metal. They are used to mix colors.

Your Work Station

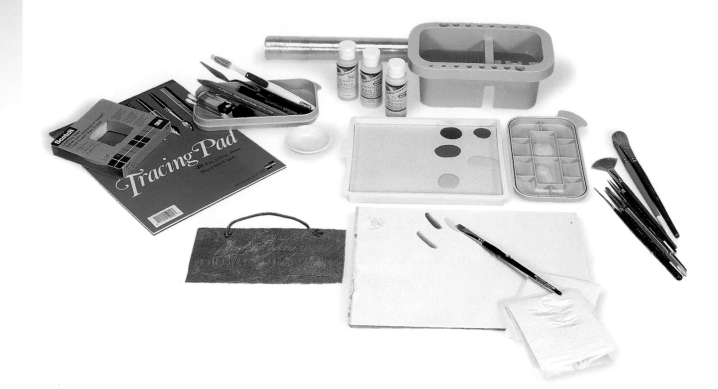

When I teach a class, I am always surprised at how few painters take the time to get organized before starting to work. Your setup should be based upon which hand you predominantly use. If you are right-handed, your water, brushes, palette and blotting towel should be on the right side of your table. The piece you are working on should be centered in front of you so you don't have to bend or turn to work comfortably. Other materials that will be used less often should be behind your piece and to your left. If you are left-handed, this setup should be reversed.

If you are right-handed, the paint should be along the top or left side of your palette. This will keep you from running your hand, arm or sleeve through it when you are working on the palette. A bubble palette, wet palette and palette pad are shown in the photo above. Generally, you would use only one or two of these at the same time. The key is to make sure they are placed close enough that your hand can comfortably reach them, but far enough from the edge that you don't set your arm in the paint.

Painting can cause arm, hand and back fatigue if you don't have a comfortable chair and table. You might find that a footstool is helpful if you sit for a long time. Whenever possible, try to sit up straight and face forward so that you are not doing a lot of bending and reaching as you paint.

Painting is easier if you organize your painting space so that your water, palette and brushes are on the same side as the hand you paint with. The work station above is set up for a right-handed person. Notice how everything is within easy reach.

 tera tip

Fold your towel so that you always have a clean edge on which to gently blot the water side of your bristles when side loading. Although it may seem natural to keep it in your lap like a napkin, try to train yourself to leave it next to your palette so you move less when painting.

Sealers & Basecoats

One of the biggest areas of confusion among beginning painters is how to seal and varnish their projects. One of the most important pioneers in the decorative painting industry is Jean Watkins. Jean founded J.W. etc. and traveled the country for many years teaching the fundamentals of sealing and varnishing at conventions and seminars. Jean was among the first artists to explain that sealing and varnishing a painted piece may be its only protection against the effects of time. Given the amount of time most artists put into painting their project, wouldn't it be a shame if it were ruined after just a few years due to sunlight, warping of the wood or sap drainage?

It is important to understand the distinction between sealing and varnishing. Sealing creates a barrier between the paint and the surface on porous materials such as wood. It equalizes the porosity of the surface so that the paint adheres evenly. Varnish, on the other hand, provides a barrier between the paint and air, dirt or other damaging elements.

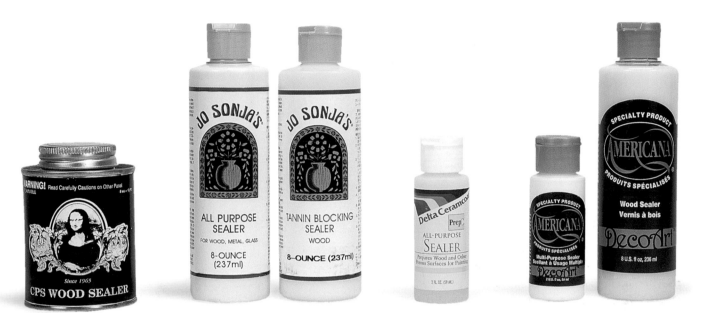

Sealers are used on porous surfaces such as wood, prior to painting. This helps to seal the surface and prevent the paint from soaking in.

Stains & Antiquing Products

Premixed stains and antiquing products add convenience and consistency to the painting process. These can be used before or after painting. If you use them after painting, be sure to seal the surface with varnish first.

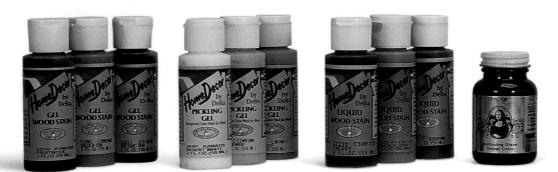

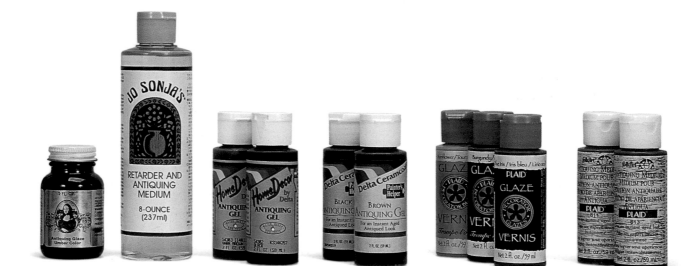

Gesso seals the surface while depositing color. You find this product usually in white and black.

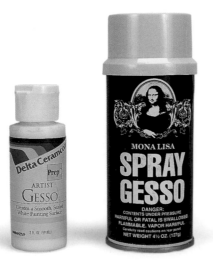

Stamps & Sponges

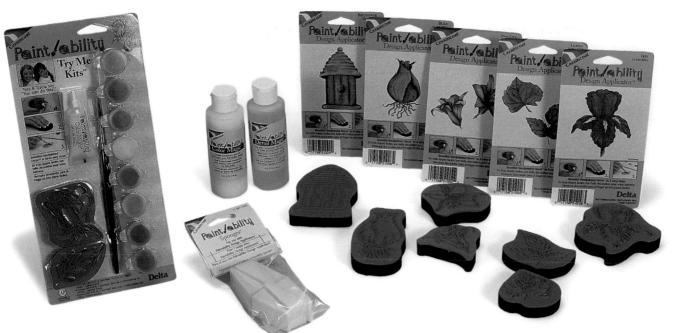

PAINTABILITY STAMPS

This product line makes it easy for the beginner or advanced painter. You can apply the stamps and paint in the lines.

VARIETY OF SPONGES

Look at the variety of sponges available and the textures they produce.

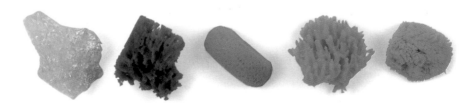

ART SPONGES

Art sponges are available in a variety of sizes and textures and have many uses, such as adding texture to your basecoat. The smaller ones work great to create background foliage.

Mediums

Regardless of the type of paint you choose, you will find a host of mediums to help you get the results you desire. Learning about the properties and applications of these mediums can be challenging for new painters; however, the results you will get are well worth the effort!

Most manufacturers create mediums for their paints, and each manufacturer has a slightly different name for its products. This can make it difficult to figure out which product to use. Below I have addressed the main categories of mediums for acrylic paints. Contact the manufacturer of the brand that you use to find out the name of the product that falls into the categories described if you do not see it here.

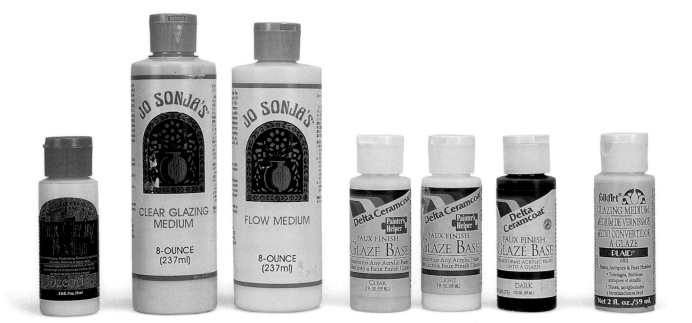

GLAZING MEDIUM

To create a glaze means to make the paint transparent or to thin the paint until you can see through it. That is exactly what these glazing mediums accomplish. Most of the products slow the paint's drying time and may level out the texture of thicker paints, which might otherwise leave brush marks. Products that fall within this category are generally called glazing, flow or thinning mediums.

FLOATING MEDIUM

"Floating" is a term that refers to the technique of floating color, side-loading or shading and highlighting by loading one side of your brush with color. Traditionally, the other side is loaded with water. These products are used to make floating easier. There are two types of products within this category—water additives and gels.

Water additives, such as Delta's Color Float and DecoArt's Easy Float, add "slip" to the water, making it easy for you to move your brush. These products work best for painters who have trouble getting enough paint and moisture in the brush. This

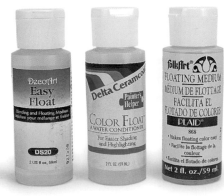

corrects the drag on the brush.

The gel-type floating medium, such as Plaid's FolkArt Floating Medium and Paintability's Detail Magic, are a gel form of water. To use them, dip one corner of your brush in the paint and the opposite corner in the medium. The gel is heavier than water, so when you blend your brush on your palette, the gel holds the paint to the side and prevents a "ghost" or trace amounts of the paint being pulled to the water side. This product works best for painters who have difficulty controlling the amount of paint and water on their brush. This is a common problem because water thins water-based paints. The water pulls the paint over to its side. The gel acts as a barrier on the brush to prevent this from happening.

BLENDING MEDIUM

Blending mediums and extenders are used to "open" or extend the drying time of paint and to increase its propensity to blend with other colors. Acrylic and gouache painters often use blending mediums to help them achieve the soft, muted effects created using oil paints. Because oil paints have a significantly slower drying time than acrylic paints, the artist can work with the paints "wet-on-wet" or without letting the paints dry between coats. This allows her to achieve a softer gradation from one color to the next. These mediums do not slow the drying time to the extent of an oil paint, but they do provide a greater open window for this type of work.

Acrylic painters must remember that the slowed drying time means that you must wait until the paint is fully dried before you paint over it. If you don't wait, you are likely to lift the paint when you attempt to paint over it. Some artists use a hair dryer to speed the drying time when they are finished working with the extender. You must then allow the piece to cool because acrylic paints work best with cool temperatures and the properties of the paint may alter if it is applied to a warm or hot piece. Also, when using a hair dryer, remember that the heat may cause the sap in wood to reactivate and leak.

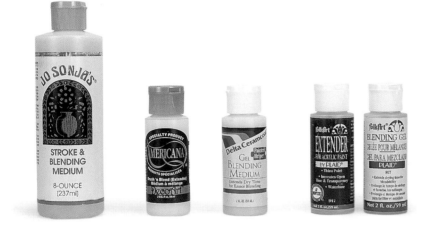

RETARDER OR ANTIQUING MEDIUM

Retarders extend the open or drying time of paint. They significantly thin paints and therefore make an excellent medium for antiquing. See chapter eight for more information.

CONTROL OR THICKENING MEDIUM

Thickening mediums are used to give acrylic paints more body or volume. This enables you to gain greater texture using standard bottle or tube paints. Kleister medium falls within this category. Although the thickening mediums will thin the paint, their purpose is to add extra body for textural patterns, faux finishing and graining.

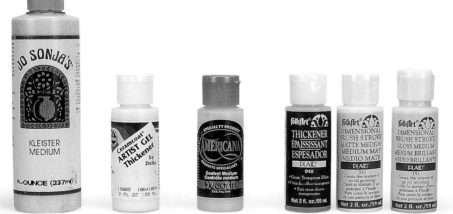

Mediums, continued

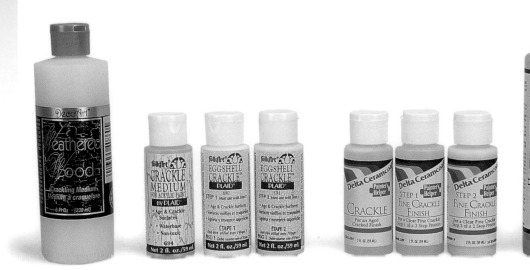
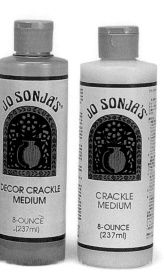

CRACKLING MEDIUM

Crackling medium creates small or large cracks in acrylic (latex) paints. Follow the instructions on the bottle to get the best results. See pages 201-202 for a demonstration of the crackling technique.

CANDLE MEDIUM

Specialty products help paints adhere to nonporous surfaces, such as glass and candles.

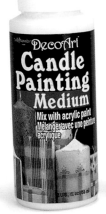

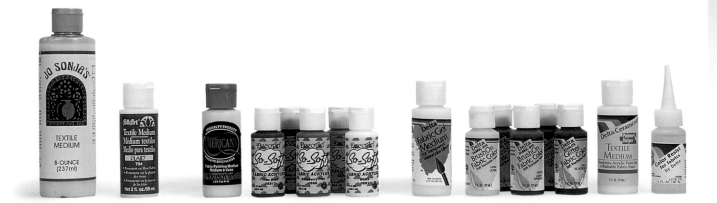

TEXTILE MEDIUM

Fabric has long been a popular surface for decorative painters. Textile mediums allow you to paint directly onto fabric. After proper application and heat setting, the paints become permanent on the fabric.

Textile mediums are added to acrylic paint or gouache to convert the paint into a product that may be heat-set and become permanent on the fabric. Also shown here are pre-mixed fabric paints that do not require a textile medium to be used with them. Each product has its own rules for use, so you should read the product literature before you paint. Most require heat setting with an iron or in the clothes dryer to become permanent. Most products suggest washing the piece inside out and on a gentle cycle after heat setting.

TEXTURE MEDIUM

Texture mediums can be used in a variety of ways in decorative painting. Prior to painting, they can be used to build up the surface of the piece for a three-dimensional effect. Many can be mixed with paint (see the label for instructions) to create a textured effect with your strokes. Some texture mediums, specifically the snow products, are meant to be added after painting for decorative accents.

Varnishes & Finishing Supplies

While sealers are used prior to painting to create a barrier between the surface and the paint, a varnish is used after painting to protect the paint from the elements. Satin and gloss finish varnishes are also used to give a finish to the piece, which adds to its decorative nature. Your choice of varnish can be part of the artistic process, as well as a protective measure.

Varnishes come in several finishes. Matte finishes are generally used for pieces that are left in a natural state or are primitive in nature, or for artistic effect. Satin finish is the most popular varnish, and it provides a light shine without a bright gloss. Gloss and polyurethane varnishes are most often used on small pieces, such as jewelry, or for an artistic effect on larger pieces, such as trays. As with most choices in this art form, your choice of the most appropriate finish is largely a matter of personal preference.

Stains are used prior to sealing and, in some cases, as a sealing product. Read the label to determine if the stain contains a sealing agent. It adds color to a porous surface. It is important not to seal before staining because the stain cannot absorb into a sealed surface.

Antiquing is used after sealing, and usually after painting, to add a transparent layer of color to your painted piece. Antiquing is used to age or make the finished piece look "antique." It is generally done after varnishing your piece so that the surface porosity is equalized and the antiquing doesn't absorb into one section of the design more than another.

Specific techniques on sealing and finishing projects are discussed in depth on in chapter eleven.

VARNISHES

Varnishes provide a barrier between the paint and air, dirt or other damaging elements. This is one of the last stages of the painting process.

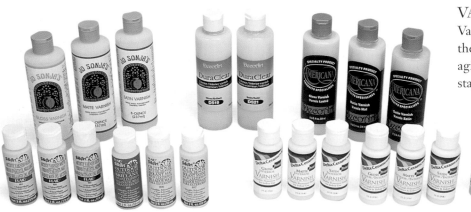

GOLD LEAFING

Gold leafing can be done after painting or as the only decoration on your surface. Some products require many steps, while others require only a few. You'll need to try the different brands to discover which result gives you the look you want. See pages 226-230 for a demonstration of gold leafing.

color

What do I need to know?

Color Basics

Color theory can be intimidating to the beginning painter, but mastery of color theory can turn an average painter into a master artist. Color theory is just that—a theory. However, the theory is not a part of the arts; it is a scientific theory involving light and the way our eyes and brains perceive light and color. As fascinating as the subject is, what I will explain is practical and basic color theory for artists.

Why Is This Important?

If you think about it, color is the only real tool in painting. We create the illusion of what we paint through our use of color. Therefore, shading, highlighting (value) and color make up the language of painting.

Understanding how the color wheel works will help you plan color usage in your design. It will also help you identify what is not working in your design. In the early stages of a design, I might find that the pattern is perfect but that the value of my color choices is off, which affects the entire design. If, for example, you understand that what is lightest in value appears to be in the foreground, you will use this to create depth in your painting. You can emphasize a detail in your design simply by using colors with opposite characteristics, such as opposite hues (highlighting a red apple with green), values (shading with a darker color) or temperatures (highlighting a blue-green flower with red-orange).

The Color Wheel

MIXING A COLOR WHEEL

The most common color theory used by artists today is based upon a color wheel. I suggest that you purchase a small color wheel and keep it with your painting supplies. I have one in my painting kit, one at my desk and one in my purse. Once you understand the language of color, you will find your color wheel to be an indispensable tool.

Primary Colors

The nucleus of the color wheel is three colors: red, blue and yellow. These are primary colors, so named because they stand alone (cannot be created by mixing other colors) and all the other colors on the wheel are made from combinations of these three colors.

Secondary Colors

A mixture of two primary colors creates a secondary color. (Just remember that second = two.) There are three secondary colors: orange (yellow + red), green (yellow + blue) and violet (blue + red). When mixing a secondary color, you must achieve a color that is not dominated by either of the primary colors. For example, a true orange is neither more red nor more yellow and a true green should not be more blue than yellow. You should see only orange or green, not one of the underlying primary colors.

Tertiary Colors

Tertiary colors are created by mixing a primary color with a secondary color. In other words, these colors contain three colors—the primary color, plus the two colors of the secondary color. Since the secondary color already contains the primary color, the tertiary color will have a stronger slant toward the primary color. There are six tertiary colors: red-violet and red-orange, blue-green and blue-violet, and yellow-orange and yellow-green.

When mixing a color wheel, it is important to choose true primary colors that do not contain traces of other color pigments.

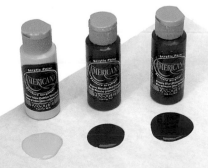

MIXING A COLOR WHEEL, *continued*

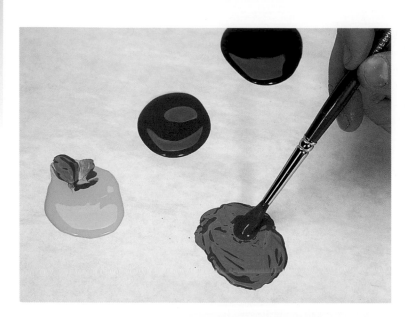

Brush mix equal parts of primary yellow into primary red to create orange.

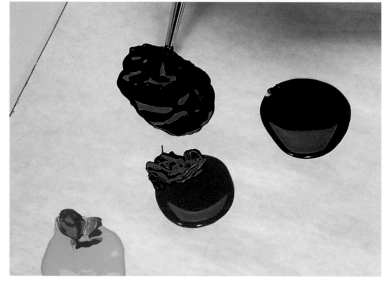

Brush mix equal parts of primary blue into primary red to create violet.

Brush mix equal parts of primary blue into primary yellow to create green.

THE COMPLETED COLOR WHEEL

The best way to learn to work with colors is to mix your own color wheel and value scale. I had mixed color wheels on my own, but in an excellent workshop led by Susie Wolfe, CDA, I had the fascinating experience of watching the participants create their own color wheel. This expe- rience made me realize how little artists really understand about color. For example, orange is not a 50/50 mix of red and yellow. If you never mix a color wheel, you might never understand the way value and pigment can affect the colors. In order to mix your own color wheel, you need to work with pure pigments.

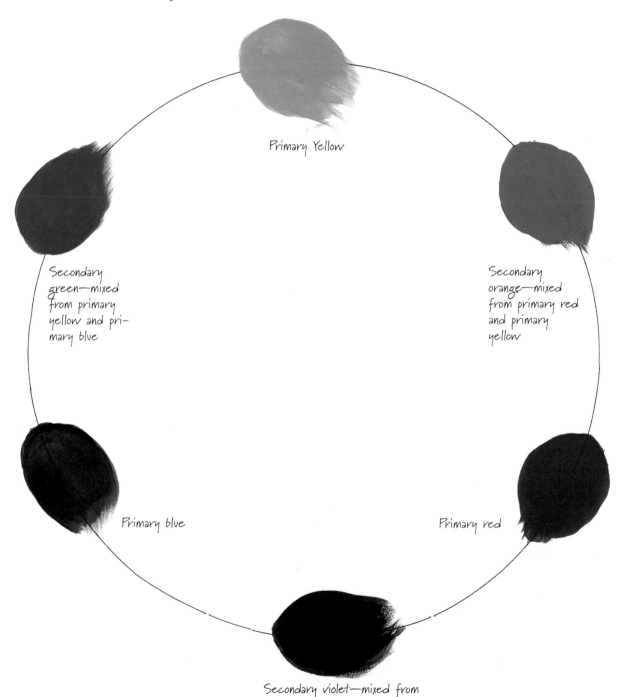

Primary Yellow

Secondary green—mixed from primary yellow and primary blue

Secondary orange—mixed from primary red and primary yellow

Primary blue

Primary red

Secondary violet—mixed from primary red and primary blue

Mixing Colors

Mixing colors can be intimidating at first. Here are a few techniques that will help you along your way.

MIXING WITH A BRUSH HANDLE
Start by placing colors on the palette, one on top of the other. Do not stir or you will get a wider and wider base of color that makes it harder to load your brush. You want to keep the puddle roughly the same size as when you started.

Put your brush handle in the middle of the top color. Draw bicycle spokes around the lower puddle, pulling paint from the outside edge in toward the middle. This will keep the paint in the same area while you're mixing.

MIXING WITH A PALETTE KNIFE
Mix color with a palette knife by applying downward pressure onto the palette to spread out the paint.

Lift and fold the color over until the paint is thoroughly mixed.

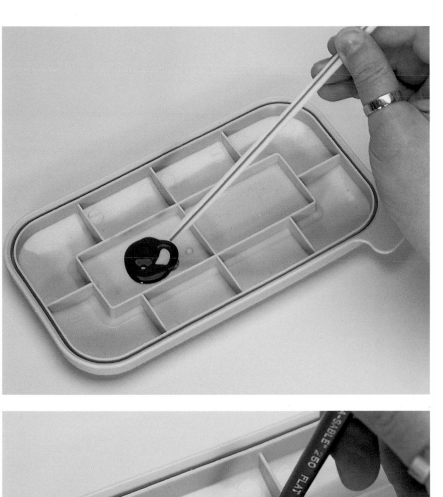

MIXING WATER INTO PAINT

An easy way to control the amount of water mixed into your paint is to use a drinking straw. By placing your finger over one end of the straw, you create a vacuum and you can place drops of water in your palette.

Mix your paint with the water using the brush handle, palette knife or bristles to create a transparent glaze or wash.

The Characteristics of Color

HUE

When we are talking about the colors of the color wheel—red, blue, green, etc.—we are describing their hue. The development of premixed colors in bottles and tubes is a mixed blessing for artists because the name or hue of a color varies drastically from manufacturer to manufacturer. In addition, many colors are hard to define; for example, mauve, taupe and teal are names assigned to a host of hues. For that reason, as artists, we have other ways to describe color. These are value, and intensity.

VALUE

Value describes the relative lightness or darkness of a hue or color. For example, if I say "baby pink," "mauve," "rose" and "burgundy," you probably picture colors in the pink or red family ranging from light or pale to dark and rich. However, the color I picture when I say "burgundy" might be substantially darker than the color you imagine. For that reason, artists

describe value on a scale of 1 to 10 with black at 1 and pure white at 10.

We aren't used to thinking of color in terms of lightness and darkness, so looking at a value scale can be confusing because it doesn't show the values in relation to color. An easy way to learn to see value is to place a piece of red acetate or plastic over your painting or color. The red will neutralize the colors and you will see the darkness or lightness of the colors. You can also do this by making a black-and-white photocopy of your color photo.

You will hear several terms used to describe the value of a color. One such term is *tint*. Adding white or lightening the color's value by mixing it with another color of a lighter value creates a tint of that color. Tints of the base color are often used as highlights. Darkening the color's value—by adding black or a darker value color to the original color— creates a shade.

VALUE SCALE

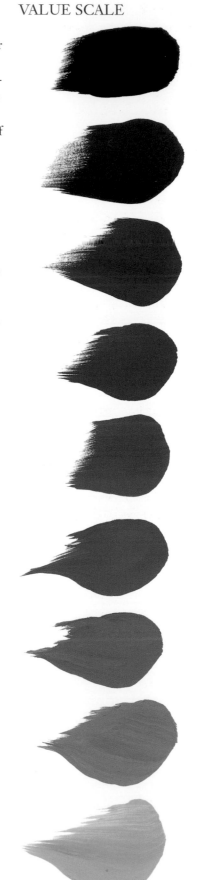

INTENSITY

The intensity of a color describes its relative clarity or dullness. A color may be dulled by adding gray, a complementary color (one that is opposite its position on the color wheel) or a primary color not contained in the original color. Dulling a color is sometimes called "graying"—the color referenced is described as being grayed or toned.

If you think about the color wheel, tertiary colors are by nature less intense because they contain multiple colors that dull the clarity of the primaries they contain. That doesn't mean that a primary color cannot be toned down by graying it.

COLOR COMBINATIONS

The placement of colors on the color wheel can be used to develop visually appealing color schemes. Complementary colors lie opposite each other on the color wheel; for example, red and green, red-orange and blue-green are complementary colors. A split complementary color scheme contains a color combined with the colors on either side of its direct complement on the wheel. The most common color scheme is the triad—three colors equally spaced from one another on the color wheel. For example, red-orange, yellow-green and blue-violet create a triad. When you are using three or more colors as the focus of your design, you will usually choose one color to dominate the design and the other colors to balance the design.

Another pleasing palette choice is made up of analogous colors that lie next to one another on the wheel, for example, blue-green, blue and blue-violet. Analogous color schemes are especially effective in projects that create a specific mood, such as a cool afternoon lake scene or a warm design of a kitten basking in the sunlight. A monochromatic color scheme is one that uses any shade, tint or tone of a single color. Blue Delft is a wonderful example of the effectiveness of a monochromatic palette. In both the analogous and monochromatic color schemes, contrast and depth are primarily achieved through value differences due to the close relationship of the colors.

tera tip

It is not enough to choose a pleasing palette based upon hue alone. Your color palette must be balanced in terms of value and intensity to be effective and visually pleasing.

INTENSITY SCALE

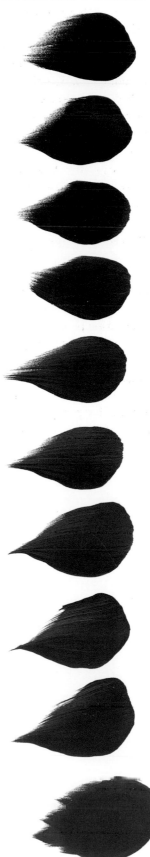

creativity & inspiration

Where can I find creativity and inspiration?

What Is Creativity?

Creativity is the intellectual process of creating or being inventive. It is often referred to in context with the arts, but in truth, creativity affects every facet of our lives. Sometimes creativity involves creating something that is wholly new, but usually it is an interpretive process—your own version of something already in existence. A simple way to think of creativity is to understand that it is problem solving. When an artist decides which color scheme to use in a design or how to lay out her composition, she is solving a problem.

We are creative beings. Every day we make hundreds of decisions that require us to exercise our creative muscles. Unfortunately, we often think of creativity as being outside our control—as though God or a muse must smile down upon us in order for us to be at our creative best. This kind of thought process can be detrimental to your art because you are taking control out of your own hands. In reality, you have everything you need inside of you at all times. Sometimes you may need a small push in the right direction, but the control belongs to you.

INSPIRATION

Sometimes creative inspiration comes to us at the moment we need it, but it is not uncommon for even the most creative artist to need an occasional jump start. Fortunately, there are many inspirational resources available to artists and a few you can create for yourself.

THE IDEA NURSERY

One way to nurture your creativity is to start an idea nursery. The idea nursery simply consists of blank books that you fill with photos, pressed flowers, sketches and clippings from magazines and other materials. Anything that inspires you can be included in your idea nursery. The purpose of the nursery is not to be a source for you to copy from (most things you will put in your idea nursery are copyrighted by others) but rather to provide you with inspiration. For example, I once created a floral design influenced by the colors used in a print ad for coffee. What you find inspiring about the items in your nursery may not be the designs themselves, but color combinations, the shape of a piece of furniture, etc.

Inspirational Materials

Draw, sketch and paste items that inspire you into blank books to use as reference materials when inspiration is needed. These are pages from one of my own idea nurs-

eries. Turn to these idea books when you need inspiration for colors, design or scale. Do not copy these designs, but use them to fuel your imagination.

Books of clip art, or copyright-free images, are a wonderful source of inspiration and reference. Many artists can draw if they have a basic reference as to shape and proportion. The books can also be used to show how to put design elements together effectively. Whether you use the designs themselves or use them as an inspirational reference, the books can be tremendously valuable to you.

Copyright-free images are in the public domain, which means they may be used without further permission from the artist. In the front of these books, the publisher will explain any limitations on the use of the images. Be sure to carefully read the licensing agreement in the front of the book before using the work. Using work from a book of copyright-free images means that you are agreeing to the license as provided in the book.

Inspirational Materials, continued

Magazines are a wonderful source of inspiration for artists. Again, you cannot use the work of another artist in your own work without written consent (and sometimes payment). However, you can use the materials as reference. If your work is at all recognizable as a derivation of another artist's work, it is an infringement on his copyright.

Magazine articles, photos and drawings can help you create an excellent reference library. Look to reference magazines as a starting point, such as the *Decorative Artist's Workbook*, *PaintWorks* and others specifically designed for decorative painters. Home décor magazines are a gold mine for creative inspiration as

they show work in the type of setting in which it will be used. I often cut out photographs of rooms that I like and then design pieces as though they would go into that room by drawing from the color scheme and general theme of the photograph.

Magazines can also be helpful by providing artist profiles, product information and tips and techniques. Because the magazines are published on a regular basis, this is an inexpensive way to build your own reference library of materials by working artists. If you choose to cut articles out of magazines, be sure to date and write the name of the publication on the article for future reference.

The Courage to Create

All creative processes require courage. It takes at least *some* courage to take the first step toward doing anything new. Creative processes are, in a way, birthing processes. All parents want their children to be popular and accepted. When we create something new we are putting a part of ourselves out before others and, while we want our work to be accepted, there is always the chance that we will be criticized for it. That can be intimidating for even the most experienced artist. For a new artist, it can be overwhelming!

When you create something new—or even express the desire to do so—there is often someone in your life that will try to discourage you. "Don't do that! You'll fail! You'll be embarrassed! No one will like it!" Maybe that someone will be the voice inside your own head.

There are many reasons that people will try to discourage you. Sometimes it is out of genuine concern that you will be hurt. Sometimes it is because they are not fulfilling their own creative destiny. Seeing you take a step toward your own future makes them so uncomfortable that they will try anything to prevent you from reaching your goals.

Whether the voice of discouragement is in your own head or comes from someone else, the first step to getting past those fears is to understand that (1) every act of creation has value and (2) that value belongs to you—the creator. If other people are happy or approve of your creation, that's icing on the cake. However, if it is your sole motivation for acting, your creative process will stall the first time you don't get that approval.

Try to remember the first time you created something. Maybe it was the old shoes with macaroni glued all over them in kindergarten. Perhaps it was painting a paint-by-numbers picture, writing a poem in third grade or arranging the furniture in your first apartment. Do you remember what that felt like? Do you remember the sense of accomplishment, the relief, maybe the joy?

GETTING PAST YOUR FEAR

Many people never get started in the creative process because just thinking about it is overwhelming to them. Here are some basic steps to help you get started.

1. Choose Your Weapon

You may have several projects you want to try, but you can do only one at a time. To start, choose *one*. Don't worry about the rest—they will get done eventually. Just start with one.

2. Define the Steps

Once you have defined your goal (and it is best to write this down on paper), identify the steps that are necessary to do this one thing. For example:

 a. seal and sand wood
 b. apply pattern
 c. apply basecoat
 d. paint details
 e. varnish

Once you have defined the steps, they seem much more manageable than the bigger goal of finishing the project. The cure for being overwhelmed is organization.

3. Find Your Creativity Zone

Everyone has her own creative quirks. Some people are most creative when they are in complete silence and all alone. Others need loud music and lots of activity. Personally, I am most creative when alone and surrounded by music. When I write, I prefer classical music with no lyrics. (Words tend to distract me from my own writing.) When I paint, I like upbeat, faster music.

Pay attention to your own creative needs. I am someone who needs a lot of visual stimulation. My house and studio have a lot of knickknacks and color. Some artists find this distracting and need to have a place free of outside stimuli. If, for example, you are inspired by nature, it would be difficult for you to do your best work in a cramped workroom without windows.

Don't fight your body clock! I am a night owl. I paint and do visual media best from 10 P.M. to 1 A.M., but I do my best writing from 3 P.M. to 6 P.M. We all have peak times when we work the best. By paying attention to what works best for you, you can maximize that creative time.

Begin to note when you are feeling your most creative. Think back to times when you have been particularly creative. What were the circumstances? What was the time? Where were you? What was happening? These clues can help you get into your peak creative state quicker.

4. Find Inspiration Everywhere

There is a misconception that all creativity springs from inside the artist as something wholly new and original. The truth is that 99.9% of creative people spend the majority of their time reading, watching, observing and filtering information to be used later. I've been inspired by a color scheme I saw in the title of a movie. I've heard "the click" at the grocery store, the hair stylist's, just about anywhere I've ever been.

Start to pay attention to things that inspire you. Perhaps there is a kind of music (like reggae, for example) that revs your engine and puts you in the mood to create. If you learn these things about yourself, you'll make it easier to get working.

5. Realize that Most First Drafts Are Lousy!

Give yourself permission to not have a perfect first draft. Put together reference books and resources that will help you if you get stuck. If you wait until you know everything about everything before you begin, you'll never begin. The most successful people in life are constantly learning. Develop the confidence so that if you get stuck, you will know where or whom to turn to for the answers you need. The first drafts of most designs are lousy. You are in good company if it takes a few tries to get it just right. Learn, move on and know that you have the knowledge and tenacity to work until it is right.

6. Go for It!

There is one guarantee about any creative endeavor: If you don't try, you will never succeed. It is okay to do several drafts. Give yourself permission to not get it right on the first try.

CREATING YOUR OWN DESIGNS

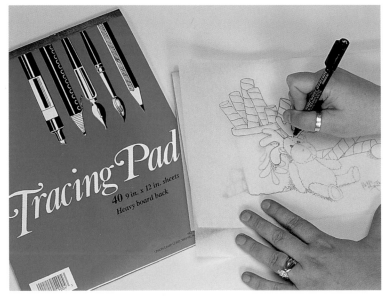

Many budding artists don't try designing because they claim they can't draw. One of the best ways to learn to draw is to trace other artists' work. By tracing over an apple, for example, your brain and hand begin to absorb and understand the contours of that shape. Like a well-worn path, your brain begins to make the connection about the shape of things. Each time you do this, it gets easier and more instinctive until you no longer need to trace a design but can begin to draw it yourself.

Another good starting point is to trace designs from your own photographs. Most artists use photo references to create their designs. It is a myth that "real artists" are able to paint from inside their head. Real artists use whatever tools are necessary to make their work a success!

Photographs are copyrighted, so unless you find a copyright-free photo reference book, it is best to work from your own photographs. These photographs can also become part of your personal reference library.

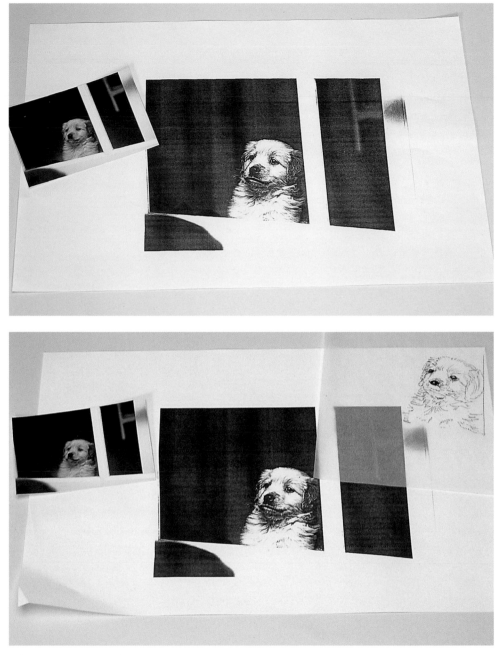

If the photograph is too small, enlarge it on a photocopy machine. Photocopies have yet another advantage. Since they are black and white, they show you the value scale (lightness and darkness in a photo) you need in order to paint the image as you see it.

When you have enlarged the photograph on a photocopier to the actual size you want to paint it, lay the tracing paper over it and draw in the major sections of the design. You may choose to draw the outline, or you may add details, such as darker values.

surfaces

Which surface should I choose?

Finding a Surface

If you are working from a traditional decorative painting book or packet, a specific surface may be recommended for that design. Look in the instruction and supplies section of the book or packet for information as to the manufacturer and supplier for that surface. (See chapter twelve for supplier listings.)

Aside from using suppliers of unfinished wood, canvas, porcelain, glass and so on, you can either recycle your own old furniture or visit garage sales, unfinished furniture stores, flea markets and online auctions to find interesting surfaces. Paints and primers are now made for paper, glass, fabric, wood, ceramic, porcelain, terra cotta, cement and many other surfaces. In this chapter, we will go through basic surface preparation for the more common surfaces used for decorative painting.

If you cannot find the recommended surface, or if you like the design but do not want to use the same surface, you can adapt most patterns to most any surfaces. This is also true if you are using an original design or adapting clip art as your design source. When you adapt a design from one surface to another, look at the overall size of the design compared to the overall size and shape of your surface. Generally you want one to be proportional to the

other. A small design on a large piece can look as out of place as a large design that overwhelms a small surface. Most designs can be resized on a photocopy machine to make the sizing more proportional to your surface.

PRODUCTS

As a rule, any surface you use should be clean and free of residue and oil before you begin painting. If it isn't clean, oil and dirt may cause your paint to discolor, peel or bubble later because the paint cannot bond to the surface. Some surfaces, such as glass or metal, require special treatment products before painting to make the paint adhere.

Many painters will skip or skimp on the preparation because they want to get on with the fun part of actually painting. Try to think of the preparation as part of the fun because this is what will make your piece last and your finished work look its best. Before sealing, make sure the surface is smooth and free of damage, dings or other defects that might detract from the design. An exception to this would be if you were painting a very rustic piece where the dings and damage might be part of the overall charm of the design.

Most surfaces need to be sealed before painting. There are several reasons to seal. First, sealing equalizes

the porosity of the surface so that your products don't sink into some areas and sit on top of others. Sealing prevents liquids in the surface from seeping into the paint. For example, wood is sealed so that the sap does not seep into the paint over time. Sealing also prevents outside moisture from getting through the paint and into your surface, which causes the wood to warp or the paint to peel.

As I mentioned before, I recommend using the same brand for your sealer, paint and varnish. I find that there are fewer mishaps with peeling and bubbling when I use products that are made to be combined with one another. You may find, through trial and error, compatible cross brands. Keep in mind, however, that manufacturers do change formulas and what works now may not work later.

COSMETIC REPAIR

Before you start, check your surface for imperfections. If you are doing a rustic or primitive piece, you may choose not to repair these imperfections since they may add to the allure of the design. However, if you are doing a more traditional piece, dings and holes will detract from your design and you should repair or camouflage them before you begin.

Common Surfaces

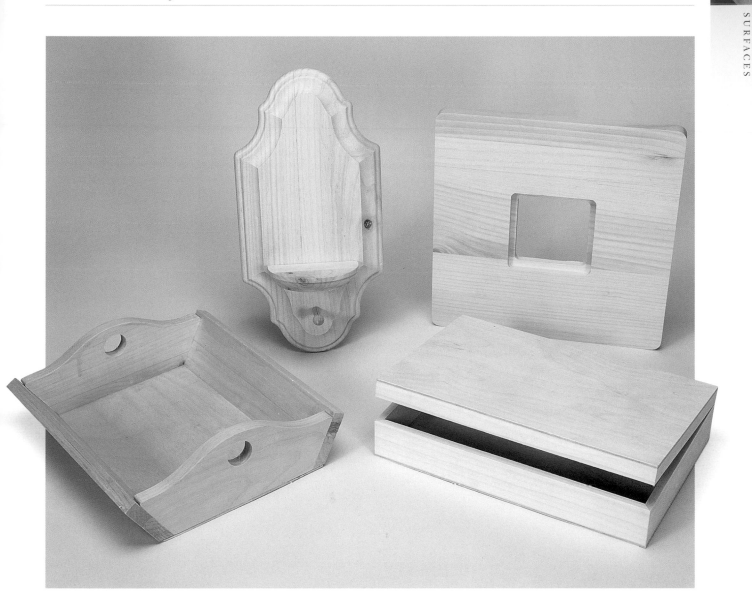

WOOD

A large variety of wood blanks are available for the decorative painter. Before sealing, make sure the piece is clean. If you need to wet the piece to clean it, let it dry well before beginning your work. Most pieces will only require dusting before you begin preparation. Lightly sand the surface and repair any cosmetic issues, such as filling dings or nail holes with wood filler. Seal knotholes with a sap or tannin blocker.

 tera tip

Many painters use tack cloth to remove sanding residue. Unfortunately, the resin in the cloth can sometimes stick to your surface. If you've had this problem, try dusting the surface with a wide, flat brush, or save your used fabric softener sheets for wiping up instead.

Common Surfaces, continued

HOW TO PREPARE WOOD

WOOD FILLER

When you are working with wood, look for nail or staple holes where the wood is put together, or dings where the wood may have been hit against a hard surface and dented. Surface dings may be repaired by dampening the area with water on your brush, or by lightly brushing the surface with a steam iron or clothing steamer while applying steam directly over the ding. After dampening, allow the piece to dry before sealing. Wetting the grain will cause it to raise and, for minor damage, that may be all that is needed.

For larger dings and holes, use wood filler. Look for wood fillers that are stainable. Some wood fillers shrink as they dry, so be sure to let them dry completely before moving on. You may have to apply more than one layer of filler to completely fill the hole.

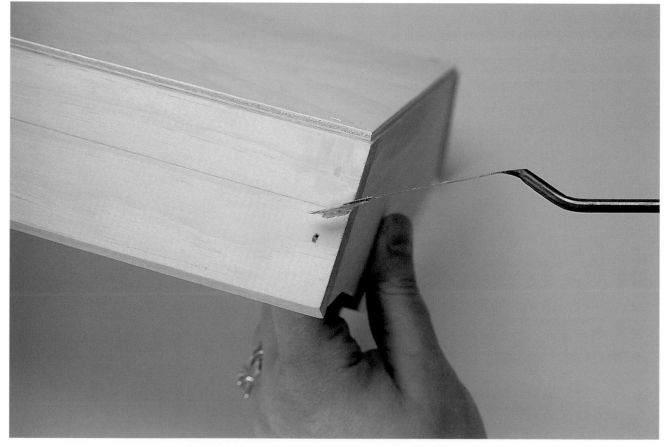

APPLY WOOD FILLER WITH A PALETTE KNIFE

Follow the directions for use on your wood filler product. Most will need to be stirred before using. Many wood fillers are reactivated by water if they dry out. Apply it to the surface with a palette knife. Fill the hole completely using the flat of the knife to push the filler into the hole. Use the side of the knife to scrape off any excess and make the filler as flush with the surface as possible

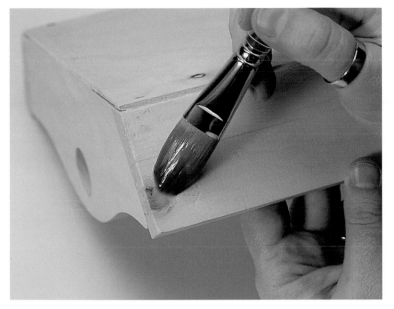

Bin or Kilz can be used to seal over previously painted wood pieces after sanding. These products will give a smooth painted surface. They are highly pigmented and usually cover even the darkest paint in one coat.

SEAL THE KNOTHOLE

Several products are available to seal knotholes and prevent sap from seeping up from the wood to discolor your paint and varnish. The products are often referred to as tannin blockers. Follow the individual product instructions and apply it directly to the knot. Allow it to dry well before sanding and painting the area.

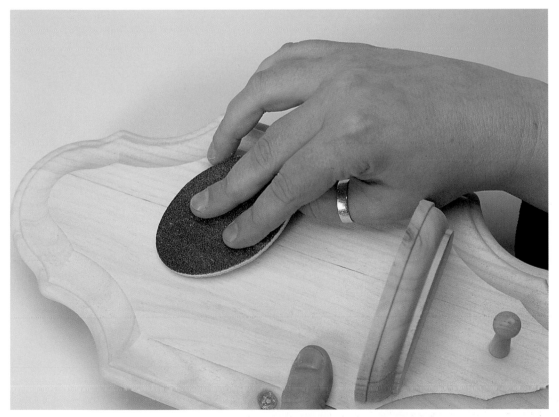

SANDING

When dealing with a rough or porous surface like wood, start by sanding. This opens the surface to accept the sealant and removes some of the roughness of the piece to make painting easier. You will generally have to sand again after you seal because the sealant may raise the grain of a porous surface.

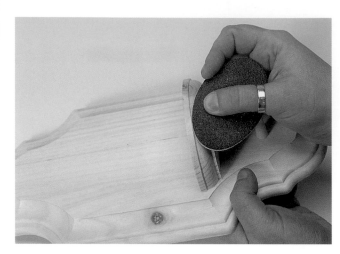

Common Surfaces, *continued*

FINE GRIT SANDPAPER

Unless you have a very rough surface, you will prepare your piece with fine grit sandpaper. We want to create a smooth surface, so avoid coarser sanding papers that might put grooves or gouges in the surface. It is best to sand in one direction with the grain if possible.

BENT SANDING PAD

There are many foam-backed sanding pads that can be bent to fit into smaller or curved areas. Areas that have been routered may be particularly rough and porous. Using tools made for this purpose will make your project easier to paint. You can also borrow a nail file from your cosmetic bag for use in tight areas.

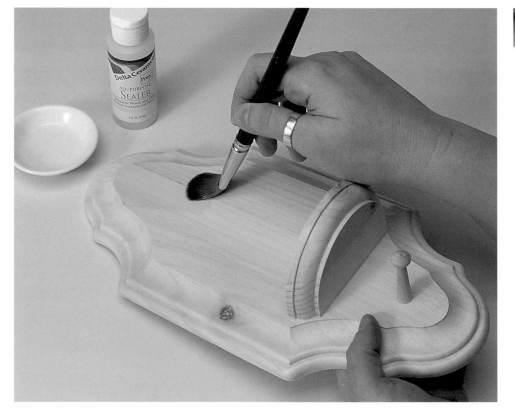

tera tip

Many all-purpose sealers can be mixed directly with paint to seal and basecoat in one step.

SEAL THE WOOD

Apply a wood or all-purpose sealer to the surface, covering it thoroughly. If the wood is going to be used in an area that is likely to be damp, such as a kitchen or bath, you may want to apply a second coat of sealer. Since sealer is clear, it is easy to miss a spot when you apply it to the surface. The extra coat will help prevent the wood from warping when it comes in contact with moisture. You will need to lightly sand the wood after the sealant dries as the moisture will cause the wood grain to raise slightly, making the surface rough. You can use a fine grit sandpaper or a brown paper bag for this final sanding. The surface should feel smooth but not slick before you begin to paint. If the surface feels slick, the sealer may not be completely dry.

PORCELAIN

Be sure that porcelain, glass and fired ceramics are clean and free of dust, dirt and oil before you begin to paint. Most products are then ready to paint. How you prepare from there depends on the product you will use to paint the surface. Some products for glass, porcelain, ceramic and tile have their own surface conditioners or cleaners. Others recommend simply cleaning with alcohol or a similar product to remove surface oil, such as the oil from your hands, before painting. You will need to read the individual product literature to determine the preparation needed for that specific product.

TERRA-COTTA, PLASTER, STONE AND CEMENT

Terra-cotta planters and outdoor plaster figurines are popular surfaces in home decor. The way you will prepare these depends on their use.

Items intended to be used with live plants, for example, should be sealed with nontoxic, plant-safe sealants. These are available through garden stores and nurseries. Be sure to let the sealer cure well before using with plants since the water may reactivate the sealer if it is not completely dry.

Sand your piece with a fine sand-paper to knock off any rough edges. Wash with mild, soapy water and then rinse well. Heat your oven to 250° F, then turn it off. Leaving the door slightly ajar, place the piece in the oven for two hours to remove all the moisture. Items not being used with live plants can be sealed with gesso.

Plaster, stones and cement are not as porous and may be sealed with a regular all-purpose sealer. You can also use products made for these items, such as DecoArt's Patio Paints, which combine the sealer and the paint in one product.

Common Surfaces, continued

GLASS AND TILE

Glass and tile can be challenging for painters because these surfaces are nonporous and slick, so they have little "tooth" or texture to which the paint can bond. Happily, manufacturers have responded with a variety of products made specifically for glass and tile. Each product has its own rules for use. Some have a surface conditioner or cleaner that you should use. Others require cleaning with alcohol before using. Read the product literature when using glass and tile paint. A few manufacturers have also come out with a glass and tile medium that can be used with regular acrylic paint. Again, be sure to follow the product directions for use.

SLATE

Slate is a natural surface much like shale. To prepare, wash it with soap and water. Natural slate is brittle. When cleaning you should gently remove loose flakes but try not to damage the overall piece. Lay the piece out to dry well before painting. You do not need to use a sealant on slate, but if you prefer to seal it first, use an all-purpose sealer or gesso.

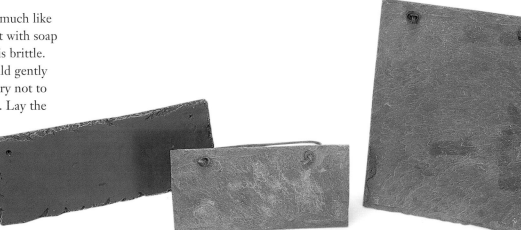

tera tip

Most slate can be drilled with a masonry bit to create holes for hanging the piece. Slate is brittle and can shatter or split during drilling. To make sure this doesn't happen after you have worked to get the piece just right, drill before painting.

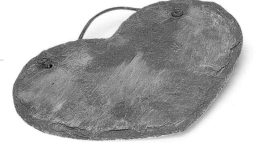
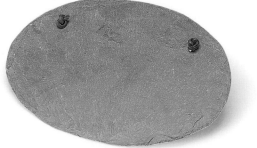

METAL AND TIN

Wash new tin with soap and water. If there is any residue on the metal, a rinse of white vinegar will thoroughly clean the piece. The biggest danger with metal is that it will rust along the seams from moisture. To thoroughly dry the piece, heat the oven to 250° F, then turn the oven off and put the piece in, leaving the door ajar. Do not do this with used tin because it may have previously contained a material that is flammable or noxious when heated. Once the oven is cool, remove the piece and seal it with metal primer. Several craft companies make metal primers or you can use a spray, such as Rust-Oleum.

If the piece will be used for decorative purposes, paint with regular acrylics. If the piece will be used for cooking or will be exposed to heat, such as a stove hood, car or teapot, it will require paint specially made for high heat exposure. These paints are available at hardware stores.

Used Metal

If the metal has previously been painted, you can either use a paint remover or paint over the design with a paint sealer such as gesso or Kilz. If the metal has rusted, use a rust remover such as naval jelly, which is available from hardware stores. Once the piece is clean, seal as described for new metal.

Galvanized Metal

Galvanized metal is coated with zinc to resist rusting and may be coated with a thin coat of oil. For that reason, you need to clean the piece thoroughly first. It is best to use a sealer specifically made for galvanized metals, which is available from hardware or home improvement stores.

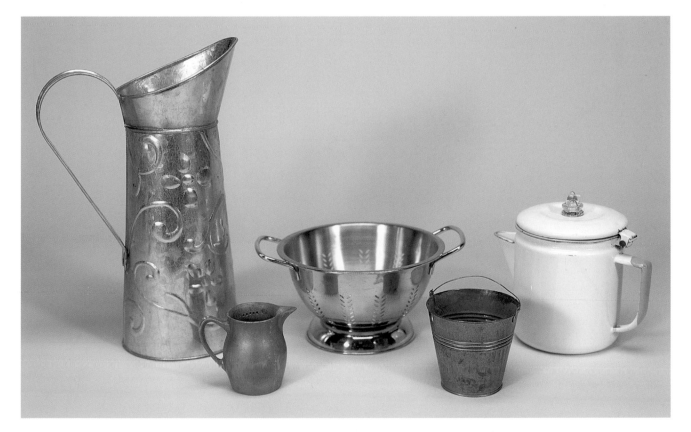

Common Surfaces, *continued*

FABRIC

Wash the fabric before painting or applying any painting prep. Do not add fabric softener to the washer or dryer as this may prevent the paint from bonding to the fabric. You may use special fabric paints or dyes, or mix a textile or fabric medium with your regular acrylic paints. Follow the specific directions for the product you choose.

HOW TO PREPARE FABRIC

tera tip

Freezer paper (waxed on one side) may be ironed onto the back of any fabric that would be awkward to secure to a board during painting. Once you have completed painting, simply peel off the paper.

TAPING WAXED PAPER TO CARDBOARD
When painting fabric, the liquid will soak through it. Secure your piece to a waterproof cardboard made for fabric painting, or tape waxed paper to a piece of cardboard to make a waterproof surface.

SECURE FABRIC TO BOARD
Secure the fabric to the board with masking or painter's tape. This will prevent the paint from seeping through to the back of the clothing or ruining your painting table.

METAL AND TIN

Wash new tin with soap and water. If there is any residue on the metal, a rinse of white vinegar will thoroughly clean the piece. The biggest danger with metal is that it will rust along the seams from moisture. To thoroughly dry the piece, heat the oven to 250° F, then turn the oven off and put the piece in, leaving the door ajar. Do not do this with used tin because it may have previously contained a material that is flammable or noxious when heated. Once the oven is cool, remove the piece and seal it with metal primer. Several craft companies make metal primers or you can use a spray, such as Rust-Oleum.

If the piece will be used for decorative purposes, paint with regular acrylics. If the piece will be used for cooking or will be exposed to heat, such as a stove hood, car or teapot, it will require paint specially made for high heat exposure. These paints are available at hardware stores.

Used Metal

If the metal has previously been painted, you can either use a paint remover or paint over the design with a paint sealer such as gesso or Kilz. If the metal has rusted, use a rust remover such as naval jelly, which is available from hardware stores. Once the piece is clean, seal as described for new metal.

Galvanized Metal

Galvanized metal is coated with zinc to resist rusting and may be coated with a thin coat of oil. For that reason, you need to clean the piece thoroughly first. It is best to use a sealer specifically made for galvanized metals, which is available from hardware or home improvement stores.

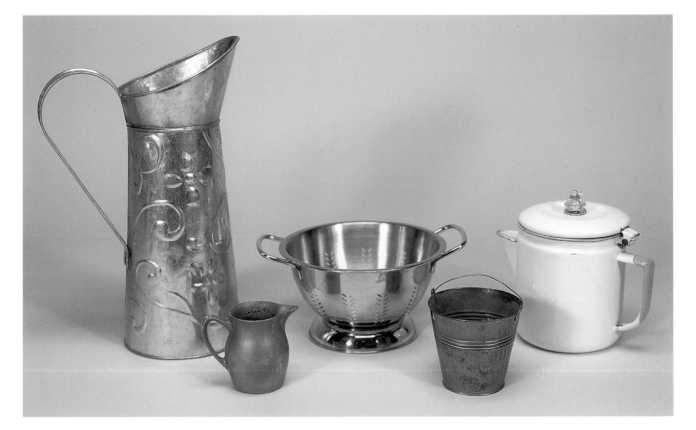

Common Surfaces, *continued*

FABRIC

Wash the fabric before painting or applying any painting prep. Do not add fabric softener to the washer or dryer as this may prevent the paint from bonding to the fabric. You may use special fabric paints or dyes, or mix a textile or fabric medium with your regular acrylic paints. Follow the specific directions for the product you choose.

HOW TO PREPARE FABRIC

tera tip

Freezer paper (waxed on one side) may be ironed onto the back of any fabric that would be awkward to secure to a board during painting. Once you have completed painting, simply peel off the paper.

TAPING WAXED PAPER TO CARDBOARD
When painting fabric, the liquid will soak through it. Secure your piece to a waterproof cardboard made for fabric painting, or tape waxed paper to a piece of cardboard to make a waterproof surface.

SECURE FABRIC TO BOARD
Secure the fabric to the board with masking or painter's tape. This will prevent the paint from seeping through to the back of the clothing or ruining your painting table.

CANDLE

Clean the candle with soap and water. Rinse it with alcohol if there is any sticky residue on it. Several companies now offer candle mediums that can be used to prepare a candle, or to mix with paint for painting on candles. Read the instructions on the product you choose for specific information on how to use it. Some companies offer an all-purpose sealer that can be used to prep the candles. See the product literature to determine if the product you have is appropriate.

Common Surfaces, *continued*

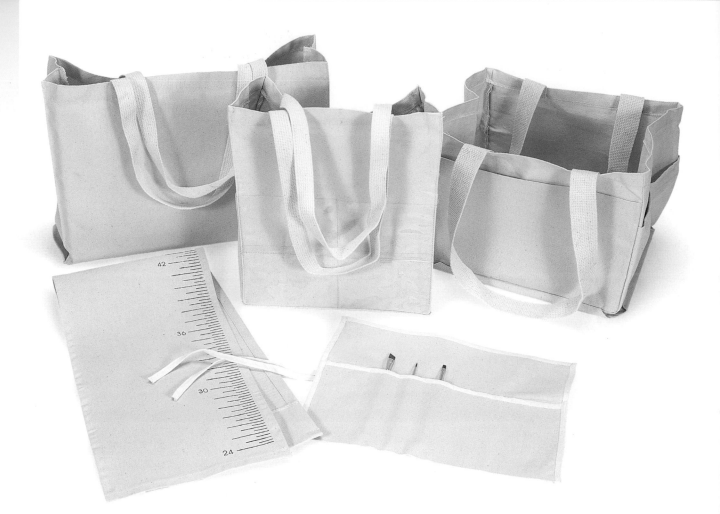

CANVAS

There are two types of rolled canvas: plain fabric and preprimed. Plain fabric canvas can be prewashed. Do not use fabric softener in the washer or dryer. You must then "prime," or seal, the canvas before painting. This can be done with gesso or fabric sealers such as J.W. etc.'s White Lightning. Canvas should be double primed with two coats on one side (sanding lightly between coats) and then one coat on the back.

Cut your canvas to the size you want it, allowing for extra fabric for a hem plus shrinkage. Prime the canvas first since it may shrink when painted. Once dry, measure the width of the hem and mark the lines with a pencil. Cut the excess off the corners so that they won't bunch up. Then fold over your edges along the pencil line and flatten them with a rolling pin or brayer. Double-faced tape or a good fabric glue can be used to hold the hem in place. With fine grit sandpaper, sand the canvas once the primer is dry before painting.

Preprimed canvas comes precut and primed—ready to paint. Some canvases are hemmed; others are cut and sealed so they will not ravel. While preprimed canvas is more expensive, it is a big time-saver.

Canvas fabric is used to create a variety of surfaces, such as the bags, brush holder and growth chart shown here. These products are specifically made for painting and do not need double priming. Treat these surfaces like fabric. Apply your pattern, and follow the directions for how to use your fabric paint, dye or fabric medium.

PAPIER MÂCHÉ

Papier mâché is one of the least
expensive and easiest surfaces to use.
You can buy preformed shapes such
as boxes, or you can make your own.
Strictly speaking, you don't have to
seal papier mâché before painting;
however, sealing will increase the
life of your surface, so I rec-
ommend it. You can use an
all-purpose sealer mixed
with paint or gesso for a
seal and basecoat in one.

Papier mâché can
sometimes develop bub-
bles when the surface is
moistened with paint.
Allow the paint to thor-
oughly dry before taking
action, because the bub-
bles will sometimes go
away when the paint dries.
If a bubble remains, use a
small straight pin to prick
the bubble, then flatten it to the
surface with paint.

tera tip

If your papier mâché has
dents in it, use wood filler to
fill them, let it dry and then
paint as normal. Another
alternative is to use a white
glue or découpage glue with
brown paper, such as paper
from a shopping bag, to
repair it.

BASECOATING A PAPIER MÂCHÉ BOX WITH GESSO

When sealing, use very little water in
your brush because water will
increase warping and the chances of
bubbles in the paper. Be sure to wipe
the papier mâché to remove any dust
or dirt before sealing. Once the papi-
er mâché is sealed, you can sand with
a fine grit sandpaper to smooth the
surface.

PLASTICS

Plaid Enterprises now makes the first craft paint for plastic, called PlasticPaint. The surface must be clean of oil residue. The paint may then be applied directly to the plastic. You can also purchase paints made for plastic in a limited range of colors from a home improvement center. The paints are made to touch up outdoor furniture. Many painters use plastic as a surface with regular acrylics. Note that manufacturers do not guarantee that their paints will adhere to plastic, so you may not want to paint on something that might be ruined. Start by washing the surface with soap and water. If there is any oil or dirt residue, apply white vinegar or rubbing alcohol with a clean towel. Then rinse again with water and dry well. With fine grit sandpaper, lightly sand the surface where you want to paint your design. Finally, spray a light coat of clear matte acrylic sealer. The sanding and light spray will give tooth to the surface. After painting, you will need to varnish and let the paint cure and dry well.

WALLS

The challenge of painting on walls is that you will not always know what kind of paint was used to basecoat the wall. Start by washing the wall area to be painted with a degreaser. This will dull any shine and remove built-up dirt and oil. Next, lightly sand with a fine grit sandpaper, then seal the area to be painted with an all-purpose sealer. After painting, varnish the wall with a product that replicates the shine on the rest of the wall. For example, use a matte varnish for a flat wall paint.

Basecoating Your Surface

The term *basecoating* can easily confuse a beginning painter because it has more than one meaning depending on the context. In most instructions, you can exchange the word *paint* for the word *basecoat*. A basecoat refers to the first coat of paint on a specific area. In some designs, that is the paint that covers the entire surface before you paint your design. On other surfaces, it means "coloring book painting" (see page 85) individual colors in the design before applying the detail.

BASECOATING WITH PAINT

The initial basecoat is done after sanding, sealing and sanding again. Paint the piece in long, solid strokes with a brush that is appropriate for the size of the area being painted. Try to keep your strokes long and even so the basecoat is as smooth as possible. When using lighter colors, more than one coat may be necessary to achieve good coverage. It is better to apply two or three thin coats than one thicker coat. Thicker paint tends to hold brush lines, which give you ridges when you paint over them. Sand lightly between coats with very fine grit sandpaper or a brown paper bag to get a smoother basecoat finish.

tera tip

It is important to use a sealant that is appropriate for your surface. Before sealing, decide on the paint you will use on your surface. Some paints have sealers that must be used before painting, for example, Delta PermEnamel has a surface conditioner that must be used before painting. Some paints have the sealer already built in, such as DecoArt's Patio Paint for cement and outdoor use. With those exceptions, most surfaces require an all-purpose sealer, or one made specifically for that surface, such as metal primer.

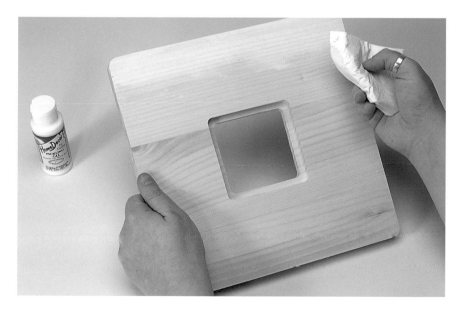

PICKLING

Basecoating may be done with a variety of products, in addition to paint. Pickling is a process by which unsealed wood is stained with watered-down paint to give it a weathered or silvery gray appearance. This allows the natural wood grain to show through while whitewashing or bleaching the surface. Although pickling is traditionally a white color, pickling mediums are available in a wide range of colors. The primary difference between pickling and staining is that pickling is done with a sheer paint solution rather than a staining product.

Basecoating Your Surface, continued

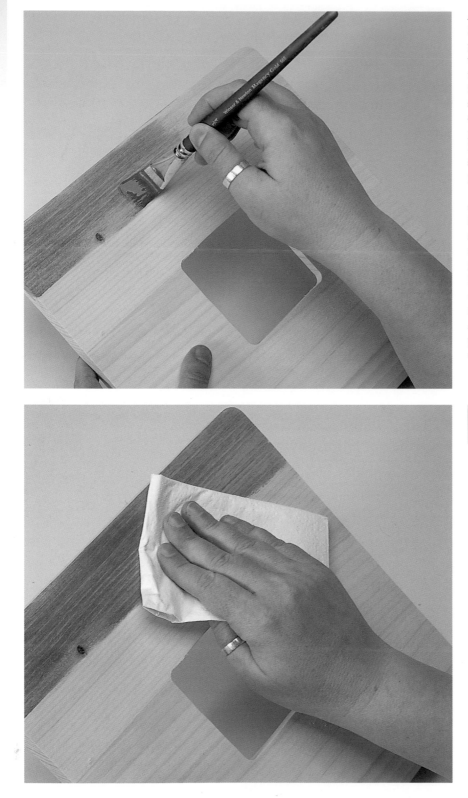

APPLYING STAIN

Staining was traditionally accomplished with pigment in an oil-based solution. However, a variety of staining products are available today. Like pickling, the purpose of staining is to add color that penetrates and colors the surface without hiding the grain or surface characteristics. Staining also provides some protection to the surface. Read the product literature to determine whether a sealer should be applied over the stain prior to painting or adding a design.

As with pickling, you should not seal the surface prior to staining. Sealing the surface inhibits the stain's ability to penetrate the surface. Stains come in a variety of colors and opacities. You should choose a stain that is slightly lighter than the color you would like it to ultimately be. You can always apply additional layers of stain to darken, but once the stain is applied, it is difficult to lighten. Always sand with the grain when staining so you don't roughen the surface and get an uneven distribution of stain.

tera tip

Always finish the back and underside of your surface with a basecoat and varnish. It creates a much better presentation of your finished piece.

COLORING BOOK PAINTING OR UNDERCOATING

Coloring book painting and undercoating are used to paint in the individual segments of your design. You may basecoat the surface with a single color before coloring book painting your design, or you may apply it directly to an unfinished surface, as shown here on slate. Coloring book painting is the first step in most decorative painting designs. Detail is then added by floating color, drybrushing or a variety of other techniques. At this stage, your design will be flat and boring because no detail has been added yet.

When coloring book painting, many painters will progress from lightest color to darkest color in value so that if they make a mistake, the next color is always darker and will cover the last. Traditional painting techniques usually call for painting a design from back (or farthest away) to front. If you are following a pattern, you should basecoat in the order given in the instructions to avoid confusion.

Undercoating is a term most often used when you are painting a light color design over a dark surface. For example, in Russian Zhostovo-style painting on a black tray, you might undercoat your flowers in white, then add color so that it will show up against the black. This undercoat contrasts the design with the black surface.

Undercoating can also be done when using colors that lack opacity so that you use fewer coats for coverage. For example, gold can be used to undercoat red. The gold gives the red luminance and one coat of red will generally cover it well. Some colors are more opaque than others, so you might undercoat red with a rust-colored paint that is more opaque. Because they are in the same color family, the red will easily cover the rust. This will require fewer coats than if you used a transparent red and tried to build up to full coverage.

Finally, undercoating can be used to give luminosity to a design. For example, you can undercoat an apple in gold and then apply layers of red over it. Or you can basecoat a window in a light color before adding layers of color to make it appear to glow with light. Applying the sheer layers of paint to build up color is known as "glazing."

Transferring a Pattern

The exciting part about learning decorative painting is that you don't have to know how to draw or design when you first begin. Even more advanced painters may use a pattern in order to replicate the same design.

An important aspect of using patterns which most beginning painters don't understand, is that tracing serves to teach your brain the shapes

of things. When you first start, you may think of an apple as being round, but as you trace apples, you find that their shapes vary. You instinctively begin to pay attention to the way things are shaped. After a while, you will most likely find that drawing is easier because you have learned to look at the world in a different way.

tera tip

To enlarge or reduce a design to the correct size, divide the dimension you want by the dimension you have. For example, if you want a design to be 16 inches wide to fit your surface, but you have a design that is only 12 inches wide, divide 16 by 12 to get 1.33. That tells you that the design you have must be enlarged by 133% to fit the new 16-inch width. I recommend dividing the larger dimension (height or width). Note that this will enlarge the overall pattern. If you are trying to enlarge a round design for an oval surface, you will have to adapt the pattern by stretching it or removing elements.

TRANSFER PAPERS

GRAPHITE TRANSFER PAPER

New graphite paper can be very dark and hard to cover. To make it more manageable, start by crumpling the paper into a ball. Then unroll the ball, flatten the paper and use a slightly damp paper towel to wipe off the excess graphite on the side used to do the transferring.

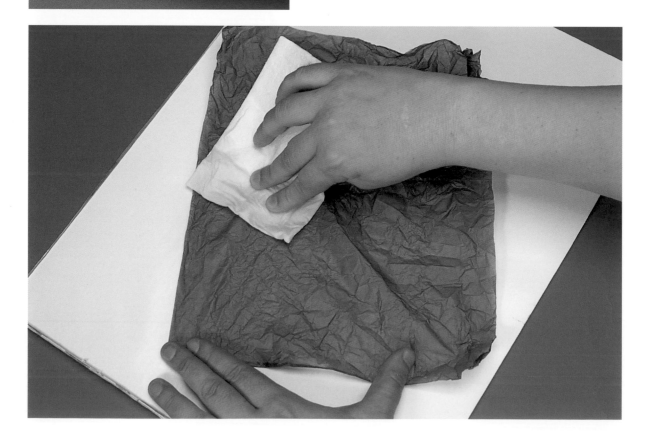

MAKE YOUR OWN TRANSFER PAPER

You can make your own transfer paper using a sheet of vellum or tracing paper. Simply rub the edge of a soft-lead pencil or dust-free chalk across the back of your sheet.

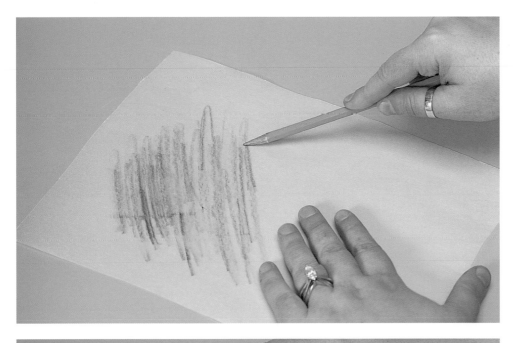

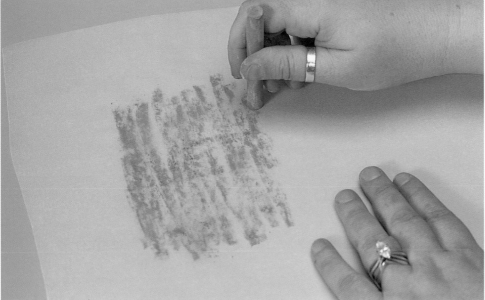

Transferring a Pattern, continued

HOW TO TRANSFER YOUR PATTERN

The first step is to trace your design onto tracing paper. Tracing paper can be purchased from an art supply store, or you can use vellum purchased from an office supply store. Any semi-opaque paper will work. Once your design is traced, place it on your surface where you would like to transfer the design, then slip your transfer paper in-between the tracing paper and surface. You can use painter's tape to hold the tracing in place during transfer. You can use a stylus or pencil to trace over the tracing, leaving a copy of the pattern on the surface below.

When tracing your design onto your tracing paper, start at the upper left and work to the right if you are right-handed, and work right to left if you are left-handed. This helps prevent smearing as you trace. It is good to use a permanent marker for your tracings so that you have them for future use.

A trick for quick tracing is to use a

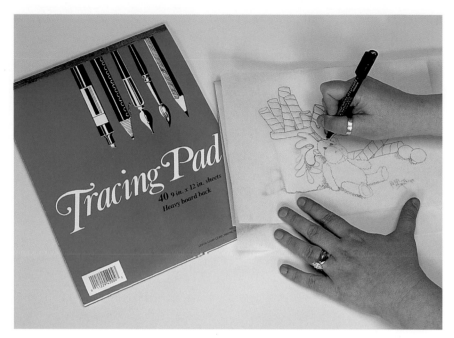

photocopy machine. There are a couple of caveats before doing this. First, read the copyright notice at the front of any book or pattern packet to make sure that mechanical reproduction is not precluded. When using a copy machine, you will need to use heavier weight vellum because the

drum of the copy machine gets hot and can melt thinner papers. If you are copying at a photocopy shop, use the weight of paper the shop recommend (generally 90-lb. [190 gsm] or greater).

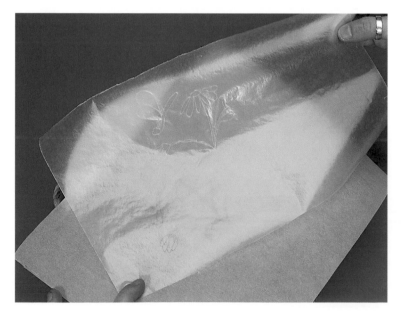

TRACK YOUR TRACING WITH WAXED PAPER

On a more complex design, it is easy to lose your place as to what you have traced. An easy way to keep this from happening is to place a piece of waxed paper over your tracing. As you trace the lines, your stylus will make a line in the waxed paper, helping you track your progress.

tera tip

For projects that you will paint many times, use acetate, which is a clear plastic transparency, for a more durable tracing paper.

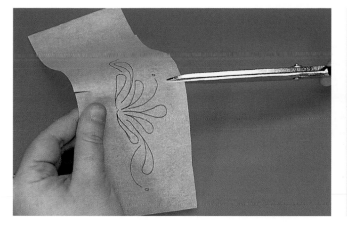

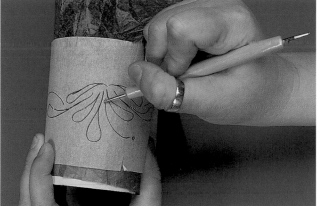

TRANSFER A PATTERN TO A ROUND SURFACE

Since much of decorative painting is done on usable surfaces, you will often work on curved or rounded pieces. You will find it easier to transfer a pattern if you trim your tracing, making it smaller and easier to handle. Also, place cuts along the edge of the tracing to make it easier to bend without rippling as you trace.

There are many different types of transfer paper. The most common product for transferring patterns is graphite. However, there are a variety of other ways to transfer designs—Chacopaper, chalk, even dust! Some surfaces require special products for effective transfer. Try several techniques to find what works best.

Transfer papers come in many colors. Take advantage of this to save yourself time. Use light colors on dark surfaces and vice versa. Baby wipes can be used to remove graphite, chalk, dust and Chacopaper lines.

PEEL OFF CHACOPAPER
Separate the Chacopaper from its backing. Blue is shown here, but it is also available in white. Save the backing paper for storage to keep the Chacopaper from sticking to itself.

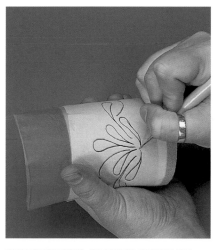

CHACOPAPER ON THE SURFACE
Apply the waxy or slightly sticky side of the Chacopaper toward your surface. Place the tracing over the top, and trace the pattern with a stylus or pencil.

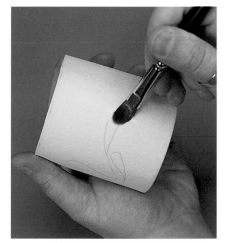

REMOVE EXCESS LINES
Chacopaper is water-soluble, so you can remove unwanted lines with a water-dampened brush.

Transferring a Pattern, continued

TRANSFER A PATTERN TO FABRIC

Fabric is one of the most popular surfaces for painting but transferring a pattern onto fabric can be tricky. Before you transfer your pattern, secure your fabric to a waterproof board, centering the section to be painted on the board.

One of the easiest methods I have found for transferring patterns is using tulle or bridal veil material. You can purchase it in small rolls or by the yard. Lay your tulle over your pattern and trace the design onto the tulle with a permanent marker. Then lay the tulle over your fabric and trace the pattern onto the fabric. The holes in the tulle will leave a faint "dotted" pattern that is easy to cover. You can use your permanent marker, regular pencil, water-soluble pencil (used in sewing) or chalk to transfer the design.

Another method is to trace the design onto regular tracing paper with a black permanent marker. Turn the paper over and trace the design on the back with chalk. Carefully place the chalk side on your fabric and then rub over the lines with the edge of a credit card or coin. It will trace faint chalk lines onto your fabric that will easily wash out later.

For more primitive designs, you can use a shortcut with your computer and printer. Purchase transfer paper that allows you to make an iron-on transfer with your printer. Scan and print out your design onto the special paper. (Once again, be sure that the designer doesn't prohibit mechanical reproduction of the design.) Follow the instructions to iron on your design. This will give you a very definite line. If you have a color printer you may want to choose a color other than black or you will get a very blocked primitive look as the line is difficult to cover with sheer fabric paints.

Tulle or bridal veiling is a thin and sturdy netting available in rolls or by the yard.

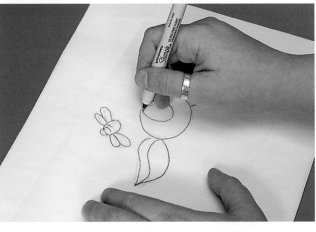

Cut the tulle to the size you need. Then place it over the design. Trace the design onto the tulle using a permanent marker.

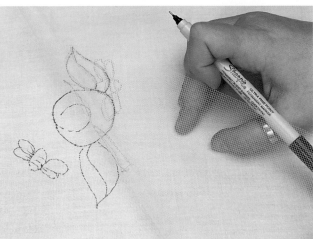

Place the tulle pattern over the fabric and trace over the lines with a permanent marker, chalk or water-soluble pencil. The tulle creates a dotted design on your fabric surface.

 tera tip

Once your fabric is secured to the cardboard, place it in a plastic garbage bag that is tightly secured over the surface. To protect the fabric you will not be painting from spatters or paint that is on your hand, carefully cut the bag away from the area where the pattern is located.

TRANSFER A PATTERN TO GLASS

Using a china marker makes transferring a design onto glass a breeze. Start by cutting your tracing so that it will fit behind or inside your glass surface. Some painters basecoat the design directly onto the glass without further tracing. If your glass is thick or has varied thicknesses, this can be tricky. You can purchase a china marker at an art supply store. The wax marker adheres to the glass easily.

Start with a clean glass. You may need to clean the glass with a special conditioner or cleaner for the paint you will be using. Even hand oil can affect paint, so if you are concerned about transferring oil, start by using rubber gloves to handle the glass until you get your basecoats on. China markers are available in art and craft stores in the pencil and pen section.

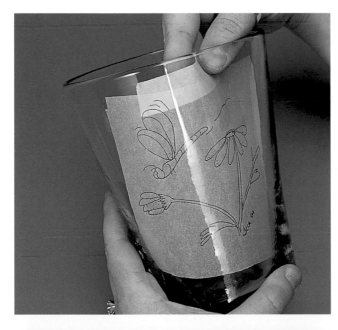

When possible, put the tracing inside or behind the clear glass for easy design transfer.

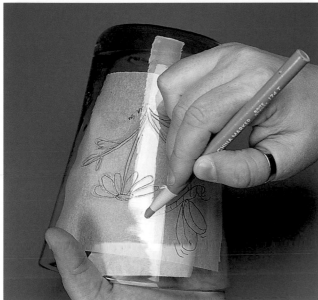

An easy way to transfer the pattern to glass surfaces is with a china marker, which is available at any art or office supply store.

tera tip

If the surface is opaque or putting the pattern behind the glass is not an option, transfer your design as you would onto wood using Chacopaper.

Transferring a Pattern, continued

TRANSFER A PATTERN WITH PAINTABILITY

New products are always coming onto the market to make pattern transfer easier. Paintability is a line of individual design components for pattern application. Similar to a rubber stamp, Paintability design applicators are made with a foam backing to give them flexibility for working on decorative surfaces. They have a deeper relief than a traditional rubber stamp, allowing them to be used with paint. They also have dots to show painters where shading should be applied. The beginner or more advanced painter can use this type of tools as a shortcut to pattern application.

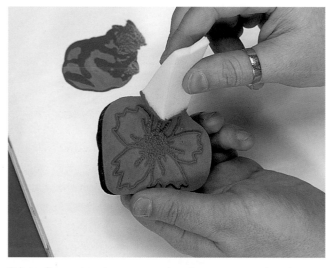

Using a foam cosmetic sponge, apply a thin, even coat of acrylic paint directly to the Paintability design applicator.

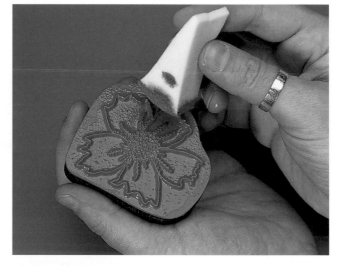

The Paintability design applicators are made for use with paint, so there is no need to worry about staying on the lines. Evenly cover the entire surface with paint.

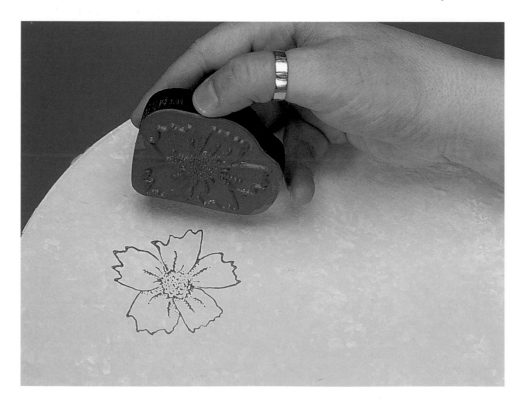

Press the design applicator to the surface and lift off.

brush techniques

What do I really need to know?

Side Loading

Side loading (also referred to as floating, floating color, highlighting or shading) is the single technique most associated with decorative painting. Unfortunately, it is often taught incorrectly, making it more difficult than it needs to be. Side loading is the technique of loading your brush with paint on one side, and water (or a water substitute) on the opposite side. When blended, the paint on the brush will graduate smoothly from full strength on the side the paint was loaded to water only on the opposite edge. This technique is used to give depth to your painting by adding highlights and shading. For that reason you should have no sudden changes in color along the brush surface.

Side loading can be done with virtually any brush but is most commonly accomplished with a flat, angle or filbert-style brush. Different brushes hold different amounts of paint and water. If you are having difficulty with side loading, you may find that a different brush will work better for you. Try different styles of brushes and filaments to find the one that works best in your hand.

The size of brush that you choose for side loading should be appropriate for the area you are working in. Even though it can seem intimidating, a larger brush is easier to control because you have a wider surface along which to spread the paint. This lessens the chance of a "ghost" of the paint color along the edge. The width of your side load is determined by the amount of paint on your brush and how much downward pressure you put toward the flat as you blend.

tera tip

Over and over in this book, I have told you that there is no one right technique in painting. In this section, I will explain what I feel is the best method for side loading. If you are side loading successfully using a different technique, you are not doing it incorrectly. If it works for you, you have found the right technique for you. If you have had some problems with side loading, the information I share based upon my experience as a painter and teacher may help.

The brush should be slightly damp but not wet. Blot your brush on a clean towel. Getting a feel for the right amount of water in your brush is the key to good side loading. You need enough water to allow the paint to blend in the brush, but not so much that it dilutes the paint and pulls it over to the water side of the brush.

Side Loading, continued

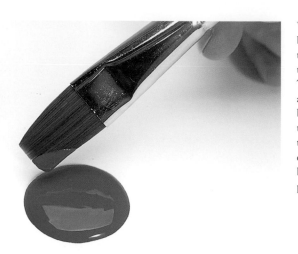

When loading paint on your brush, lift paint from the side of the puddle instead of pushing the bristles down into the paint. This lets you control the amount of paint going onto your brush when you lift. If you push the bristles down, you push them together and it is harder to control how far the center of the brush is pushed toward the paint.

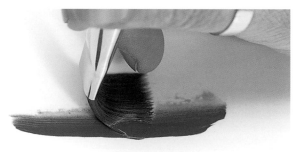

Holding the brush perpendicular to the surface and bracing your hand as you would when writing, blend the paint into the bristles on your palette. Do this by taking the brush all the way down to the flat in both directions.

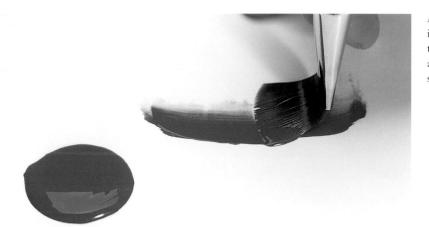

A common mistake that is made when floating is to only blend the paint on one side of the brush. This results in a bulge of paint along the back of the brush. Blending both sides works the paint through the bristles.

tera tip

The importance of holding your brush perpendicular to your surface can be easily demonstrated if you think about using a broom. If you try to sweep with a broom and hold it at an angle to the floor, the broom is not very effective and leaves dust and crumbs on the floor. Instead, if you hold it perpendicular to the floor and allow all the bristles of the broom to touch the surface, it will pick up every speck beneath it.

In order to remove a ghost from the edge of the brush, you must put only the last few bristles on the towel and pull the brush toward you to separate those bristles from the rest of the brush. If you blot the brush, you will push the bristles together and make the problem worse. This is only necessary if you have a ghost on the brush.

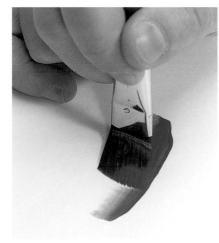

When you are blending, it is important to keep your hand braced so that you can blend within the same pool and along the same line. If you allow your hand to travel, you will pull the water side of the brush toward the paint, or the paint side of the brush toward the water. Some painters blend down on their palette, pick the brush up and then blend in another spot. The problem with this is that although they are blending, they are also removing paint and water from the brush. This means they have to reload the brush more often. By blending in the same spot, you push the paint through the bristles for an even load.

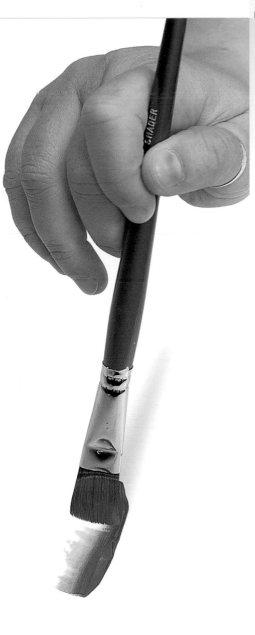

A WORD OF CAUTION

Holding your hand up in the air gives you two disadvantages:

1. It is harder to get the brush down to the flat to work the paint through the bristles.
2. Your hand will migrate left and right. I cannot reiterate enough how important it is to brace your hand on your palette while blending with your brush.

Side Loading, continued

SIDE LOADING HELPER PRODUCTS

There is good news if you are having trouble with side loading—manufacturers understand and have created a host of products to help you. To get the most out of the products, however, you have to understand that different products fix different problems and you need to use the one that will be most beneficial to you. There are two categories of helper products for side loading. The first is water additives. Two examples of this product category are Delta Color Float and DecoArt Easy Float.

Painters who get blotchy side loads do not get enough moisture in their brush. The additive products add slip and help the brush move across the surface. Unfortunately, the increased slip in the water can dilute the paint and increase the likelihood of getting a ghost on the water side of your brush.

To use an additive, follow the directions on the bottle. Add the product directly into your water. You may want to use a separate bin of water for floating to keep it clean. Then use this as you would plain water in your brush.

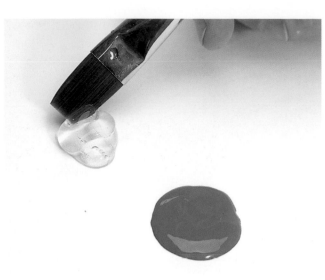

For those of you who have problems with ghosting or controlling the amount of water on the brush, the other category of helper products—gels—can help you. Examples of these gels are FolkArt Floating Medium and Delta Paintability Detail Magic. These products are a gel form of water. They are approximately the same density as paint and, when loaded on one side of the brush with paint on the other side, they help hold the paint to the side and center. This helps you get a soft gradation of color on the brush without developing a ghost on the water or gel side of the brush.

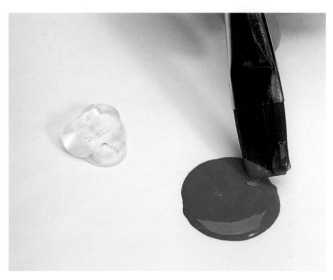

The gels are used with a damp brush and with slightly less water than you would with regular floating. Pick up gel on one side of your brush the same way you load your paint with water—by lifting from the edge of the puddle. On the opposite side of the brush, load paint in the same manner as you would with water.

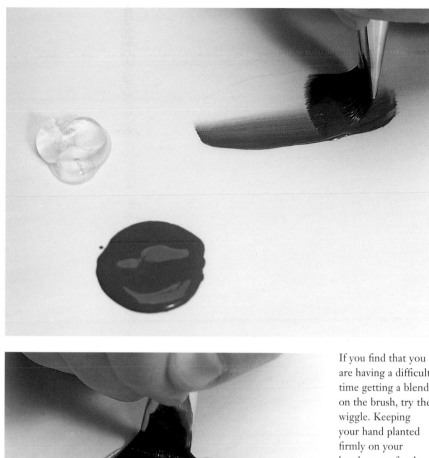

As with water, blend the paint into your brush by taking the brush down to the flat on both sides. Keep your hand firmly planted on the palette as you would when writing.

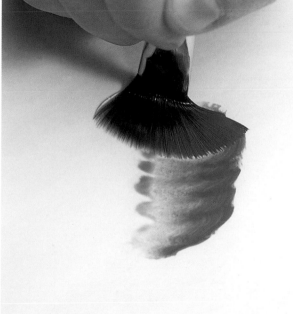

If you find that you are having a difficult time getting a blend on the brush, try the wiggle. Keeping your hand planted firmly on your brush, press firmly down to the flat, splay the bristles out and move the ferrule to the right and left. This movement will blend the paint in the center of the brush.

Side Loading, *continued*

WHAT AM I DOING WRONG?

TOO MUCH PAINT ON THE BRUSH
This type of mistake will give you a blob of paint at the edge of the your brush.

TOO LITTLE PAINT ON THE BRUSH
With this problem, the brush will give a very narrow edge of paint and the gradation from paint to water will not be even on the surface.

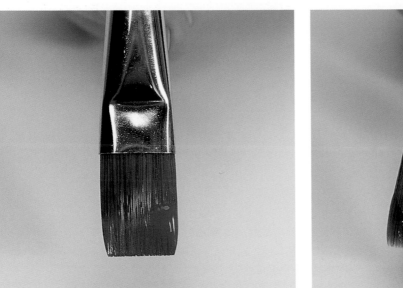

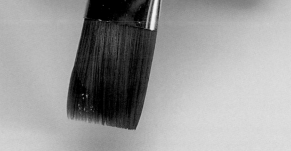

TOO LITTLE WATER ON THE BRUSH

Too little water on the brush will create a skid-mark effect to your side load. Your brush will have a tendency to separate, especially on the water side.

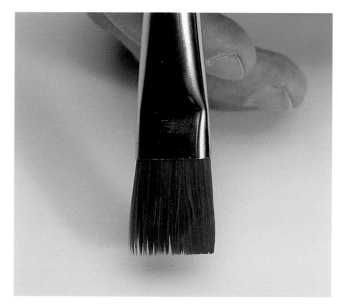

GHOSTING

When you have too much paint or water in your brush, or you overblend the paint into the brush, you can get paint on the water side of your brush for what is called a "ghost." A ghost is a line on the water side of the brush that is tinted with the paint color. This ruins the effectiveness of the side load because it detracts from the gradation from dark to light when it ends in a single line. To combat this, use your towel to pull the paint from the water side of the bristles.

Note that this is not the same as blotting the brush on the towel. The trick is to put only the last few bristles on the towel and pull the brush toward you to separate those bristles from the rest of the brush. If you blot the brush, you will push the bristles together and make the problem worse.

Side Loading, *continued*

CORRECT SIDE LOADING

1. WITH WATER

2. WITH FLOATING MEDIUM

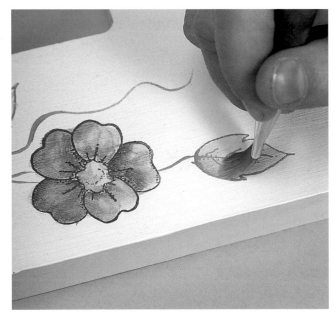

SHADING

The result gained from side loading should be a soft gradation from your full color to no color. When used for shading, a darker color creates depth and dimension, making the darkest section appear to be recessed or behind nearby sections.

HIGHLIGHTING

Side loading a color that is a lighter value than the surrounding colors will create a highlighting effect. The color may be a lighter value of the same color or a complementary color as shown here.

SIDE LOADING PROJECT

by Tera Leigh

materials

Surface:
Large rusty French flower tin

Brushes:
Loew-Cornell La Corneille
 Filbert no. 10
 Flat nos. 10 and 12
 Round no. 8

Palette:
Delta Ceramcoat
 Black
 Black Green
 Chocolate Cherry
 Gleams Metallic 14K Gold
 Mendocino Red
 Navy Blue
 Pink Quartz
 Raspberry
 Seashell White
 Woodland Night

Miscellaneous Supplies:
 Palette paper, Paintability Detail
 Magic, water basin, Chacopaper,
 Delta Ceramcoat Acrylic Spray
 Sealer—Matte, Ceramcoat Exterior
 Varnish—Gloss, paper towels, stylus

Surface Preparation:
 Spray rusty tin with a coat of clear
 matte Spray Sealer so that the rust
 does not come off on your hands as
 you paint.

Basecoating:
 Using a no. 12 flat brush, basecoat as
 follows: rectangle background—
 Seashell White, frame of tulip
 design—Navy Blue.When dry, apply
 pattern with Chacopaper using
 stylus.

tera tip

It is important to remember
that tin is a non-porous sur-
face. The trick to painting
over most metal is to allow
the paint to dry well before
working on it with the next
coat of paint or detail. This
will prevent the under-layers
of paint from lifting.

tera tip

Paintability Detail Magic was
specifically designed to help
you learn to "float color."
The product is a gel-based
water that is approximately
the same density as your
paint. When you load it on
one side of your brush in
equal or greater quantities
than the paint loaded on your
brush, it helps to hold your
paint to its side of the brush,
while allowing you to blend
the paint to the middle. This
helps to eliminate the ghost
or faint paint line on the
water side of your brush.

SIDE LOADING PROJECT, *continued*

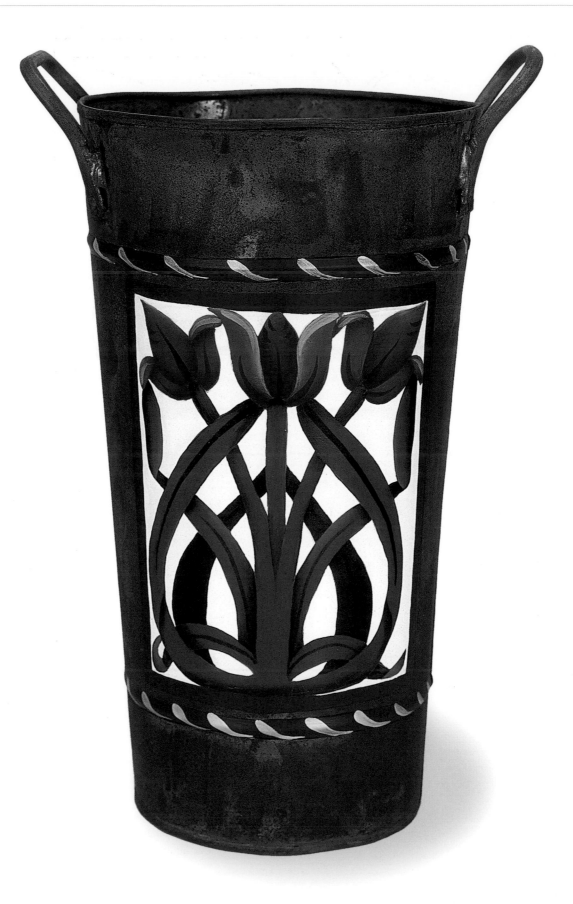

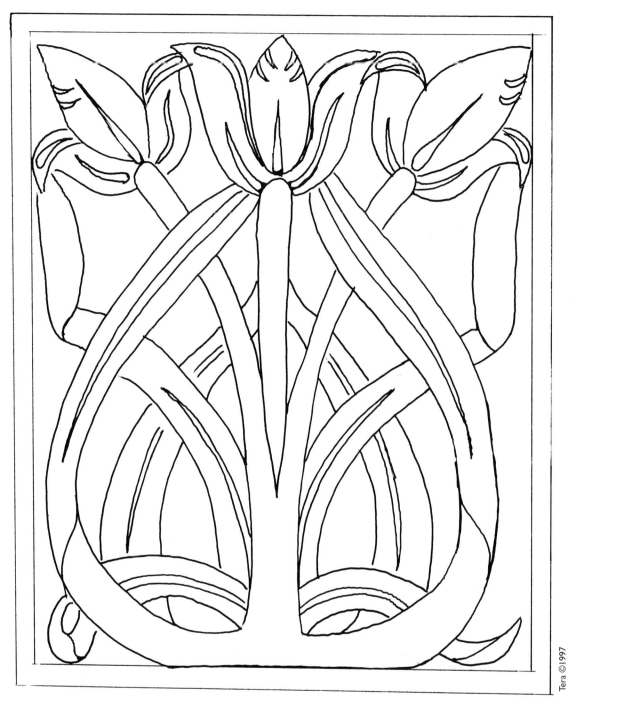

Tera ©1997

With your filbert brush, basecoat the tulips in Raspberry, and the leaves and stems in Woodland Night. Basecoat the curved leaves that touch the center of the flower stem in Black Green.

 tera tip

When blending the paint on your brush—whether you use water or Paintability Detail Magic—firmly plant your hand on the palette as you would when you write. If you hold your hand up in the air, it will drift left and right, causing the paint to blend into the opposite side of the brush.

First Shading

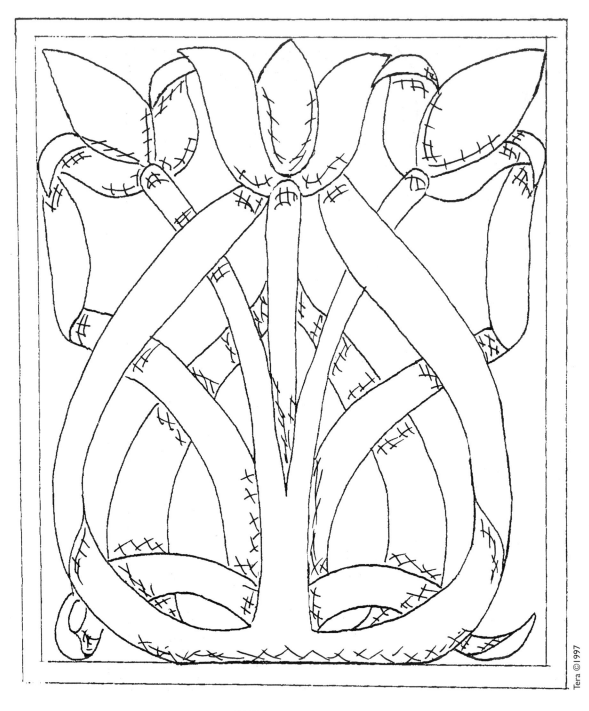

Tera © 1997

When dry, apply the first shading to the tulips with Mendocino Red using your no. 10 flat brush. Refer to the shading placement diagram above for the location. Apply the first shading to the stems and leaves with Black Green using your no. 10 flat brush. Again, refer to shading placement diagram for the location.

 tera tip

In order to get a true float of color, your brush must remain perpendicular to the surface. If you find that your floats are not looking even, watch to see if you've let your brush drift back in your hand like a pen.

Second Shading

Tera ©1997

When dry, apply the second shading to the
tulips with Chocolate Cherry using your
no. 10 flat brush. Refer to the shading place-
ment diagram above for the location. When
dry, apply the second shading to the leaves
and stems with Black using your no. 10 flat
brush. Refer to shading placement diagram
for the location.

Highlighting

Tera ©1997

When dry, apply highlighting to the tulips with Pink Quartz using your no. 10 flat brush. Refer to highlight placement diagram above for the location.

When dry, using your no. 8 round brush, apply comma stroke detail to tulips using Chocolate Cherry for the strokes coming from the bottoms of the flowers. The strokes painted at the tops of the outside flowers are painted with Raspberry. For help painting comma strokes, see the "Strokework" chapter of this book.

Double Loading

Double loading a brush is a fast and effective way to achieve dimension. As the name suggests, the brush is loaded with two distinct colors, one on each side of the brush. When the colors are blended on the palette, each side of the brush maintains its distinct color with a gradual blending of the two colors in the center.

The flat brush is the easiest to use for this technique because of its wide surface, but with practice, virtually any brush can be used to double load. Following are some examples of correctly double-loaded flat and round brushes.

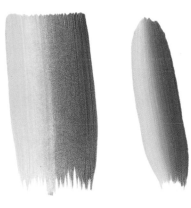

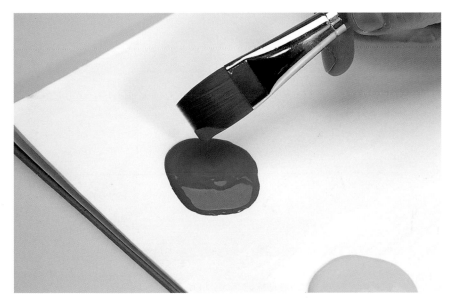

Start with two different colors of paint in small puddles on your palette. Load your flat brush in the same manner that you used for side loading, picking up one color on one side of the brush, and then the other on the opposite side.

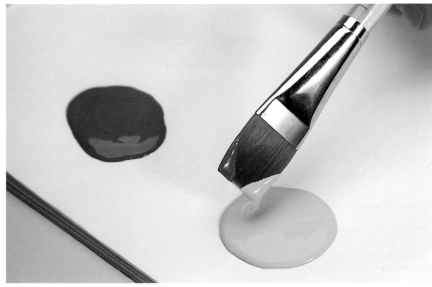

Remember to lift paint from the edge of the puddle so that you can control the amount of paint in the brush.

107

Double Loading, *continued*

Blend the paint into the bristles on your palette as you did when side loading, working both sides of the flat. Make sure that your hand is braced on the palette as you would when writing.

Priming the brush for double loading requires that you build up the paint in the bristles by adding paint to the brush and blending on the palette. Then add more paint, blend and so on until your brush is fully loaded and blended. This requires a little patience, but the difference is worth the practice it takes to perfect this technique.

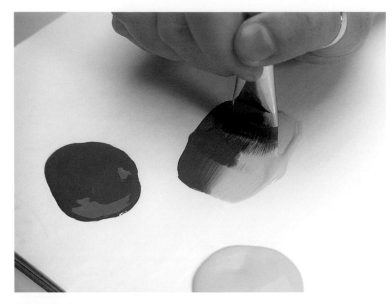

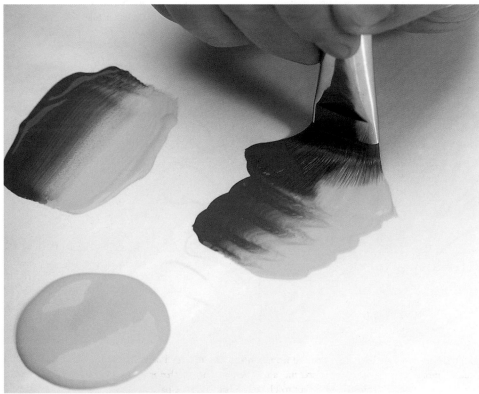

Until you are used to double loading, it can be difficult to get a smooth blend of colors in the center of the brush. Usually this is caused by not having enough paint on the brush. Add more paint to each side. You don't need to clean the brush and start over—just go back into your paint and lift more onto the brush. Then push the brush down to the flat and wiggle it side to side to help blend the paint in the center.

Legendary painter, author and teacher Priscilla Hauser teaches her students the importance of proper brush loading by having them add paint to their brushes, blend on the palette, add paint and then blend. She has them blend seventy times before going to their surface. The most common error in the double-loading technique is not having enough paint on your brush. A properly loaded brush moves across the surface like silk. When there isn't enough paint on the brush, it's like using a pen that is running out of ink.

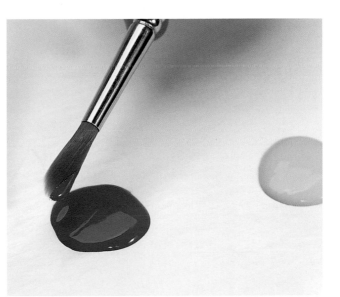

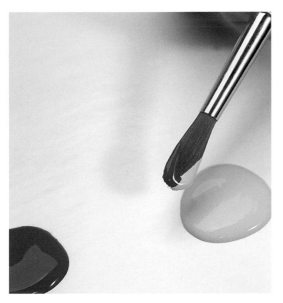

Double loading with a round brush takes more practice than working with a flat ferrule brush. When you first begin, you might find it easier to slightly flatten the bristles of the round brush with your fingers so that you have a wider surface with which to pick up paint.

Lift the paint from the puddle on each side of the brush as you did with the flat brush. Since the surface of this brush is smaller than that of a flat, you will need less paint.

You should still build up the paint in the brush by adding paint and blending on the palette, then adding more paint and blending and so on.

Bracing your hand firmly on the palette, blend back and forth. The round brush presents a unique challenge in that it is important not to spin the brush but to blend the brush on the palette so that both colors are visible from the top of the brush. If you spin the brush so that one color is on top, you will blend the colors together into one color. As you blend on the palette, both colors should be visible.

Double Loading, continued

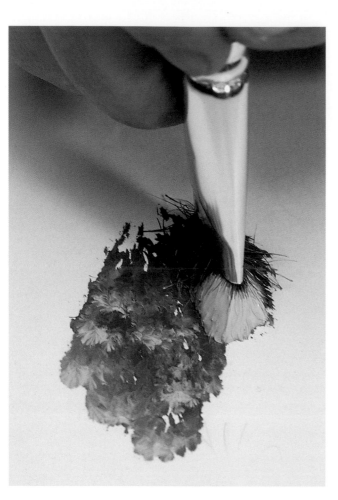

A unique part of the one-stroke system is the scruffy brush. The scruffy is a stippling brush. Donna Dewberry uses the one-stroke scruffy, which is a flat style of brush, to double load color for stippling flowers and shrubbery. The One-Stroke brand also includes a liner brush for painting thin lines, such as vines and branches. All of the brushes are now available in multiple sizes.

DOUBLE LOADING: WHAT AM I DOING WRONG?

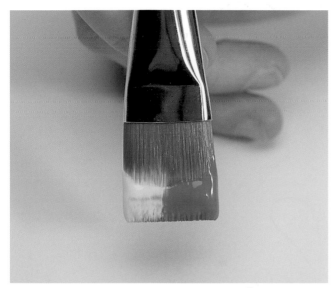

TOO MUCH PAINT

If you add too much paint to the brush at the start, it is difficult to get an even blend on your brush. The trick is to build up the paint in your brush by priming it with paint, adding more and blending, and adding more and blending until you have enough paint on your brush.

TOO LITTLE PAINT

To get a proper double load, you must use enough paint to load the entire brush with paint and blend the two colors in the center of the brush.

NOT ENOUGH WATER

When you see a separation in the bristles of the brush, it is usually caused by not having enough water and paint in the bristles.

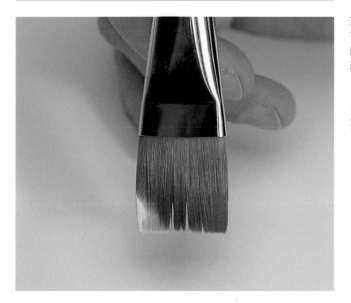

Double Loading, continued

DOUBLE LOADING: WHAT AM I DOING WRONG?

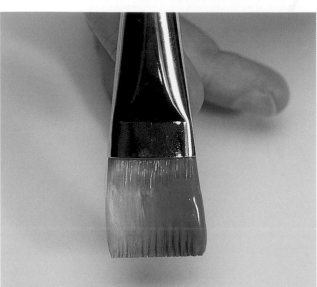

OVERBLENDED
Although you need enough paint in your brush, if you overwork it, you can blend the paints across both sides of the brush to a muddy mess.

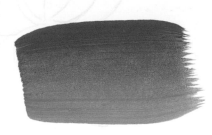

NOT BLENDED ENOUGH
You should be able to see distinct colors at each end of the brush and a gradual blending of the paint colors in the center.

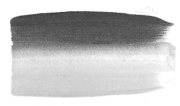

DOUBLE-LOADING PROJECT

by Tera Leigh

Double-loading projects have regained popularity recently thanks, in part, to Donna Dewberry's One Stroke products. The primary difference between one-stroke and more traditional double-loaded designs is that the traditional designs are based upon the elements of strokework. Another difference is that one-stroke is done with a flat brush, while traditional double loading, like multiloading, may be done with virtually any style brush, such as a flat, round, filbert or other specialty brushes.

Priscilla Hauser often describes painting as a language. Like any language, you must learn the elements or "alphabet" that are combined to create words. In decorative painting, these elements are basic stroke shapes that are combined to paint objects such as flowers, leaves and people. To do this project, you will be painting the alphabet of strokework with a double-loaded brush. In addition to the step-by-step worksheets, you should refer to the "Strokework" chapter of this book.

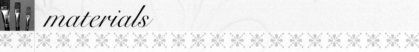

materials

Surface:
Large papier mâché travel case

Brushes:
Loew-Cornell La Corneille
 Flat nos. 6 and 12
 Rake no. 12
 Round no. 6 or no. 8—You may feel more comfortable double loading with a larger brush when using a round.

Palette:
Delta Ceramcoat
 Antique White
 Avocado
 Gleams Metallic 14K Gold
 Old Parchment
 Pink Quartz
 Raspberry
 Rhythm 'n Blue
 Stonewedge Green
 Straw

Miscellaneous Supplies:
Palette, paper, water basin, Chacopaper, Delta Ceramcoat Interior/Exterior Gloss Varnish, paper towels, stylus; optional: Delta All-Purpose Sealer or Delta Artist's Gesso

Surface Preparation:
If your piece is in good shape, papier mâché does not need preparation before basecoating. If it is not smooth or you want to seal it, you can seal with Delta All-Purpose Sealer or Delta Artist's Gesso.

Basecoating:
Using a no. 12 flat brush, basecoat as follows: top of case (large flat side)— Antique White; bottom of case— Avocado; side of case, middle section—Old Parchment; outside sections—Stonewedge Green. Apply the pattern to the front flat side.

DOUBLE-LOADING PROJECT, *continued*

Iva ©1999

Pattern is full size.

Flat Brush Strokes

CHISEL EDGE LINES

C-STROKE

1.

2.

3.

1. Touch the chisel edge of the brush to the surface and pull to the left on a curve.

2. On the downward pull, increase the pressure of the brush toward the sur-face.

3. Finish the bottom of the C with the brush parallel to the starting edge by lifting the brush back to the chisel edge.

U-STROKE

1.

2.

3.

UPSIDE-DOWN U-STROKE

1.

2.

3.

1. Touch the chisel edge of the brush to the surface.

2. Apply pressure on the downward stroke, pulling on a curve.

3. Finish the side of the U with the brush parallel to the starting edge.

Use the same steps as in the previous U-stroke, except flip the U over.

S-STROKE

1.

2.

3.

1. Touch the chisel edge of the brush to the sur-face and pull left.

2. Apply pressure on the downward pull.

3. Finish the bottom of the S with the brush parallel to the starting edge by lifting the brush up to the chisel edge while sliding to the left.

For more information about strokework, see chapter six.

DOUBLE-LOADING PROJECT, *continued*

Round Brush Strokes

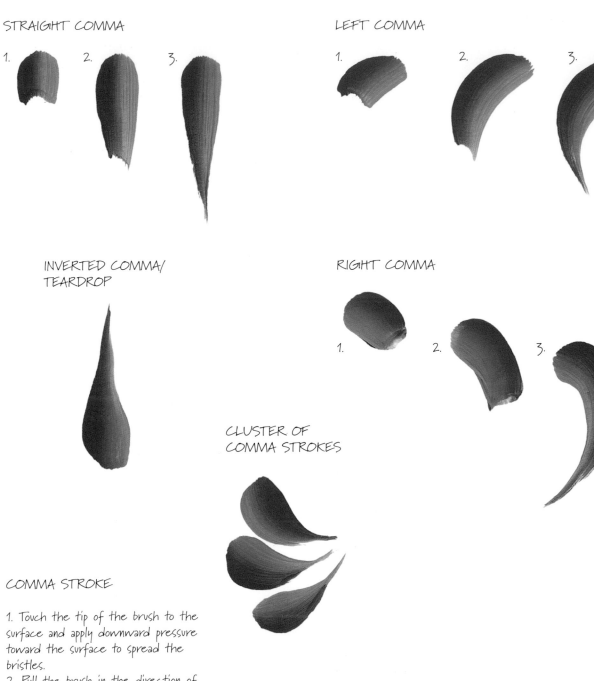

STRAIGHT COMMA

1. 2. 3.

LEFT COMMA

1. 2. 3.

INVERTED COMMA/
TEARDROP

RIGHT COMMA

1. 2. 3.

CLUSTER OF
COMMA STROKES

COMMA STROKE

1. Touch the tip of the brush to the
surface and apply downward pressure
toward the surface to spread the
bristles.
2. Pull the brush in the direction of
the stroke by moving your arm, not
your hand.
3. Gradually decrease the pressure
until only the tip of the brush touches
the surface.

See pages 148-151 for instructions on
creating comma strokes.

STEMS:
With the chisel edge of your flat brush, paint the stems of the three large pink flowers. To add the details; load your round brush with Avocado and pull two comma strokes where the flower stems meet.

LARGE FLOWER PETALS:
Load your round brush with Raspberry on one side and Pink Quartz on the other. The petals are comma strokes painted from the inside out. The Raspberry edge faces out on most of the petals, except for the bottom petals of the top flower.

 tera tip

If you are not used to double loading with a round brush, you might find it easier to dampen the brush with water first, and flatten the bristles with your fingers so that they are flat and wide. Then dip one corner into each paint color and blend on your palette.

 tera tip

Remember that the downward pressure you apply with your brush toward the surface creates a comma stroke. Start with a lot of downward pressure and then lift as you pull the stroke toward you. Move your entire arm as you pull the stroke. As you lessen the pressure, the stroke becomes thinner.

1.

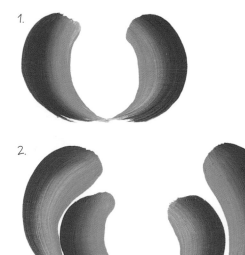

2.

3.

4.

 tera tip

Don't worry if each stroke is not perfectly even. What is important is that they are each about the same length. As you practice, you'll find strokework comes as naturally as handwriting. It will never happen if you get easily discouraged. Just keep at it!

117

DOUBLE-LOADING PROJECT, *continued*

1.

2.

LARGE FLOWER CENTER:
Pull a straight comma stroke with
your round brush loaded in Old
Parchment. Once dry, use the tip of
your brush handle to apply small dots of
Straw around the edge of the
stroke.

3.

 tera tip

When painting with a rake
brush, load your brush with
paint mixed with water to an
inky consistency. Once you
have the paint in your brush,
push your brush down to the
flat and splay the bristles on
your palette while wiggling
the brush. This pushes the
paint to the tips of the bris-
tles where you need it.

1.

2.

LEAVES:
The green leaves are double-loaded
comma strokes, with the brush loaded
with Stonewedge Green on one side
and Avocado on the other. There are
three accent strokes painted in
Straw as indicated on the pattern.

3.

1.

2.

CALYX:
On the large flowers, the calyx is
painted with the round brush loaded in
Avocado. This is a straight comma
stroke. Pull the stroke from where
the pink strokes come together
directly into your stem line.

3.

1.

2.

3.

"U"-shape
inverted

1

2

3

2

3

SMALL FILLER FLOWERS:

With your no. 6 flat brush double loaded with Rhythm 'n Blue on one side and Pink Quartz on the other, paint the flower as shown in the step-by-step diagram. Touch the chisel edge of the brush to the surface and pull on an upward curve, then apply pressure on the horizontal side. Finish the stroke with the brush parallel to the starting side and lift the brush to the chisel edge. This flower is a series of simple U-strokes painted in a 2-3-2-3-2-3 pattern (2-3 refers to the number of strokes per level). The top of each stem has a single U.

BORDER:

Using your round brush, paint simple S-strokes around the case with a one-half-inch space between each. When this is dry, paint again over the top with 14K Gold. Using the handle of a brush, place Rhythm 'n Blue dots between each S-stroke.

SIDES OF THE CASE:

The outside bands of Stonewedge Green are painted with a plaid design created with a rake brush. The straight vertical lines are painted in Avocado. The horizontal wavy line is painted in Old Parchment.

When you are painting the long wavy line, you will need to stop to reload your brush. The best place to stop is in the middle of the vertical lines. You can then pick up and continue to paint without the stop and start marks being noticeable.

The inner band is painted with a simple strokework design in Avocado. Using your round brush, paint a long, straight comma. On either side, paint two progressively shorter comma strokes. At the bottom, finish with two horizontal comma strokes to match the design on the front of the case. In between each of these flourishes is a dot of Raspberry that is painted using the handle of your brush. Note that the flourishes face the opposite direction on each side of the clasp at the top center of the piece. Paint the indented band between the center and bottom sections of the case with 14K Gold.

Be sure to sign your piece when you finish before you varnish. See the section on varnishing for details.

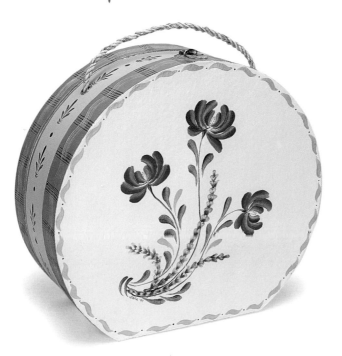

Double Loading: The One-Stroke Way

DOUBLE LOADING AND DONNA DEWBERRY'S ONE-STROKE TECHNIQUE

There has been some confusion among painters as to how Donna Dewberry's One-Stroke technique differs from traditional double loading. The primary difference is that One-Stroke is a freehand technique and is not based upon strokework. Traditional double loading is used in combination with a series of teachable strokes which are building blocks for painting a wide variety of subjects. The One-Stroke technique uses laminated teaching guides that allow you to practice step-by-step illustrations of specific subjects, such as flowers, leaves, birds and more. Instead of concentrating on a common language of strokes, the One-Stroke technique focuses on the end results of the subject by breaking it down into individual steps.

One-Stroke is a product of Plaid Enterprises, Inc. and has a variety of products made specifically for it. These include brushes, teaching guides, videos and kits. Like traditional double loading, the One-Stroke brush is loaded on each side with a different color and then blended on the palette so that you have distinct colors on each side of the brush and a graduated blend in the center.

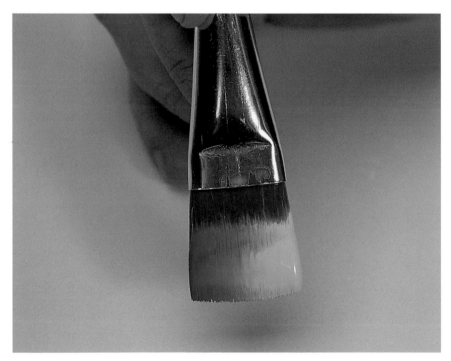

As with traditional double loading, the most important aspect of learning the technique is having sufficient paint in the brush. As a One-Stroke certified instructor, I have found that the biggest problem painters have learning the technique is that they do not have enough paint in the brush. You will need to add paint, blend, then add more paint and blend, just as you would with a traditional double load.

The One-Stroke system is based upon a series of reusable laminated guides showing a step-by-step breakdowns of the subjects. These guides allow you to practice a subject over and over by simply wiping off the surface with a baby wipe or damp paper towel and starting again. The guides give you the opportunity to paint directly over Donna Dewberry's own strokes to see how each step should look. This helps you to gain confidence before you begin painting.

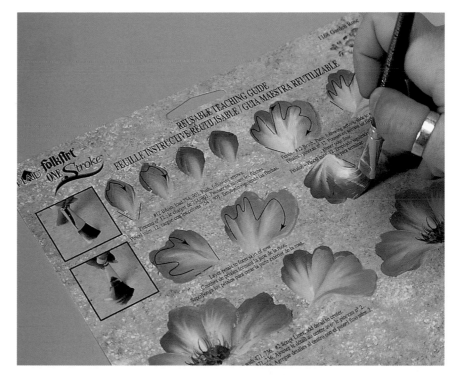

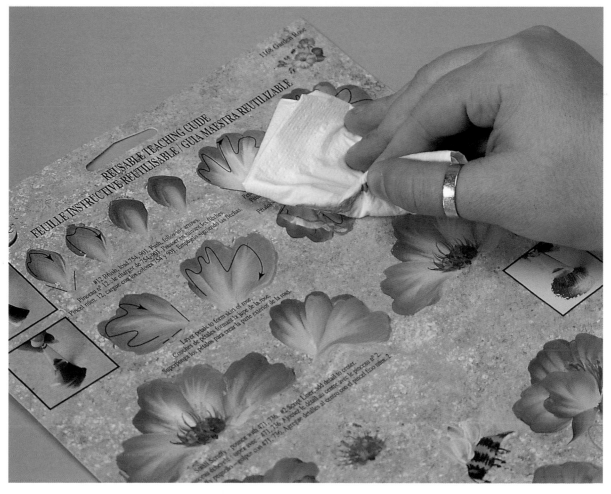

Double Loading: The One-Stroke Way, continued

THE ONE-STROKE WAY: WHAT AM I DOING WRONG?

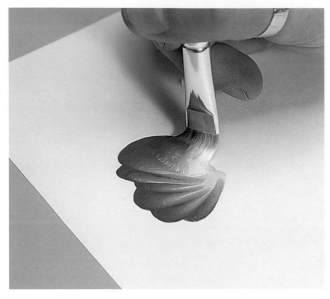

When painting the One-Stroke technique, keep the brush down to the flat throughout most strokes. This downward pressure toward the surface gives you the lovely blended One-Stroke look.

As with traditional double loading, part of what makes the technique effective are the two distinct colors on the brush. In the One-Stroke technique, the distinct colors are usually used to shade and highlight in "one stroke." If the colors become blended together all the way across the brush, the effectiveness is lost.

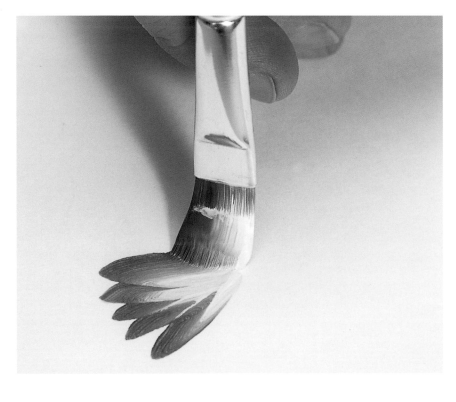

One of the most common mistakes in using the One-Stroke technique is not using sufficient downward pressure. You must take the brush all the way down to the flat to get the lovely blend associated with this technique.

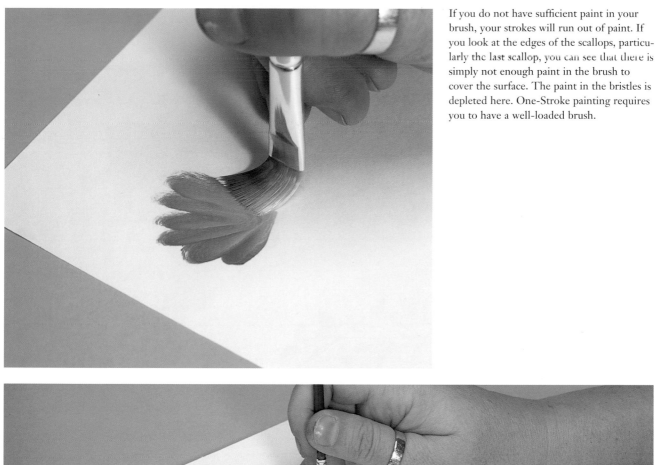

If you do not have sufficient paint in your brush, your strokes will run out of paint. If you look at the edges of the scallops, particularly the last scallop, you can see that there is simply not enough paint in the brush to cover the surface. The paint in the bristles is depleted here. One-Stroke painting requires you to have a well-loaded brush.

Although it is not double loaded, the One-Stroke liner brush is used to accentuate One-Stroke designs. Be sure that your paint is thinned with water to an inky consistency before starting. The long bristles of the One-Stroke liner can be difficult for the beginning painter to become accustomed to using. You must keep your hand braced on your surface. This lets you use the brush to steady your hand and maintain the same distance from the surface. To use any liner, the thinnest line comes from the tip of the brush and widens with downward pressure. Keeping your hand braced will enable you to maintain the same distance throughout your lining.

ONE-STROKE HIBISCUS AND CARNATION SERVING TRAY

by Tonya Mills, OSCI

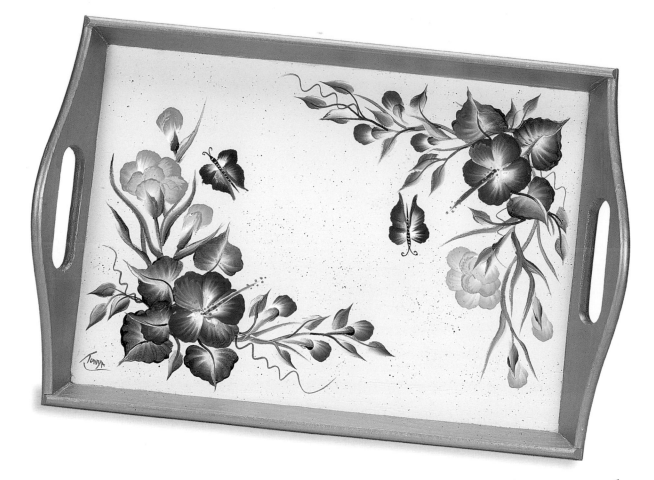

This pattern may be hand-traced or photocopied for personal use only. Enlarge at 200% to bring to full size.

PETAL.

Double load a no. 12 flat brush with Yellow Ochre and Wicker White. Start with the chisel edge on the line. Spread the bristles flat by applying pressure and slightly wiggle the brush up and down while turning the brush and following the arrows. Finish by standing the brush up on the chisel edge and pulling down to end on the line, making a clean edge.

First layer—four petals

Second layer—three overlapping petals

Last layer—one petal

BUD

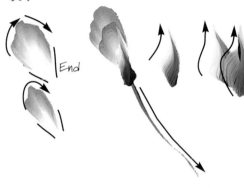

With a no. 12 flat brush double loaded with Sap Green and Buttercream, paint two little overlapping One Stroke leaves for the calyx.

materials

Surface:
Wooden serving tray

Brushes:
Plaid FolkArt One-Stroke:
 Flat nos. 8 and 12
 Script liner no. 2

Palette:
DecoArt Americana
 Buttermilk
Delta Ceramcoat
 Gleams Metallic 14K Gold
Plaid FolkArt
 Buttercream #614
 Dioxazine Purple #558
 Fuchsia #635
 Licorice #938
 Sap Green #458
 Wicker White #987
 Yellow Ochre #917

Miscellaneous Supplies:
 Plaid FolkArt ClearCote Hi-Shine
 Glaze #785, stylus or toothpick,
 1-inch sponge brush, Chacopaper

Surface Preparation:
Wipe the tray free of dust. Using a 1-inch sponge, basecoat the flat part of the tray with Buttermilk, basecoat the sides and handles with Yellow Ochre and topcoat sides and handles with Metallic 14K Gold.

 Transfer the pattern to the tray using the stylus and transfer paper.

ONE-STROKE HIBISCUS AND CARNATION SERVING TRAY, *continued*

HIBISCUS

Double load a no. 12 flat with Sap Green and Buttercream to make the calyx up to the bud.

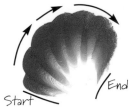

Start / End

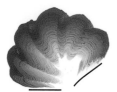

Double load a no. 12 flat brush with Fuchsia and Wicker White. Start with the chisel edge on the line. Spread the bristles flat by applying pressure. Then slightly wiggle the brush up and down while turning the brush and following the arrows. Finish by standing the brush up on the chisel edge and pulling down to end on the line, making a clean edge.

Overlap the petals to form a circle

BUD

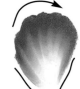

Create the stem with a no. 12 flat brush double loaded with Fuchsia and Wicker White. Starting at the center of your circle, make a line heading out of the flower. Lead with the Wicker White. Add dots with a stylus dipped in Yellow Ochre.

BUTTERFLY

1 2
3 4

Double load a no. 8 flat brush with Dioxazine Purple and Wicker White. Starting on the chisel edge, wiggle to a point and slide back up to your starting point.

Start
End
5
Start End Start

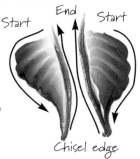

Chisel edge

Use a no. 2 script liner loaded with inky-consistency Licorice to create the body and antennae. Use Wicker White for the stripes on the body.

LEAVES

Large leaf: Double load a no. 12 flat brush with Sap Green and Buttercream. Start with the chisel edge on the line. Push the brush and apply pressure to flatten the bristles. To create the leaf, slightly wiggle the brush while turning the brush and following the arrows. Finish by standing the brush on the chisel edge and pulling to create the tail of the leaf.

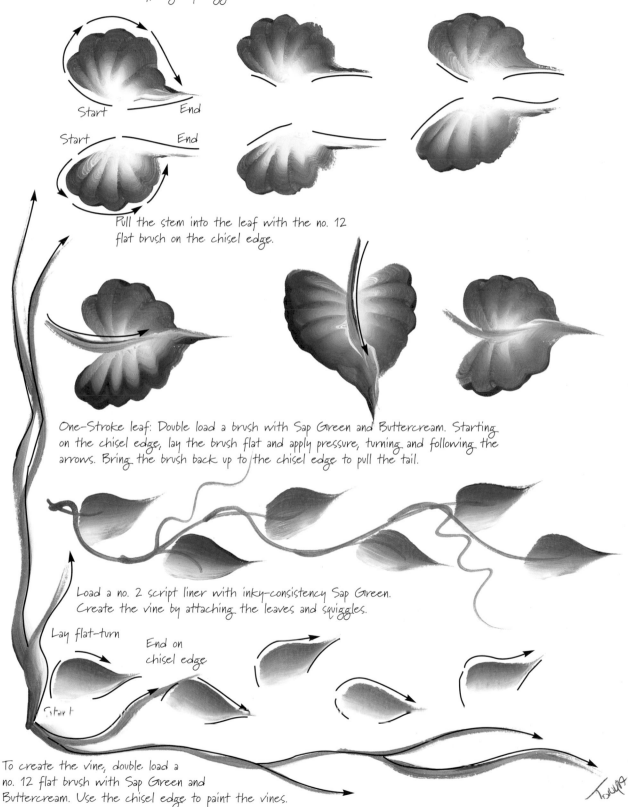

Start End

Start End

Pull the stem into the leaf with the no. 12 flat brush on the chisel edge.

One-Stroke leaf: Double load a brush with Sap Green and Buttercream. Starting on the chisel edge, lay the brush flat and apply pressure, turning and following the arrows. Bring the brush back up to the chisel edge to pull the tail.

Load a no. 2 script liner with inky-consistency Sap Green. Create the vine by attaching the leaves and squiggles.

Lay flat—turn

End on chisel edge

Start

To create the vine, double load a no. 12 flat brush with Sap Green and Buttercream. Use the chisel edge to paint the vines.

Multiloading Methods

Another brush technique is multiloading. This is primarily used in regional techniques, such as the Bauernmalerei project by Erika Ammann starting on page 130, but it can be adapted for many uses. This technique primarily uses a round brush. Unlike traditional double loading with a round brush, the entire brush is loaded with the first color by pulling the color out from a pool of paint on your palette. Fully load the brush down to the flat.

The second color is loaded on a single side by laying the brush down in your puddle of paint and pulling the brush down to the flat away from the puddle. Do not blend back and forth or you will mix the colors on the brush.

The third color is loaded onto the brush by "tipping." Tipping is a technique that can be done with any loaded brush. Dip the tip of the brush into a pool of fresh paint of a different color, lift straight up and do not blend the brush on the palette. All three colors should be visible and distinct on the loaded brush.

tera tip

When the brush is loaded with one color—the main color—it is round with no side. Once a second color is picked up and gently blended into the bristles, the brush automatically flattens a little and you will now have a side. (When I talk about loading a side, I mean the flat side of the brush.) Further colors are loaded either on the dark or light side as indicated in the instructions. Basically, the brush is always loaded from dark to light. Keeping this in mind will make it easier to understand on which side the next color should be placed.

For example, if your first color is a dark value, every following color lighter than the first is loaded on the same side, meaning one on top of the other according to the values. In this case, some colors will be sandwiched in between. If you load with a medium value first, any color lighter than the first is loaded on the same side (called the light side), and any color darker than the first is loaded on the opposite side (called the dark side).

Every color needs to be gently pushed or blended into the bristles. As you apply pressure on the bristles when painting a stroke, you will achieve a shaded look. When you look at the brush from the top, the colors face to the side with the most outer colors visible at the same time. The brush is used on the chisel to paint the stroke unless otherwise indicated in the instructions. Keeping it to the side achieves that shaded appearance. When facing the color down toward the surface or up toward the ceiling, a different look is achieved.

Facing the light color toward the ceiling will show it as the dominant color. Facing the dark side toward the ceiling will show it as the dominant color. Stroking through the dark or light color once more after the brush is loaded with the initial colors and before painting a stroke will achieve a dark or light beginning to the stroke.

MULTILOADING PROJECT

by Erika Ammann

As always, it is difficult to translate the feeling of a word. Loosely translated, *Bauernmalerei* means "farmer painting": *Bauern* = farmer, peasant, countryman; *malerei* = painting. Bauernmalerei is pronounced *bow-urn-mall-ur-eye*.

 materials for the multiloading project

Palette:

DecoArt Americana Acrylics
 Antique Gold Deep
 Brandy Wine
 Burnt Umber
 Deep Midnight Blue
 Lamp Black
 Light Cinnamon
 Napthol Red
 Shale Green
 Titanium White
 Yellow Light
 Metallic Treasure Gold

Brushes:

Erika's
 Liner no. 00
 Multiload no. 4

Miscellaneous Supplies:
 DecoArt Sealer/Finisher in Gloss
 Raw Umber oil paint

Surface Preparation:
Prepare the background with two coats of Shale Green, sanding between each coat. Paint the rim with Brandy Wine to cover. When this is dry, trace as much of the pattern as you feel is necessary. Do not trace the dotted lines—these are ghost lines and will be freehanded at the very end.

Scrolls:
Each scroll is repeated several times around the tray, so you will get plenty of practice.

Antiquing:
Antique using your preferred method. I antiqued the piece using Raw Umber oil paint and an oil patina medium that I mixed. I wiped off more patina in the center and left it darker around the edge. With Treasure Gold and my finger or a cloth, I wiped around the carved rim of the tray.

Finish:
I sprayed several coats of DecoArt Sealer/Finisher in Gloss.

SCROLLS ARE PAINTED IN THREE STEPS

First, base each scroll with Antique Gold Deep plus Light Cinnamon gently blended into the bristles on one side. Paint the shadow strokes that are clearly marked on the pattern. When painting the strokes, face the Light Cinnamon side toward the inside of the tray and paint on the chisel edge.

Clean the brush and load with Antique Gold Deep plus Titanium White. Paint the highlight commas with Titanium White facing toward the outside of the tray.

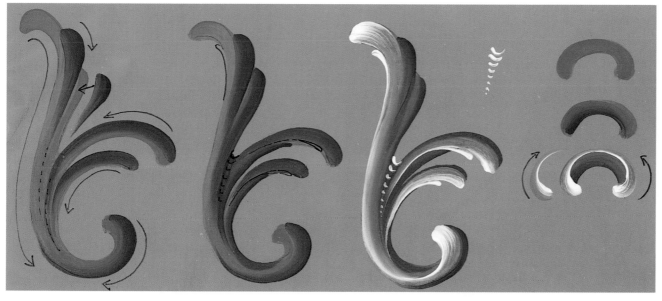

STEP 1—BASE

Begin at the longer end like a reversed S on one side or like an S on the opposite side. Then add each stroke, flowing toward the opposite end. Apply one from the opposite end to complete the shape.

STEP 2—SHADOW

After the larger scroll is based, apply the shadow strokes. Pull each stroke in as long and flowing a manner as possible. With the Light Cinnamon facing the inside of the tray, paint on the chisel edge, not the tip.

STEP 3—HIGHLIGHT

Clean the brush and double load with Antique Gold Deep and Titanium White. Paint the highlights. With the Titanium White facing toward the outside of the tray, paint the four larger highlight commas. Then, with the liner brush and a little Titanium White replaced for each stroke, paint the fine commas along the three larger comma strokes. Paint the small curved strokes down the middle.

For the small C scroll, base, shade and highlight the commas, joining at the center and outer edges.

 tera tip

It is important to place the project in a comfortable position for each stroke, enabling you to pull the strokes in an easy motion. Before you apply the stroke, think about where you should end up and position the piece accordingly. Practice some C shapes with a pencil to get a feel for the direction and how far you are able to pull a stroke. Paint with your fingers and not your arm. Keep enough moisture in the brush for easy flow.

MULTILOADING PROJECT, *continued*

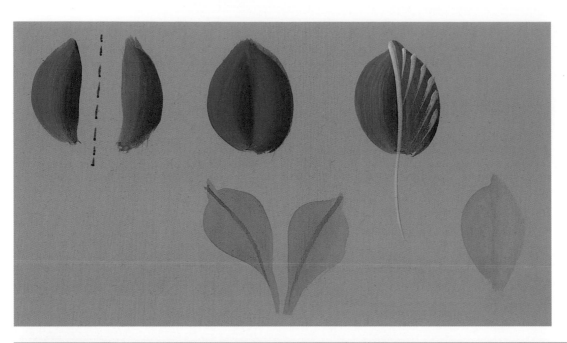

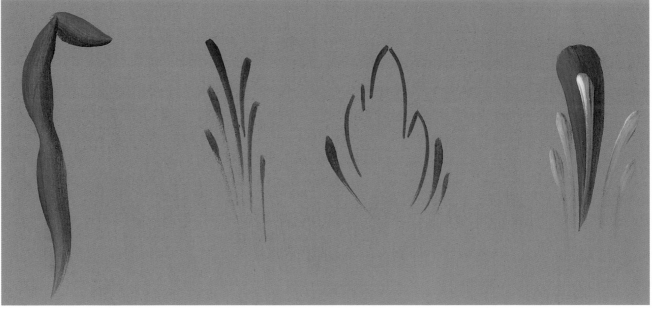

LEAVES

Mix Yellow Light and a little Lamp Black together to a darker but still recognizable green. Load the brush with this mix and pull through Antique Gold Deep on one side gently pushing it into the bristles several times. The Antique Gold Deep should be visible on the brush, otherwise it will not be showing after the stroke is applied. Face the gold side toward the left and, beginning at the tip of the leaf, apply pressure to the bristles and pull the stroke down half of the leaf toward the stem position. Without replacing any paint and with the remaining gold still

facing toward the same side, paint the second half of the leaf the same way you painted the first half. Using the same color load, paint the large commas as well. Do not paint the filler commas or ghost lines just yet.

TULIP LEAVES

Double load the brush with the green mix and Antique Gold Deep. Face the Antique Gold Deep toward the side. Start gently at the tip, then increase and release the pressure, ending on the tip of the brush. The bent leaf is done using two strokes—one for the tip and one for the remaining leaf.

WASH

Load with the green mix thinned with water. Paint leaflike strokes between some of the solid painted leaves and cover the center gaps of the design. This will give more depth in the center on a light background. If you paint a wash over any tracing lines, the lines will be visible because the wash is transparent. Erase them before painting the wash.

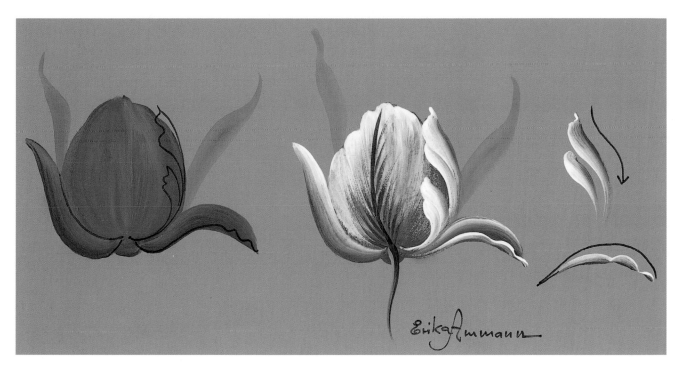

TULIP

Mix some Titanium White with a mix of Napthol Red + Burnt Umber to create a dark pink and base the tulip first, keeping the shape in mind. Double loading your brush with the pink and lots of Titanium White, face the white toward the ceiling. Pull fat comma strokes from the top edge of the center petal toward the base, releasing the pressure and letting the strokes fade out. The based pink should be exposed at the base of the tulip.

Replace some pink and Titanium White. Face the white to the side and toward the top of the tulip, and paint the petal on the left using a thin-thick-thin stroke, ending at the calyx position. Use the same stroke for the petal on the right. Afterward, paint a turn on to this petal with the white facing toward the inside of the petal. Use gentle pressure for a nice effect.

To finish, paint the overlapping petals on the right of the center part. Loading your brush with lots of Titanium White, and using the tip of the brush, begin at the top and then increase pressure, releasing again while the stroke is curved toward the right and then to the base. Join another comma next to it to complete this petal. Add another smaller one a little lower. For completion, use the liner brush and Napthol Red, pull a fine line from the base toward the tip of the tulip as well as few from this center line toward the side. Curve it slightly.

Rose

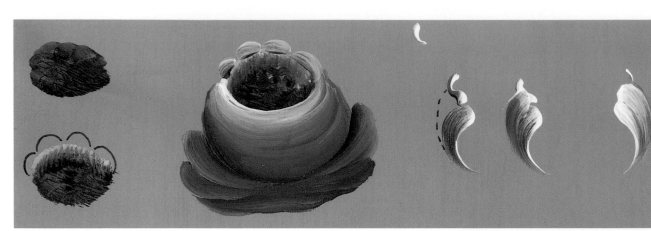

DAB CENTER

Mix Napthol Red and some Burnt Umber together. Do not use too much Burnt Umber as it will turn to brown. A reddish glow should still be recognized. This is called braking the red (BR). Load the brush with BR (Napthol Red + Burnt Umber). Pick up some Gold on one side. Face the BR toward you and the Gold side toward the top of the rose. When looking at the center of the rose, imagine a clock face (with twelve o'clock at the top of the rose) and begin at six o'clock. Lean the handle of the brush to the right so the bristles point to the left. Apply a little pressure to the bristles. Then lift the brush and move clockwise around the center. Press the bristles down, then lift, and move on. Keep the tip pointed to the left at all times. When coming around to six o'clock again you will see a little gap in the center. Tap this area the same way until it is filled in. Add a little White and dab the upper part of the center with a little highlight.

BACK PETALS

Without cleaning the brush, replace a little White on the light side. Face the White toward the top of the rose and paint small curved strokes around the back (top) of the rose. Replace a tiny amount of White on the tip or use the liner brush, turn the rose to a comfortable position and paint fine curved commas below these petals. Alternate the commas resulting in multi-layered petal effect. Continue the same around the front of the center shaping the center at the same time.

BOWL

Replace more White and paint a thin-thick-thin stroke from left toward the right side, closing and shaping the center at the same time. With remaining paint continue adding the same strokes from one side to the opposite side replacing BR as necessary till the bowl is filled. Replace a little White and paint a hook as follows.

The White on the brush is laid with just a gentle touch (painting with the paint and not the brush) onto the surface on the left side of the rose, resulting in the effect of the petal coming from the back wrapping itself around the center. Then push the White along the top of the petal. Now apply pressure to the tip of the brush and pull the stroke down toward the base, gradually releasing the pressure ending on the tip of the brush at the base. Turn the White to the inside of the rose while pulling the stroke down and think as if you were painting a comma. Face the darker side toward the left side of the rose and push back into the wet White, pulling as many strokes down as needed to complete the petal, blending gently. If there is not enough of the dark left in the brush, pick up a little more to darken the left side, blending toward the center. Repeat the same technique for the petal on the right, keeping it lighter.

Replenish the White and push it uneven along the top of the center petal, turning the White slightly to the right as the stroke is pulled down toward the base. Leave a small gap between this and the side petal. Now turn the remaining White to the left, pushing into the wet White on the left of the petal, pulling it down again. Continue to push back into the White and pull it down till the petal is complete, blending at the same time. Curve the strokes on either side but straighten them toward the middle of the petal. Keep the pattern in front of you so

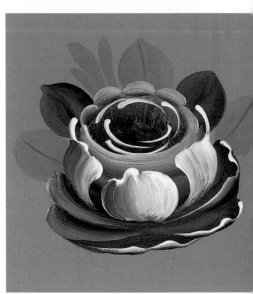

you can read the placement of the petals as you need to freehand them. Keep the overall look of the rose lighter on the side toward the tulip and darker toward the opposite side. You can either load with more White or BR to adjust whichever side after the petals are already painted and blend accordingly.

SKIRT PETALS

Load the brush with BR and a touch of White. Face the lighter side toward the outside of the rose and fill the side petals. Turn the rose sideways to fill the bottom petals. Add White sparingly along the tip of the brush on the light side, then paint some turns along the edge. Face the White toward the inside of the petals and apply and release pressure along the edge on the side toward the tulip and along the bottom.

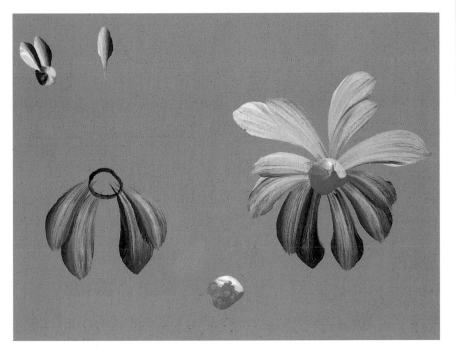

DAISIES

Load the brush with Deep Midnight Blue and on one side blend some Titanium White into it to lighten the value. Then pull through a little more Deep Midnight Blue on the dark side. Face the dark toward the ceiling before painting two comma strokes for each of the daisy petals, ending at the same point in the center. Keep one a little shorter than the other. Continue to paint the petals this way but adding a little more Titanium White each time, thus giving variation to the daisy.

VEINS

Triple load the liner brush with the green mix, Yellow Light and Titanium White on top of the Yellow Light. Blend the Titanium White into the Yellow Light so the veins do not appear to be White but rather a light green. Begin the center vein at the tip, pulling a stroke toward the stem position. Then add some side veins from the outer edge toward the center vein.

FILLER COMMAS

With the triple load of the green mix, Yellow Light and Titanium White, paint the commas over and next to the large commas that were painted at the same time as the rose leaves.

FINISHING DETAILS

With the green mix only and the liner brush, paint the remaining fine filler commas and stems. Then add a little Yellow Light and paint a small dot at the base of each daisy bud.

This pattern may be hand traced or photocopied for personal use only. Enlarge at 200%. Then enlarge at 116% to bring to full size.

Acrylic Blending & Painting in Oils

Historically, decorative painters used oil paints. However, in the last twenty years, acrylic paints have gained in popularity because of the health hazards associated with some oil paints and mediums. The good news for oil painters is that due to stricter health laws, most of the dangerous paints have been taken off the shelves and replaced with safer alternatives.

Acrylic blending can be used in large areas and for individual subjects. Shown here is a leaf coated with acrylic blending gel. A second color is applied and then blended wet-on-wet into the basecoat color. A mop brush can be used to smooth the blending as you learn to control the color.

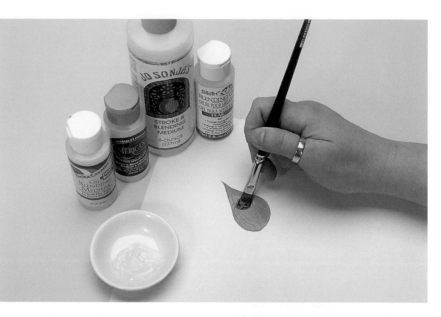

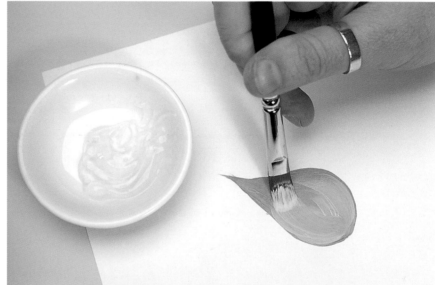

By mixing several colors together on your surface, acrylic blending can also be used for scumbling to create a beautiful background.

The technique of acrylic blending was created to help acrylic painters achieve the smooth blend and balance of oil painting. Acrylic paints can create most of the effects of oil painting, but they have the benefit of not requiring turpentine, which is toxic, or some of the other more odorous oil-painting mediums. Acrylic paints dry much faster than oil paints and mediums must be added to extend or retard the drying time. Various mediums have been created to give acrylic paints properties that are closer to those of oil paints. These include extenders, thickeners and glazing mediums.

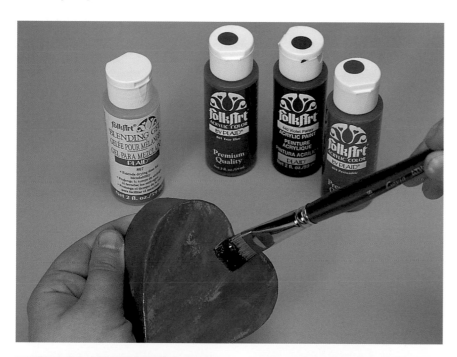

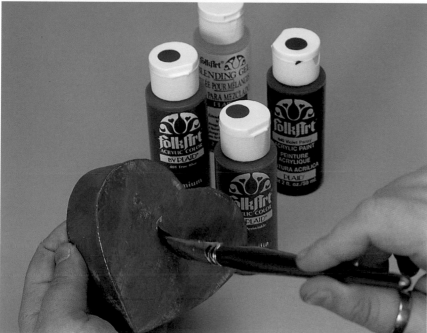

ACRYLIC VS. OIL PAINTING PROJECT

by Sue Pruett, MDA

The project in this section shows the same pattern painted in both acrylic and oil paints. With practice, painters can achieve the smooth blend associated with oil paints by using acrylic paints and mediums. This is especially important for painters with allergies to oil paints and products, or those who prefer the faster drying time associated with acrylic paint. As an artist, I recommend that you try oil paint as it is an excellent tool in your paint box. There are also a wide variety of new paints on the market, such as water-soluble oil paints and the Genesis heat-set oil paints.

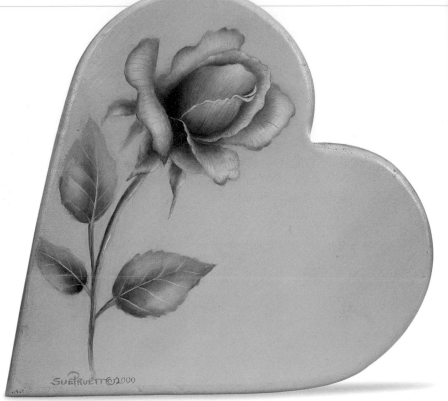

ACRYLIC PROJECT

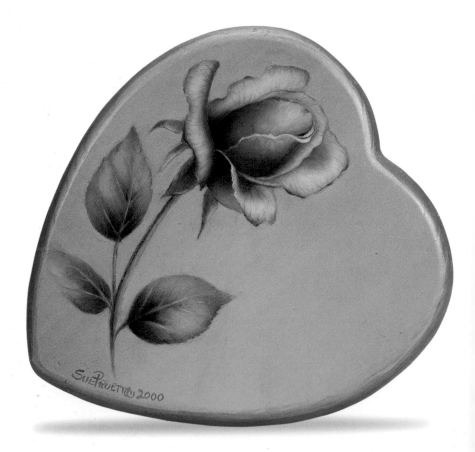

OIL PROJECT

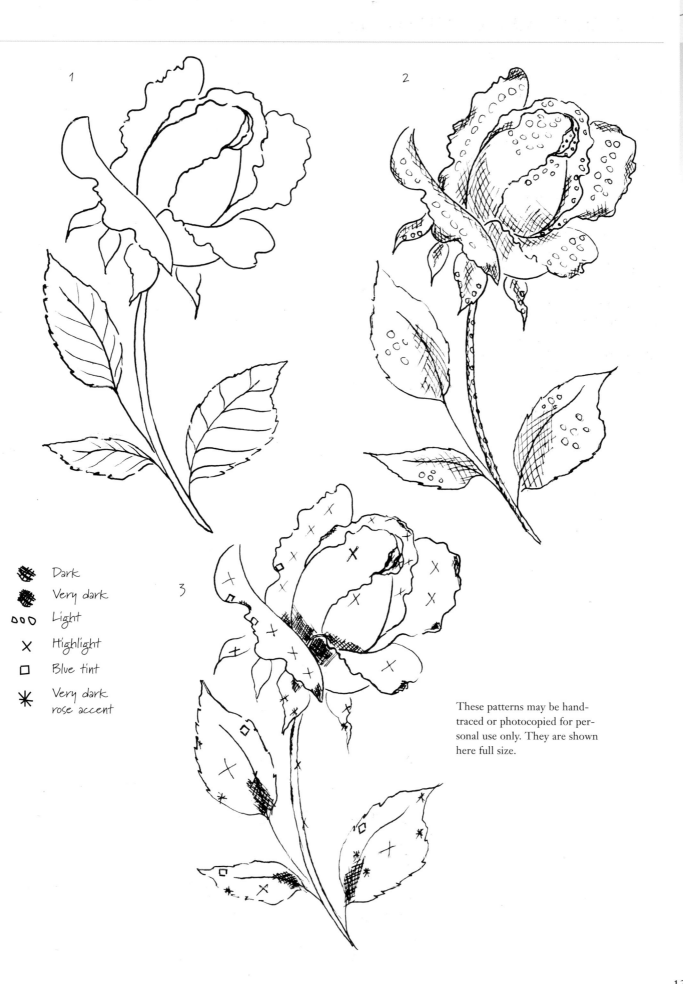

Dark

Very dark

Light

Highlight

Blue tint

Very dark
rose accent

These patterns may be hand-traced or photocopied for personal use only. They are shown here full size.

materials for the acrylic project

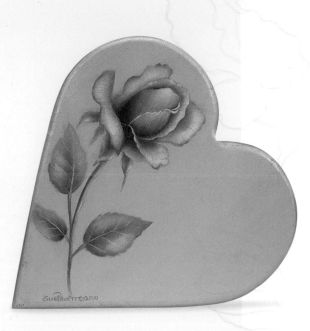

Palette:

Delta Ceramcoat Acrylics
 Burnt Sienna
 Dark Foliage Green
 Georgia Clay
 Light Ivory
 Mello Yellow
 Peachy Keen
 Red Iron Oxide
 Rosetta Pink
 Salem Green
 Silver Pine
 Tomato Spice
 Wedgewood Blue
 Wedgewood Green

Brushes:

Winsor & Newton
 Series 500 nos. 6 and 8
 Series 530 no. 0
 Series 550 no. 2
Ann Kingslan brushes
 no. 0 mop

Wood Source:
 Punched tin heart box (can be pur-
 chased from Sue Pruett)

Surface Preparation:
 Prepare the wood. After letting the
 sealer dry, lightly sand and apply an
 undercoat of Silver Pine using a
 sponge brush or large flat brush. Let
 this dry, then apply another coat for
 solid coverage. Trace the pattern and
 transfer it to the surface using
 graphite paper.

Mix the Following Colors:
Rose
 HIGHLIGHT—Mello Yellow + Light
 Ivory (1:1)
 LIGHT—Peachy Keen
 MEDIUM—Rosetta Pink
 DARK—Rosetta Pink + Georgia Clay
 (2:1) + a touch of Tomato Spice
 VERY DARK—Dark mix + Burnt
 Sienna + Tomato Spice + Red Iron
 Oxide (1:1:1:1)
 TINTS—Wedgewood Blue

Leaves
 HIGHLIGHT—Light mix + Light
 Ivory (1:2)
 LIGHT—Medium mix + Mello Yellow
 (1:1)
 MEDIUM—Salem Green +
 Wedgewood Green (1:1)
 DARK—Medium mix + Dark Foliage
 Green (2:1)
 VERY DARK—Dark mix + Dark
 Foliage Green (1:1)
 TINTS—Wedgewood Green
 ACCENTS—Red Iron Oxide

Always moisten any areas with water
before layering the color.

STEP 1—ROSE AND LEAVES

Basecoat the leaves and roses with a no. 8 flat brush loaded with the medium values. Retrace the lines on the rose to separate the petals.

STEP 2—ROSE

Using a no. 2 filbert, load the brush with thinned paint, set the brush on the area and pull it, spreading paint to the size of the area. Soften the edges of the color using a no. 0 mop. Using a no. 6 or no. 8 flat side loaded with the dark value, stretch the paint to the size of the area.

LEAVES

Using a no. 2 filbert, follow the same method above using the light green mix. Add darks using the same method. The stems are created with a liner brush. Reapply these colors until you achieve the effect you like.

STEP 3—ROSE

Reinforce the dark and light areas, pyramiding with the very dark mix and light mix. Reapply to strengthen. Add blue tints to the lower left area. Using a liner brush loaded with the very dark rose apply faint vein lines here and there. Add highlight lines on the front edges of the petals.

LEAVES

Using a liner brush loaded with water-thinned light green, pull vein lines, noticing the graceful curves. Add touches of highlight green to the center area of the vein lines. Side load very dark green along the back of the leaf to shade the vein. Apply tints and accents with a side-loaded brush.

Let this dry and varnish with a satin varnish.

materials for the oil project

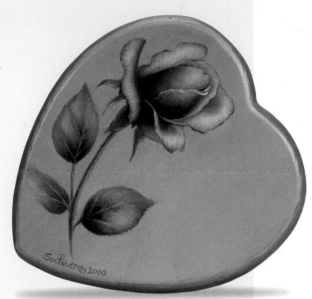

Palette:

Archival oils
Burnt Sienna
Cadmium Scarlet
Cadmium Yellow Medium
Permanent Alizarin
Titanium White
Ultramarine Blue

Delta Ceramcoat
Silver Pine

Brushes:

Winsor & Newton
Flat no. 4 and larger
Liner
Series 710 nos. 0, 2, 6
and 12
Sponge brush

Ann Kingslan
Mop nos. 0 and 1
Filbert nos. 2 and 4

Miscellaneous Supplies:
Krylon matte varnish
Krylon satin #7002

Wood Source:
Punched tin heart box (can be pur-
chased from Sue Pruett)

Surface Preparation:
Prepare the wood. After letting the
sealer dry, lightly sand and apply an
undercoat of Silver Pine using a
sponge brush or large flat brush. Let
this dry, then apply another coat for
solid coverage. Trace the pattern and
transfer it to the surface using
graphite paper.

Mix the following colors:
Warm white—Titanium White + a
dot of Cadmium Yellow Medium

Rose
HIGHLIGHT—Warm White
LIGHT—Warm White + a touch of
Medium mix
MEDIUM—Warm White + Dark mix
(3:1)

DARK—Cadmium Scarlet + Burnt
Sienna (1:1) + a small touch of
Cadmium Yellow Medium + a
touch of Warm White
VERY DARK—Dark mix + Permanent
Alizarin (1:2) + a touch of Burnt
Sienna

Leaves
HIGHLIGHT—Light mix + a touch of
Warm White
LIGHT—Medium mix + Warm
White (4:1) + a touch of Cadmium
Yellow Medium
MEDIUM—Cadmium Yellow Medium
+ Ultramarine Blue (2:1) + a touch
of Warm White
DARK—Medium mix + Ultramarine
Blue (3:1)
VERY DARK—Dark mix + a touch of
Permanent Alizarin
TINTS—Light mix + a touch of
Ultramarine Blue
ACCENTS—dark value from rose

STEP 1— ROSE AND LEAVES

Apply values using a no. 4 filbert or no. 6 flat, keeping the edges fuzzy.

STEP 2—ROSE

Using the same brush as in step 1, hold the brush at a 45° angle with half of the brush on each value. Using a light touch, pull the brush toward you, blending the values. Soften, if needed, using a mop brush. Using a no. 4 filbert, blend the highlight value into the light area.

LEAVES

Blend the values together. Using the chisel edge of a no. 4 flat, hold the brush perpendicular to the leaf. Using a light touch, pull vein lines as indicated on the pattern, removing some paint and exposing the background color. Watch the leaf direction. Keep the veins flowing, not stiff.

STEP 3—BASE

Spray with Krylon matte varnish. Let this dry outside at least fifteen minutes. Pour water over the painting and sand lightly with wet/dry sandpaper. Dry with a towel.

Apply medium value and pyramid smaller areas of very dark and highlight. Using a no. 0 flat brush, blend tints and accents on the outside edge of the petals. Don't overdo this. The color should be soft and subtle. Add accents in the middle of the vein line on the leaves. Using a liner brush apply faint vein lines on the petals, avoiding the highlight areas.

Let this dry for a few days. Spray with Krylon satin #7002 to protect.

strokework

How do I get my strokes to look like that?

The cornerstone of folk art decorative painting is strokework. By learning the basic strokes, you will master brush control that will enable you to do most other types of decorative painting. You will also learn the building blocks for painting strokework-based designs.

Strokework is often described as an alphabet for learning the language of painting. Today, many painters do not learn strokework, except perhaps a brief lesson in their first few weeks that teaches the basics of brush control. This was my own experience. I did not learn strokework until several years after I began to paint. My painting improved 100% when I mastered strokework because I learned how the brush works, how it holds paint and how it moves. This knowledge will help you in every kind of painting that you do.

Strokework can be broken down into two elements—the downward and the sideways pressure put on the brush. When you hold a brush handle perpendicular to a surface, the amount of downward pressure you exert toward the surface will change the width of the stroke—the greater the pressure, the wider the stroke.

GETTING STARTED

It is easiest to work from left to right if you are right-handed, and right to left if you are left-handed. Working in this direction will help you avoid putting your hand over the wet paint as you work.

Although you want to have your hand loose and relaxed when painting strokework, you must brace it against your surface like you would when writing. This gives you stability and control. Try taking a pencil and writing your name while holding your hand up in the air. You can form the basic letters without bracing your hand, but it isn't the neatest or most controlled version of your handwriting. For that reason, you should always put your little finger or the side of your hand down on something to brace your brush when painting.

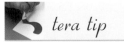

tera tip

When painting strokework, remember to move your entire arm, not just your hand. Moving your arm will give you a smooth, easy stroke. If you try to hold your arm in place, your hand cannot move enough to get the full sweep needed for strokework. Try it! You'll be amazed at the difference.

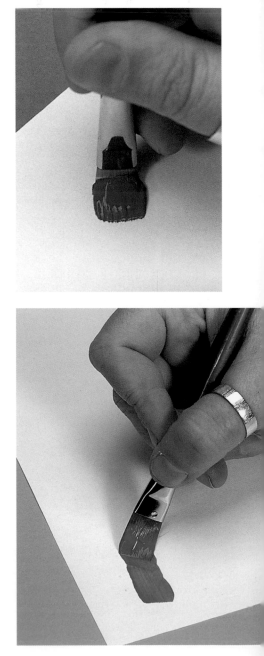

Handling the Brush

When painting, pull your brush toward your body to allow you to see ahead of the area you are painting and to have control of the bristles. If you pull or push the brush away from your body, it is harder to control the splay of the bristles and the paint on your surface. Pushing the bristles into the surface can also damage the brush. There is at least one technique that employs the splay of the bristles caused by pushing the brush away from you, but unless the technique calls for it, you should avoid using your brush in this way.

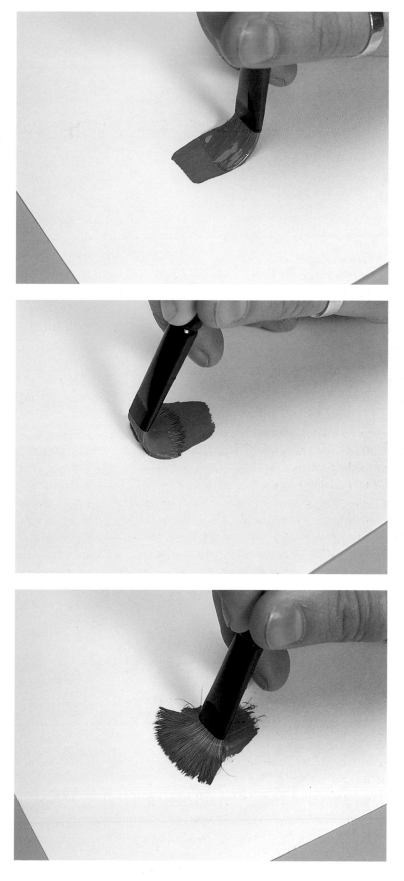

Handling the Brush, continued

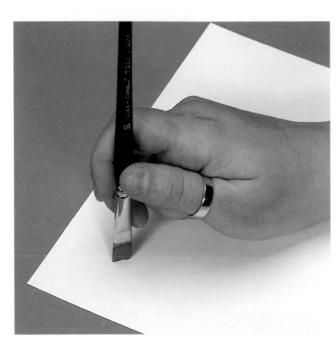

Chisel: The chisel edge of a brush is the very tip of the bristles. If you hold a brush with the tips of the filaments touching your surface but without applying enough pressure to move the brush forward or bow the bristles downward, you are holding it on the chisel edge. If you picture the flat pointed edge of a steel chisel, you will understand the reference to the chisel edge of a brush.

If you drag the tips of the bristles along the surface, it will create a fine line. This is called a "line stroke." Your brush handle must be kept straight up and down, perpendicular to your surface. The exception to this is if you are using an angle brush. In that case, you should hold the brush on an angle so that all of the bristles touch the surface. It is important to brace your hand because it is difficult to maintain the same distance from your surface if you are holding your hand up in the air. If you apply more downward pressure toward your surface, your line will get thicker; if you apply less pressure, the bristles will lift from your surface and you will get a skip in your painting.

Flat: Using the flat edge of your brush means to apply downward pressure so that the sides of the filaments are fully touching the surface. This term can sometimes be confusing because there is also a style of brush called a flat. Any style of brush can be taken down to the flat.

The key to painting down on the flat is to have an evenly-loaded brush and to use even pressure as you pull the brush toward yourself. When you come to the end of your stroke, lift the brush smoothly until you are back to the chisel and then lift directly off the surface. If your brush has blobs on one end or the other, your edges will look wavy. If there is not enough paint on the brush, your paint will skip and look uneven.

 tera tip

No matter how experienced you become, and how long you paint, not every stroke is going to be perfect. Relax! You don't want to be sloppy, but you also don't want to be so rigid that your strokes look stilted and mechanical. The purpose of painting is to beautify, so relax and enjoy the process. If your stroke is not perfect, the next one will be better. That's the way it goes in painting and in life!

Basic Strokes

Although you will learn to turn your brush and add some variations, most strokes employ the flat and its chisel edge to make them. Yes, it's really that simple. So why doesn't everyone paint perfectly? Lack of practice! As a society, we tend to move on to projects before we have mastered the basics. Practicing strokes is not nearly as exciting as painting projects and finishing beautiful designs. However, if you want to become a master painter, taking time to learn brush control now will advance your painting skills greatly and make learning other skills much easier.

Left-Handed Painting

If you are left-handed, do not try to paint the strokes the way they are shown on these pages. I am a right-handed painter and if you copy my strokes, your hand will obscure what you are painting most of the time. You will need to reverse the direction on some of the strokes to make them work for you. If you photocopy them, the strokes will be reversed for you to work from. Take heart! There are many terrific left-handed painters. Just like you have to adapt in a right-handed world for other things, you will have to make some adaptations for painting. It's worth the effort!

tera tip

One of the most common mistakes in painting is to not take the brush fully down to the flat.

This photo shows the brush with full pressure down to the flat. The flat uses the full surface of the bristles to pull the paint, allowing for the widest possible stroke. Some strokes will go fully down to the flat, and then slowly come up to the chisel edge.

Learning to control the downward pressure of the brush toward your surface is the key to good strokework!

The Comma Stroke

The comma stroke can be accomplished with any style of brush. Touch the chisel or tip of the brush against your surface. Put downward pressure on your brush toward the surface, which will create the round head of your comma as the bristles flair out slightly. Pull the brush toward your body, curving gently, and begin to ease up on the downward pressure. As you do this, the line created by the brush will become narrower until you are back to the chisel edge of the brush. Continue to pull the stroke to a fine point.

Don't be frustrated if it takes you a few tries until this feels comfortable. See the examples of typical problems new painters have with strokework on page 151. Inconsistent pressure will cause the line to get thicker, then thinner. Not enough paint on your brush will give you a straggly line. Lifting the brush before you return to the chisel edge will give you a fuzzy ending or an abrupt stop.

Another common problem is turning the brush in your fingers instead of creating the arc in the comma stroke as you would with a pencil. If you have this problem, pull out a pencil and draw a comma shape. You don't need to turn the pencil in your hand because you are drawing the curve. You'll do the same with your brush. Don't make this stroke harder than it needs to be!

FLAT BRUSH

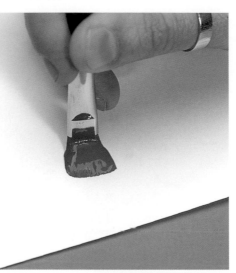

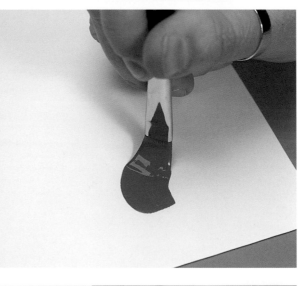

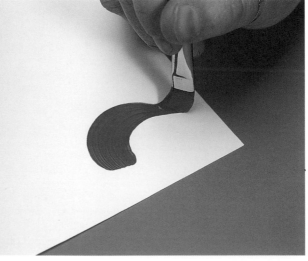

 tera tip

You will need to be able to paint a comma stroke in both directions. If you have a movable surface, simply turn it so that it is facing the right direction for your stroke. One direction will inevitably feel easier to pull than the other but with practice you will easily be able to paint both.

ROUND BRUSH

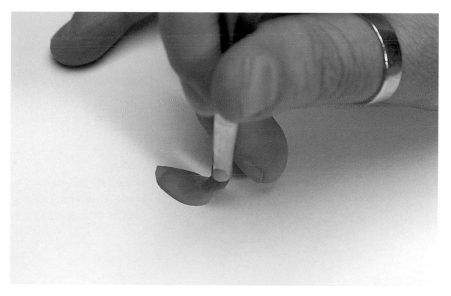

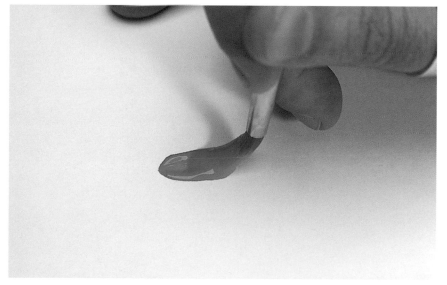

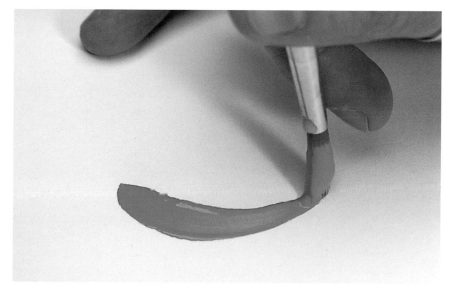

The Comma Stroke, *continued*

LINER BRUSH

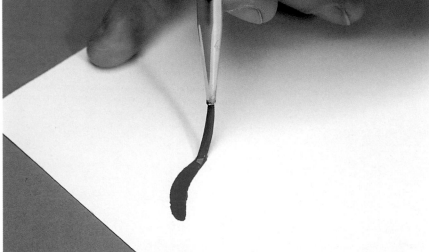

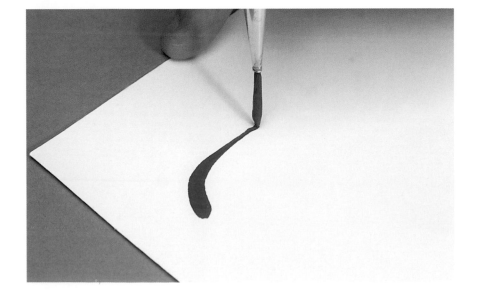

WHAT DID I DO WRONG?

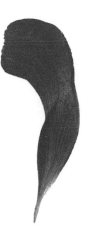

Inconsistent pressure

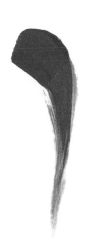

Not enough paint

Fuzzy ends

Abrupt stop

Turning the brush in your fingers

The Teardrop Stroke

There are two ways to paint a teardrop stroke. Shown here is essentially a straight version of a comma stroke. You can also paint this in reverse by starting with the chisel and then increasing pressure until you have the rounded teardrop. Practicing both will enable you to gain greater brush control.

Keeping your brush handle perpendicular to the surface, apply downward pressure to bring your brush to the flat. The hairs will flair out slightly to form the head of the tear drop. Pull the brush toward your body, gradually decreasing the downward pressure to bring the bristles to a chisel point.

To paint a Norwegian teardrop stroke, start with your brush at the chisel edge or point. As you pull the brush toward you, gradually increase pressure until your brush is down to the flat at the desired length. With the brush at the flat, stop and then lift the brush handle straight up to bring the brush to the chisel or tip. By doing this, the tip should end in the middle of the fat part of the teardrop.

LINER BRUSH

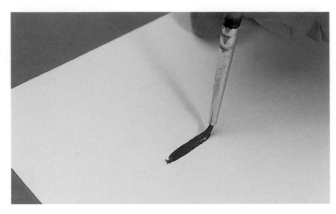

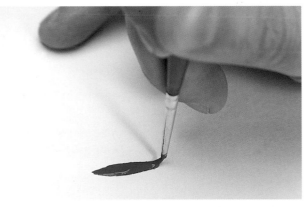

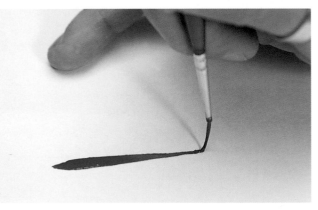

ROUND BRUSH

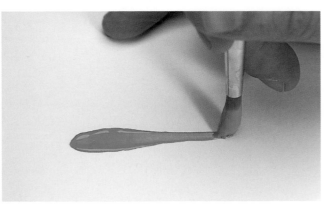

The S-Stroke

One of the most beautiful strokes is the S-stroke. As a beginner, this may seem intimidating, but since you already know how to write an S, painting it is just as easy. The only difference is the downward pressure you put on the brush, which you don't need to do with a pen or pencil.

Start with the brush at the chisel or tip and the handle perpendicular to the surface. For a flat brush, you will need to start it at an angle to correspond with the angle of the top of your S. The curve of the S-stroke is much more subtle than the letter S, which makes it easier to paint. When painting the S, your format is chisel, flat and then chisel. This means that you start with no downward pressure on the brush. It should be resting lightly on the surface to paint a thin line. As you begin the wide part of the S, apply downward pressure, bringing the brush to the flat. Gradually ease the downward pressure on the brush as you slide the bristles over to end with a thin line.

FLAT BRUSH

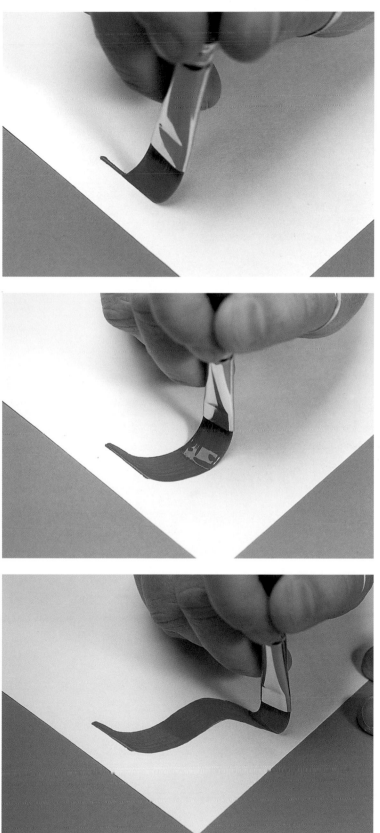

The S-Stroke, *continued*

ROUND BRUSH

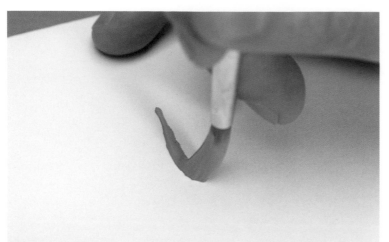

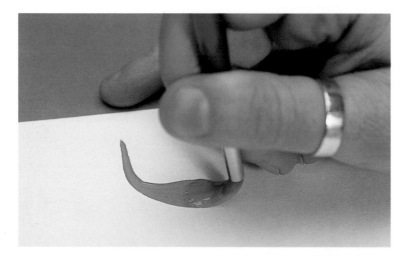

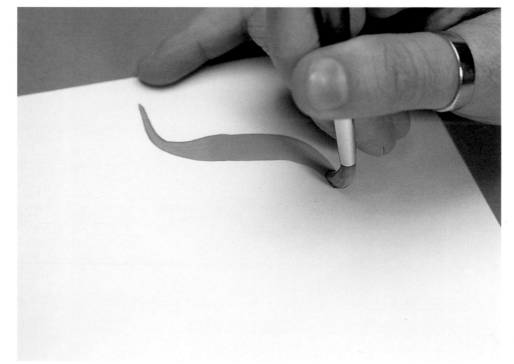

LINER BRUSH

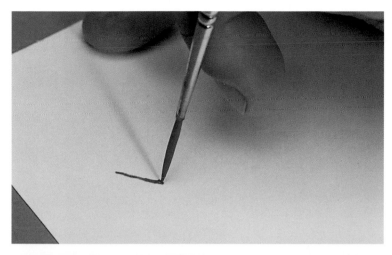

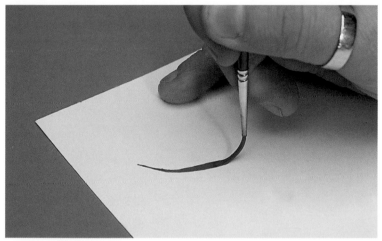

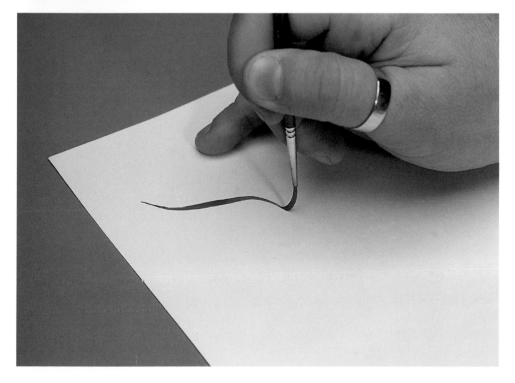

The C-Stroke

The C-stroke is another chisel-flat-chisel stroke. This stroke is sometimes called a U-stroke when it is turned on its side. Start with the brush on its chisel edge and pull to the left. When you get to the point where you are ready to begin the fat curve, begin applying downward pressure and pull the brush toward your body. Begin to ease the downward pressure on the brush as you reach the bottom and curve back around to the right until the brush is back to its chisel edge.

The most common mistake with this stroke is putting downward pressure on the brush too soon or not finishing the stroke to the chisel edge. As you paint, think "chisel-flat-chisel" to remind yourself that you need to ease up on the pressure and start and end with the thin line that creates the top and bottom of the C.

FLAT BRUSH

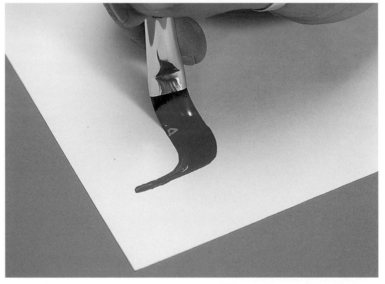

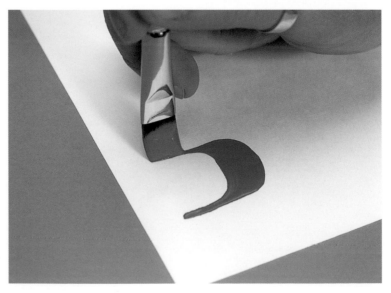

ROUND BRUSH

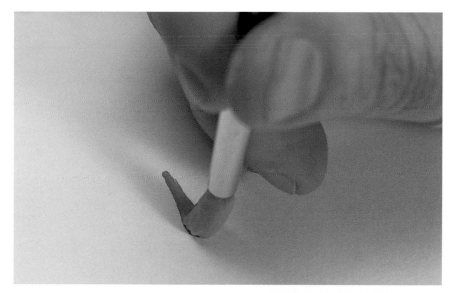

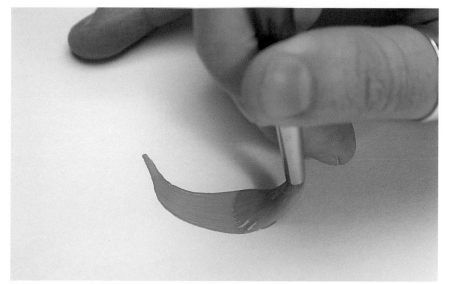

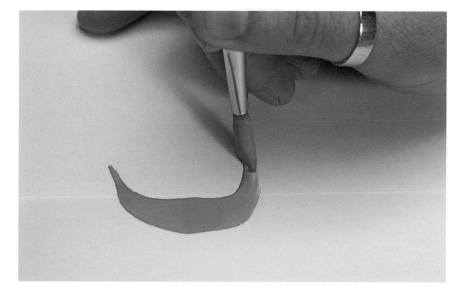

The C-Stroke, *continued*

LINER BRUSH

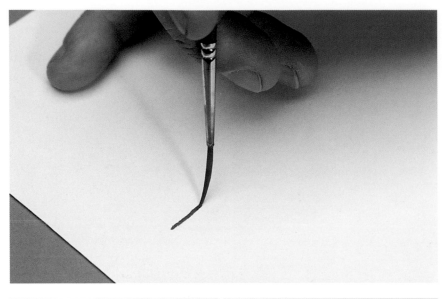

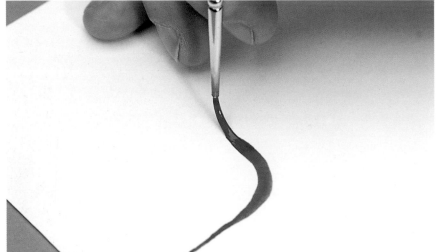

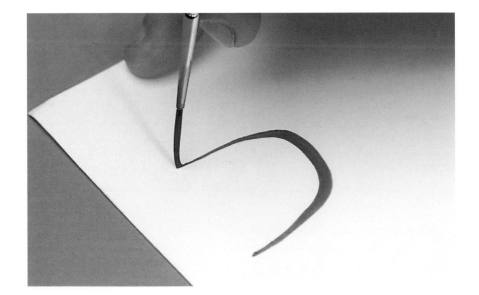

The Z-Stroke

There are dozens of strokes that you can learn, and you can make up a few of your own! The Z-stroke, sometimes called the *zigzag* stroke, is a good practice stroke.

This stroke is similar to the S-stroke, but instead of the gradual increase and decrease in pressure to get the gentle curve, you will stop abruptly and go from chisel to flat and then to chisel again when you change directions. This stroke is great for creating borders!

FLAT BRUSH

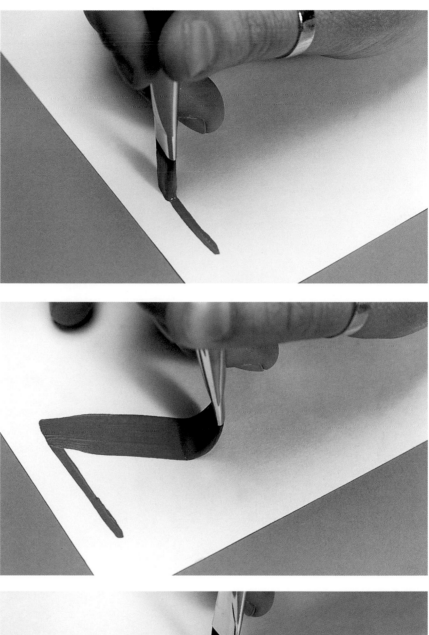

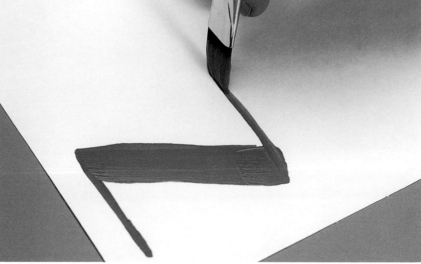

The U-Stroke

You can create variations on strokes by changing elements. This U-stroke is a reverse of the C-stroke. You will paint flat-chisel-flat. Start with your brush on the flat while pulling to the left. Ease the downward pressure on the brush and come up to the chisel, pulling the brush toward your body. Finish the stroke back at the flat.

Using what you have learned about controlling the downward pressure on the brush, you can add other elements for even more versatility.

FLAT BRUSH

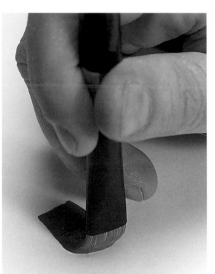
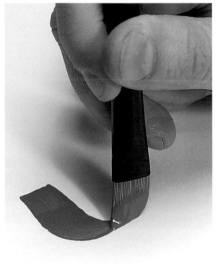
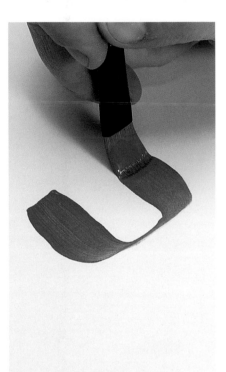

Single-Stroke Leaf

Some strokes include actually turning the brush in your hand as you move it along the surface. Using a flat brush, take the brush down to the flat edge. The splay of the bristles will create the round edge of the leaf. Pull the brush toward you as you ease the downward pressure on the brush, and turn the bristles one-quarter turn until you are back up at the chisel point creating the tip of the leaf. You should start with the bristles pointing to twelve o'clock and end with the bristles pointing to three o'clock.

SINGLE-STROKE LEAF IN ONE COLOR

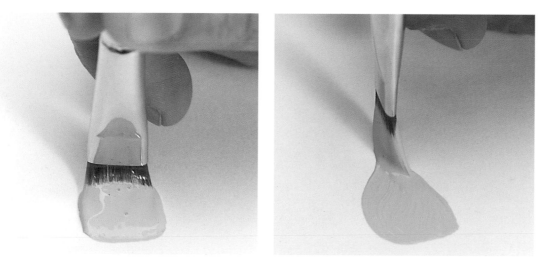

SINGLE-STROKE LEAF PAINTED WITH DOUBLE-LOADED BRUSH

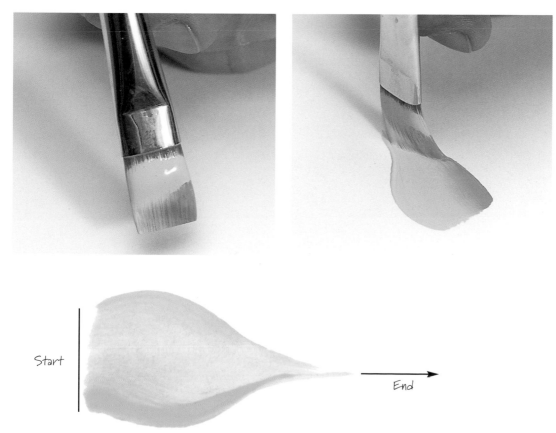

Ribbon Stroke

Ribbon is one of the most popular subjects for beginners. It is easy to paint if you remember to let the brush do the work for you. This technique uses both sides of the flat of the brush. Start at the chisel edge and pull the stroke as you would when painting the S-stroke. Bring the brush down to the flat by increasing the downward pressure toward the sur-

face. When you are ready to curve the ribbon, flip the brush over to the opposite side of the flat and immediately apply downward pressure so that you are back down to the flat immediately. You should not come back up to the chisel in between the two—simply flip the brush over as you move it.

As you paint the ribbon, you can

flip the brush over as often as you like to make the ribbon appear to be curling over. I've used a double-loaded brush in my example because it helps to show the depth of the ribbon. However you can do this with one color of paint and then side load in the shadows where the ribbon flips.

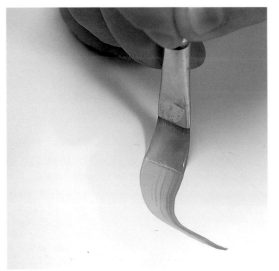

Multiloaded Stroke

You can paint all the brushstrokes shown by loading your brush in one, two or three colors of paint. This makes the techniques very versatile as you will get more than one look out of a single technique! The technique does not change when you double load or multiload your brush.

Create Your Own Strokework Designs

One of the other benefits of learning strokework is that it puts simple design elements into your hands. Using the strokes shown earlier, I have painted a variety of designs. The sky is the limit in your painting!

Create Your Own Strokework Designs, continued

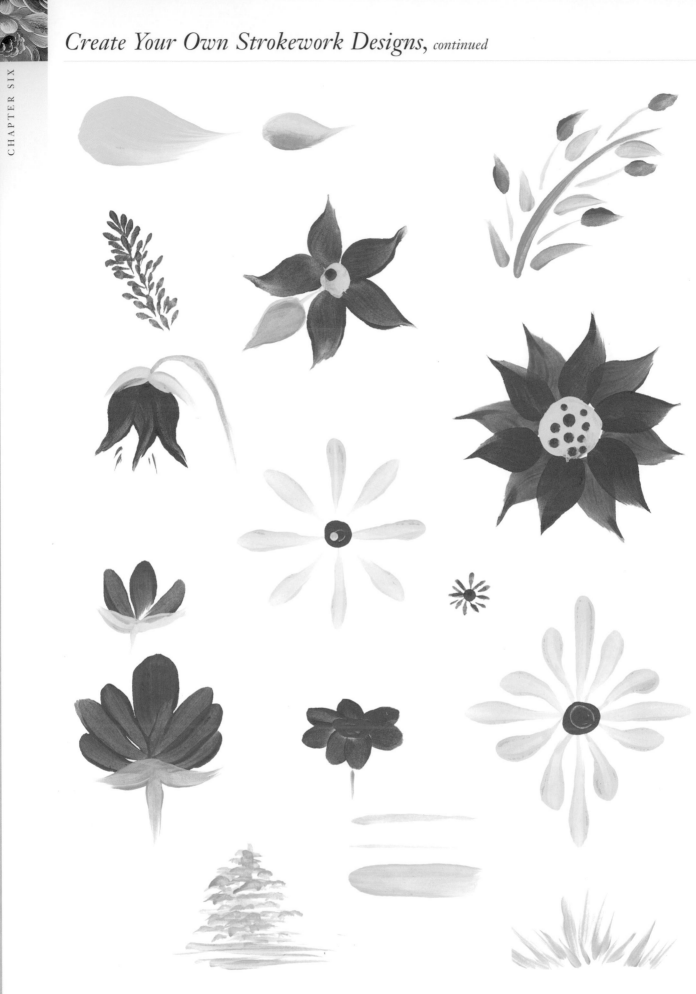

EASY DIP DOTS

Don't forget that the other end of your brush is a useful painting tool as well! The samples shown here are a few ways to incorporate handle dots into your designs. Remember, however, that if the dot is dimensional, it will take longer to dry than the rest of your paint.

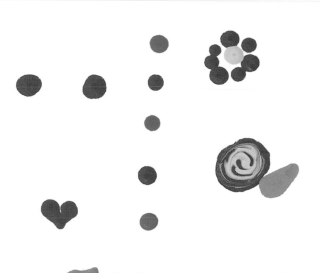

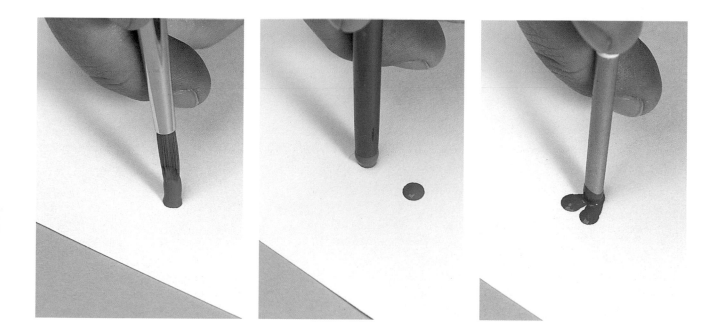

165

Examples of Strokework

TRADITIONAL STROKEWORK

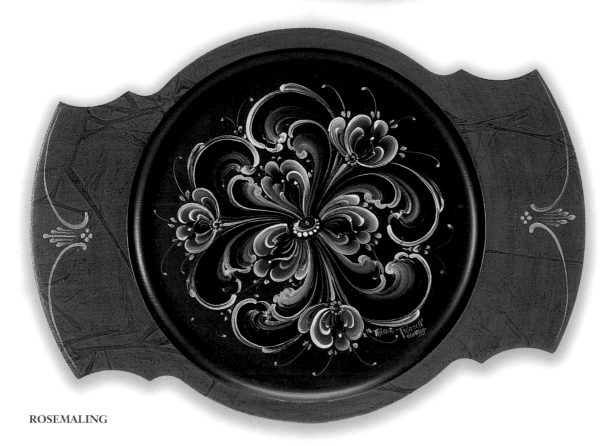

CLASSIC

ROSEMALING

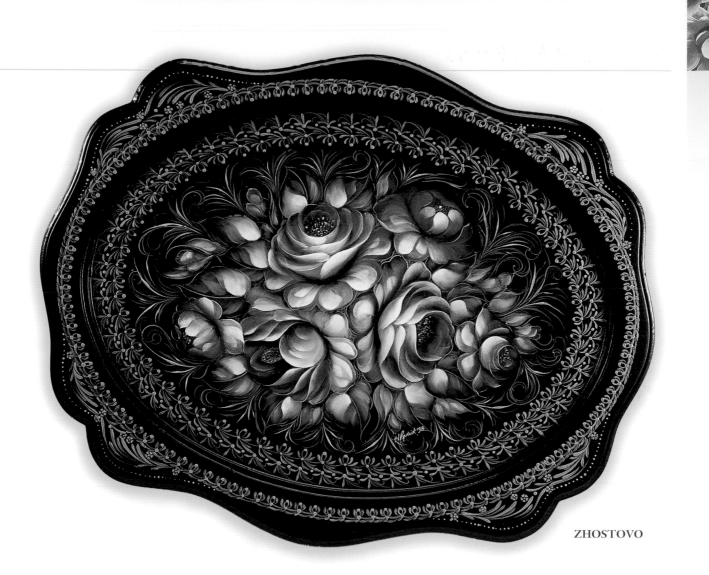

ZHOSTOVO

MODERN
STROKEWORK

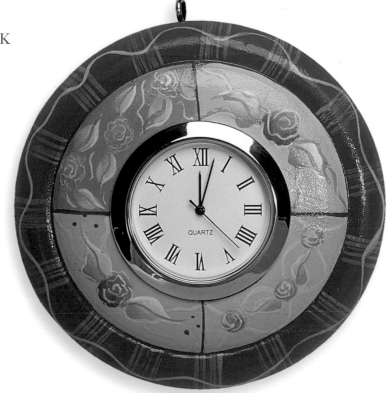

faux finishes

How do I create special finishes?

Faux is the French word for "false" or "fake." A faux finish is a painted fake or forgery of another material such as marble or granite. As you go through this chapter, you will find that many faux finishes can be accomplished through a combination of several basic techniques. The examples here show just one way to get each effect. As you build your painting skills, you will have the opportunity to try other techniques and you should use what works best for you.

There is no exact formula to use in faux finishing. When you paint the techniques in this chapter, you will find that your finished pieces do not look exactly like what is shown.

When you are sponging or spattering colors, it is impossible to get the exact mix on your surface. At this point, you must go back to the very first premise of this book—there is no such thing as "wrong" in painting. Just keep painting until you get it to look the way you want. The more you try, the more you'll learn, the better you'll get.

Sponging

One of the most fun and easy faux finishing techniques is sponging. This is the basis for quite a few more advanced faux techniques and can provide a beautiful background for other painted designs. Different types of sponges provide vastly different looks. The stiffer and coarser the sponge, the more distinct the pattern. Softer sponges provide a smoother, more refined pattern.

Sponging can be done with a single color or a variety of colors over a solid basecoat or raw surface. For a soft look, choose colors that are close to one another on the color wheel or different shades of the same color. For a more distinct pattern and greater contrast, mix colors and intensities. Always work with a damp, not wet, sponge.

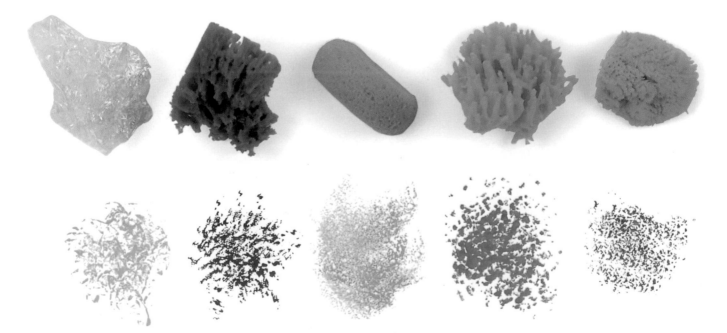

TERA'S SPONGING TECHNIQUE

This technique is my variation on traditional sponging. I work with all the colors at once and use a glaze base to extend the drying time on my palette. A glaze base is similar to an extender. It will slightly thin the paint while slowing the drying time so that you have more time to work with the paint. I load all the colors onto my sponge at the same time because it is faster, and because I find it easier to get an even mix of colors on my finished piece for a basic background.

Dip your damp sponge into the swirl of paint and glaze until you have loaded a wide area of the sponge with the mixture. To load your sponge, dip it in the paint mixture, then "pounce" the sponge up and down on a different part of the palette. This lets the paint absorb into the sponge and works out any blobs of paint. Do not over-work the paint into the sponge or you will blend it all together and get a muddy colored mix instead of the distinct colors represented on the palette.

tera tip

If you are doing it right, your hands are going to get paint on them. If that bothers you, use lightweight surgical gloves to protect your hands. They are available at most hardware or beauty supply stores.

After you push your sponge down on your surface, you should spin it in your hand before you push down again (push, lift, turn, push, lift, turn, etc.). This ensures that a different part of the sponge touches your surface each time and prevents you from getting a repeated pattern that will detract from the overall design. When you sponge, you should press down and lift. Do not wipe or blend with your sponge or you will not get the mottled effect sponging provides.

The amount of pressure that you apply when you push your sponge down to the surface will affect the size of the pattern. Practice a few times on your palette to see what you like best. Generally, a light pressure will give a more distinct, lacey look; a heavier hand will soften and smash the pattern together.

If you find that your sponged surface is a bit too spotted and distinct, use a dry mop brush and pounce it in an up-and-down motion along the surface. The glaze base allows you to work on the surface for a longer period of time to lightly blend the colors together. As with your sponge, you should spin the mop brush each time you hit the surface to avoid getting a pattern from any paint lifted from the surface.

Marbleizing

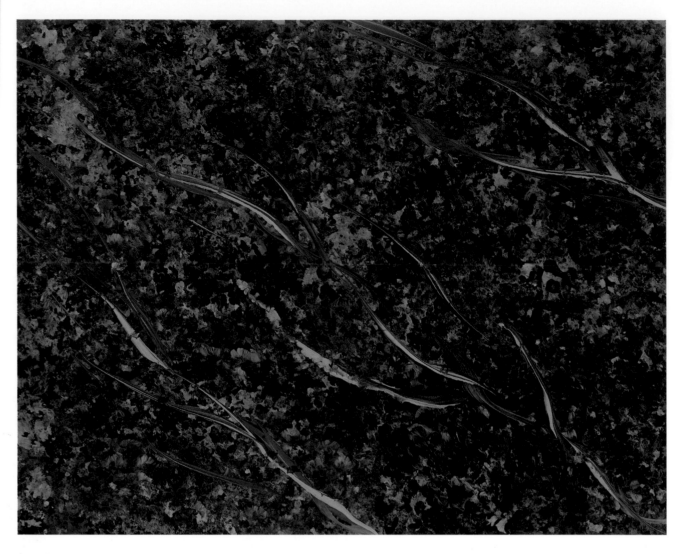

Cracks in marble are formed by the movement of the earth, so the cracks are usually roughly parallel. When the lines do cross, they are usually not at extreme angles. Move your brush or feather with a shaky hand. You may find it easier to hold your brush like a bow over a violin, pulling it in a single direction.

This technique shows you how to sponge one color over another wet-on-wet—applying the next color before the first color has dried.

MARBLE FORMULAS

GREEN MARBLE

Delta Ceramcoat
Black Green
Woodland Night
Alpine Green
Oasis Green

Plaid FolkArt
Wrought Iron
Hunter Green, Shamrock
Poetry Green

DecoArt Americana
Black Green
Deep Teal
Arbor Green
Green Mist

BLACK MARBLE

Delta Ceramcoat
Charcoal
Black
Williamsburg Blue
Cadet Grey

Plaid FolkArt
Wrought Iron
Licorice
Settlers Blue
Dapple Gray

DecoArt Americana
Charcoal Grey
Lamp Black
Williamsburg Blue
Dove Grey

PINK MARBLE

Delta Ceramcoat
Rose Mist
Candy Bar Brown
Normandy Rose
Antique White

Plaid FolkArt
Potpourri Rose
Apple Spice
Sedona Clay
Tapioca

DecoArt Americana
Mauve
Rookwood Red
Dusty Rose
Buttermilk

WHITE MARBLE

Delta Ceramcoat
Antique White
Cadet Grey
Nightfall Blue

Plaid FolkArt
Tapioca
Dapple Gray
Denim Blue

DecoArt Americana
Buttermilk
Dove Grey
Uniform Blue

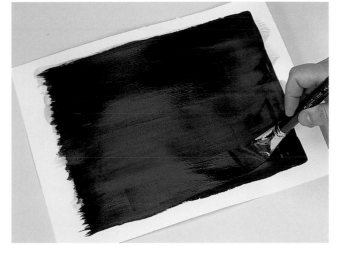

For marble, I prefer to use a firmer sponge to produce a more distinct pattern. Basecoat your surface in a solid color, then load your damp sponge with your first color.

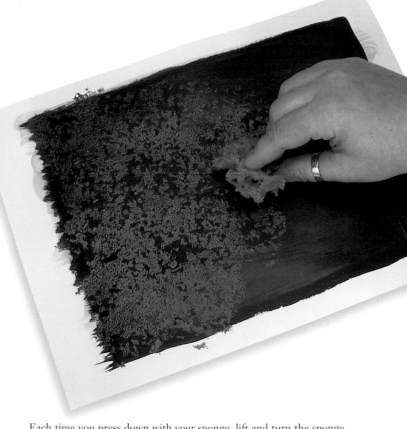

Each time you press down with your sponge, lift and turn the sponge, then press down again. Reload the sponge with paint as needed until you have covered the entire surface. Make sure that you keep a sponge effect—the background color should show through.

Marbleizing, continued

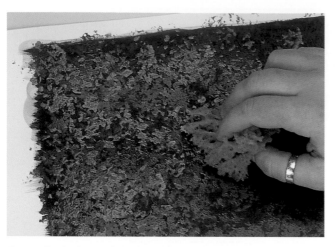

For a softer look, simply load your sponge with the next color and continue. For a more distinct coloration, or if you are using very different color values, wash the sponge and start again.

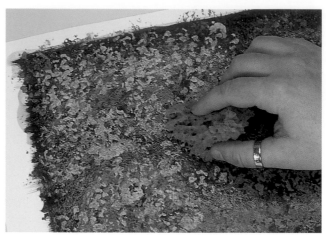

Your sponge should be damp but not wet. For each successive color, add a bit of clear glazing medium or extender to your paint to extend the drying time as you blend color into wet color.

You want the colors to layer over one another, but not to obliterate the color beneath.

Veins may be applied with a feather, dagger brush, liner brush or even the chisel edge of a flat brush.

Keep a loose hand and work both sides of the feather or brush to keep an uneven line. If you want to soften the color, thin your veining color with a bit of clear glazing medium or extender.

If the lines are too distinct from the background, go back in with your sponge and the basecoat color mixed with clear glazing medium or extender, and lightly pounce here and there to soften the lines.

Marbleizing with Plastic Wrap

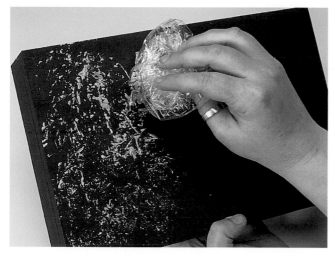

An alternative to using a sponge is to use plastic wrap to pounce paint on your surface. Crumple a sheet of plastic wrap into a ball and use it like a sponge. You will find that you get a distinct pattern with this method.

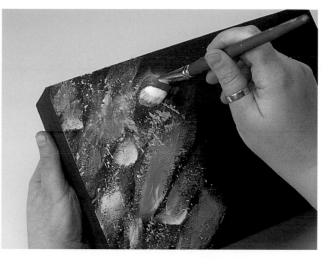

Plastic wrap can also be used for a soft marbled look. Start with a dark background color, such as a dark charcoal gray. Coat your surface with an extender or Kleister medium, or mix it in with your paint. With a soft brush, apply two or three contrasting colors, such as a softer gray, black and white, in a mottled pattern.

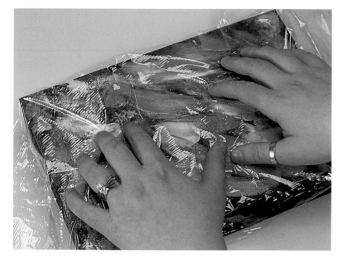

Lay a piece of plastic wrap that is slightly larger than the size of your surface over the top of the paint while it is still wet.

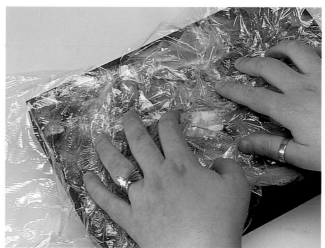

Crumple the plastic wrap, pushing it into the wet paint and letting it sit for a moment until the paint feels tacky. Do not let the paint dry with the plastic wrap on it.

Slowly lift the wrap from the surface. You should have a soft blend of colors on your surface.

tera tip

If the colors on your design are too distinct, wait until the paint dries thoroughly and then apply the paint and extender again using less paint. You can also blend some of your original basecoat color for a softer look.

Lapis Lazuli

A technique that is similar to marbleizing but adds the new skill of glazing is the beautiful lapis lazuli. For this technique, I used a crumpled paper towel to "sponge" my colors on the surface. You can also use a regular sponge or plastic wrap. When working with a paper towel, do not dampen it first. Keep working the towel in your hand so the part that touches the surface is crumpled and textured. Cheaper and rougher paper towels tend to work better.

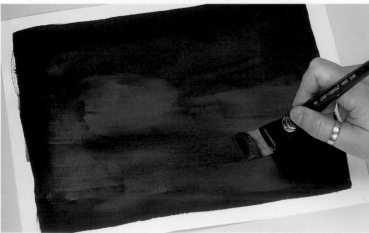

Start with a basecoat of solid black.

As with our first sponging technique, swirl two colors of paint on your palette to load two colors at once. Using *Delta Ceramcoat* Phthalo Blue and Midnight Blue, rotate the towel each time you press down so that you don't get a repeating pattern.

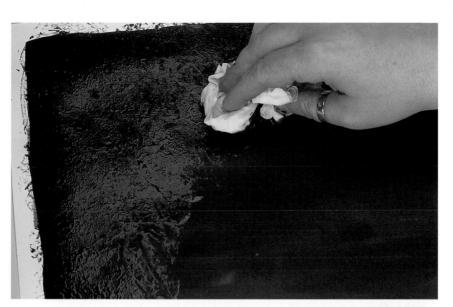

When you switch colors with this technique, do not go to a clean towel. Using the same dirty towel, dip into Oyster White and add highlights here and there. Once again, rotate the towel and make sure it remains crumpled in your hand.

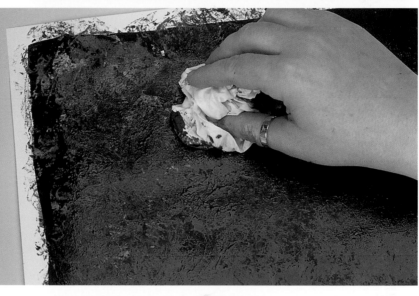

Any time you add a contrasting color like white over a dark surface, it will be very extreme. To soften, use the same dirty towel and touch back into the black basecoat color. Go in over the white to soften all the colors. Since you are using a dirty towel, all of the colors will remain on the towel and blend together.

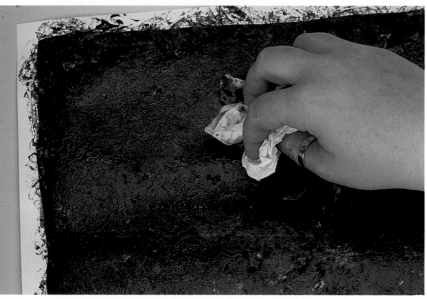

Lapis Lazuli, *continued*

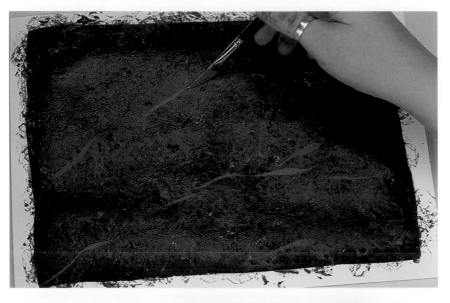

Lay in vein lines in Oyster White mixed with water to an inky consistency. As with the marble, the lines will be roughly parallel and uneven. If the lines are too bold, you can sponge back in over the lines with your dirty towel, as you did with the marble vein lines.

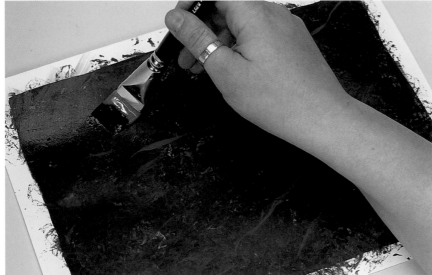

The final step for the lapis lazuli technique is glazing. Glazing is applying a sheer coat of color over your surface. I used *Delta's* Clear Glaze Medium with Phthalo Green and then Purple.

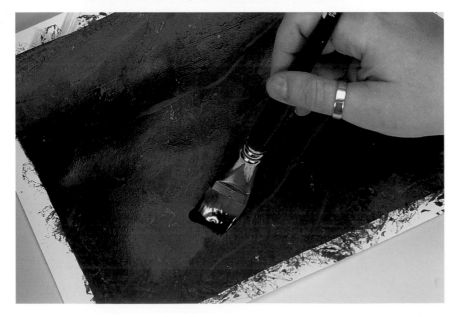

In this technique, each color should be distinct in small areas. You are not going to cover the entire surface, but merely place a hint of color here and there on the surface. When using a glaze, you want to mix at least eight parts glaze to one part paint. This is a very sheer, light touch. For a final touch on your lapis lazuli design, you can lightly spatter gold over the surface. (Learn more about spattering on page 200.)

Fresco

Sponging can also be used to remove paint from your surface, creating a beautiful soft effect. In this technique, we will glaze colors on the surface and then use the sponge to remove the majority of the color. The resulting finish is a delightfully soft texture.

Start by basecoating your surface in *Delta Ceramcoat* Light Ivory, then apply a thick layer of clear glazing medium. You want to have an extended drying time for the paint on your surface, so use enough glazing medium that you can work with the paint to apply it and then sponge it off. When you do this technique, work in small areas and overlap the edges as you move on to the next section.

Fresco, continued

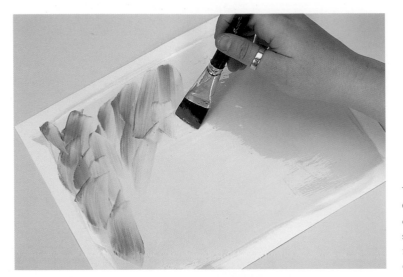

With a wide brush, apply random patches of Terra Cotta, Golden Brown and Straw. You will want some areas to be distinctly more one color than another. Apply this in a slip-slap or scumble fashion. This means to use the full flat of both sides of your brush to apply paint in a random pattern.

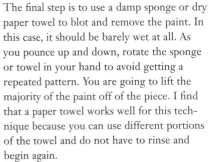

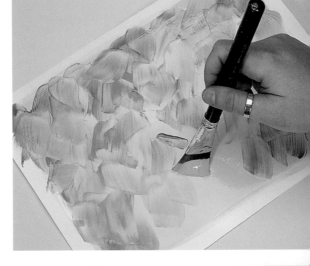

The final step is to use a damp sponge or dry paper towel to blot and remove the paint. In this case, it should be barely wet at all. As you pounce up and down, rotate the sponge or towel in your hand to avoid getting a repeated pattern. You are going to lift the majority of the paint off of the piece. I find that a paper towel works well for this technique because you can use different portions of the towel and do not have to rinse and begin again.

If you remove too much paint, wait for the paint to dry, go back in with more glazing medium and paint, and then sponge again to remove the excess. You can do as many layers as needed for the results you want as long as you let the paint dry in between. Your finish should be textured and soft, allowing both the background color and each of the glazed colors to show on the surface.

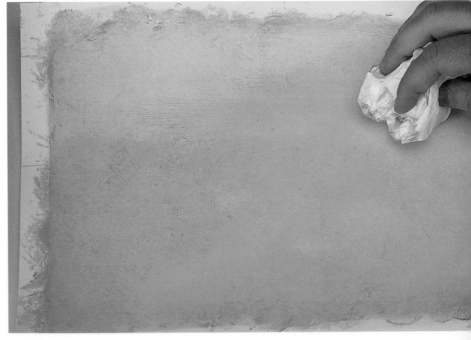

Granite

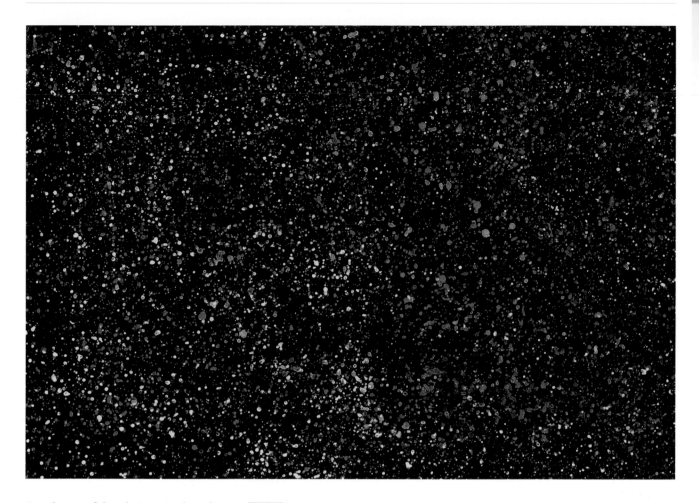

Another useful technique in faux fin-ishing is spattering, also known as fly-specking, flecking, specking and sometimes splattering. There are many tools available to get just the right touch. I will demonstrate several in this chapter. As always, I recommend that you try each tool and use the one that works best for you.

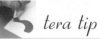
tera tip

No matter which tool you use, practice with it on paper before using it on your surface. This allows you to test the consistency of your paint, the distance from your surface and your technique with the tool of your choice to make sure it is producing the results you desire.

Granite is a fast and easy project, but all spattering can get a bit messy, so be prepared. I prefer to do larger spattering projects outside or in the bathtub so that it is easy to clean up with a hose. If you are spattering inside, you may want to cover your painting table with a plastic tablecloth and move anything you don't want spattered out of the way. As you become more experienced with spatter-ing, you will get better at controlling the spray, but even the most experienced painters are occasionally surprised.

Granite, continued

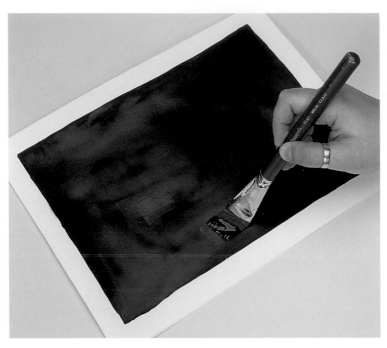

The key to painting granite is a fine, even mist of spatters on your entire surface. Start with a smooth basecoat of DecoArt Americana Lamp Black.

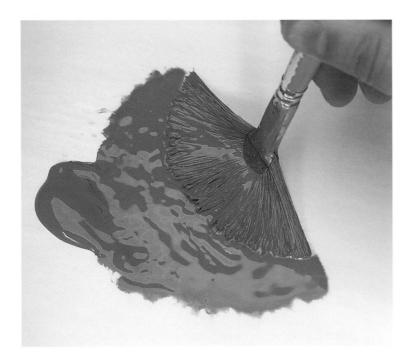

I used a fan brush for this technique. To spatter with a fan brush, create a pool of paint thinned with water on your palette. Wiggle the fan brush back and forth in the paint so there is paint loaded throughout the bristles.

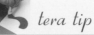 *tera tip*

TO BLOW-DRY OR NOT TO BLOW-DRY? Many painters use a travel hair dryer in class or in their studios to hurry the painting process. Keep in mind that blow-drying adds a new component to your painting—heat. Some surfaces, slate, for example, hold heat very well and may take a while to cool. Others may contract or expand with the heat. Heat may also temporarily change the properties of some products you are using. It is important to be familiar with the products and surfaces before using a hair dryer on your painted surface. You may find that forcing the drying process with heat causes some products to crack or crackle. Be sure to test a small area of your project before you apply heat to the entire surface. I also recommend that you do it in a well-ventilated area in case the heat releases fumes. If you are impatient, try working on more than one piece at a time. While you are waiting for a project to dry, you can be tracing, basecoating or painting another project during breaks.

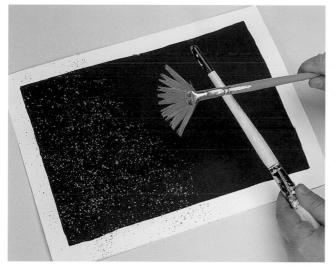

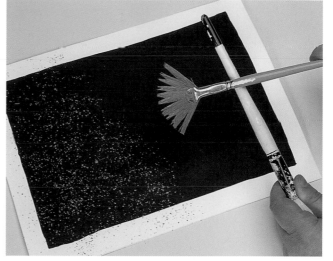

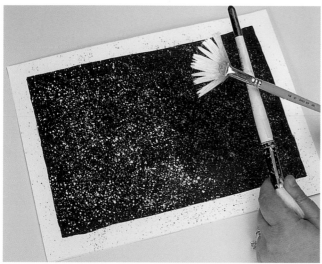

Using the handle of another brush perpendicular to your fan brush, strike the handle of the fan brush just below the ferrule and down toward your surface. This will create a fine spray of paint along your surface. If you are getting spatters that are too large or watery, you probably have too much paint loaded in your brush. Simply blot your bristles on a towel and try it again. You will have to reload your brush as the paint is applied to the surface.

tera tip

A fine spray of a clear matte varnish will seal your surface and allow you to wipe your spatters off if you do it quickly. Use a baby wipe to remove the paint. If you are trying to spatter just one area next to an area that you don't want spattered, you can cover it with paper or apply a thin coat of extender over the area. The extender will keep the spattered paint wet and allow you to wipe it off the areas you don't want spattered.

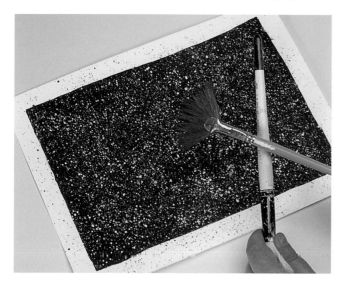

Allow the paint to dry between colors or the wet colors may bleed into one another. You will need to rinse your brush when you change colors for spattering. Continue to spatter your surface until you get the mix of color that looks right to you. When working with the fan brush, you can experiment with alternative techniques, such as turning the bristles of the brush vertical to the surface or holding the fan brush still and striking the handle with the other brush. Each slightly changes the result. Use what works best for you!

Rust

Rusted finishes have recently gained popularity as more rustic designs gain favor. The mix of colors in rust makes it a beautiful contrast for many painted designs. This technique shows you how to paint rust step-by-step. There are now products on the market that will allow you to apply a metallic base to any surface and then chemically rust it. Technically, this is not a painted finish, so it is not shown here but it is a tool you should be aware of.

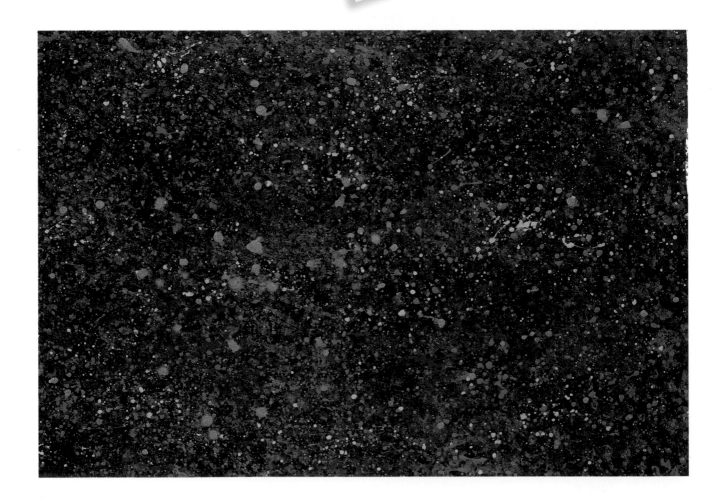

Start with a base of *Delta Ceramcoat* Burnt Umber.

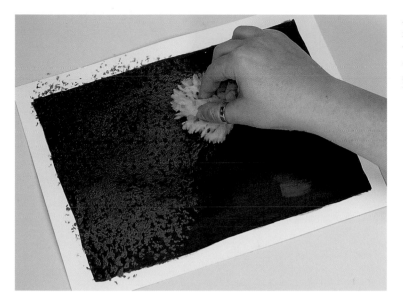

As shown in the marbling technique on page xx, sponge successive layers of color starting with Burnt Sienna. Use a dirty sponge with each color and pounce while the last color is still wet. Rotate the sponge in your hand in between pounces.

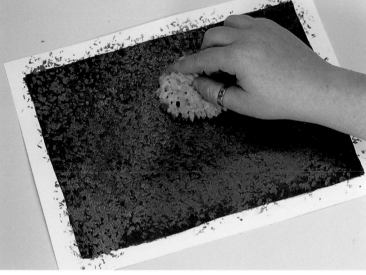

Sponge on Raw Sienna.

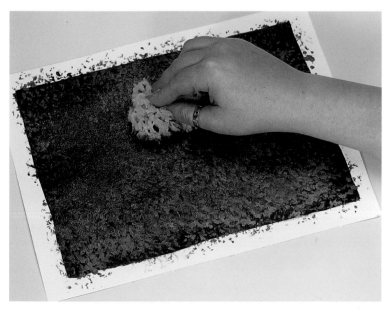

Then lightly sponge on the basecoat color of Burnt Umber to bring back contrast if needed.

Rust, *continued*

Using an old toothbrush as a spattering tool, spatter on Burnt Umber.

Without letting the previous color dry, spatter on Burnt Sienna.

tera tip

Load a toothbrush as you would a fan brush; mix the paint with water to an inky consistency. Keep your brush moving so you don't get too much paint in a single area—you want to have an even spray of paint across the surface. To spatter with a toothbrush, move your finger or a palette knife across the bristles, pulling them toward your body. This will send the spray of paint away from you and onto your surface.

Without letting the previous two colors dry, spatter on Raw Sienna. The colors should blend together.

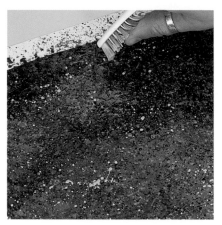

Next, spatter on Maple Sugar Tan.

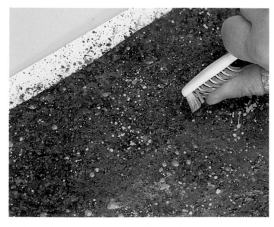

And finally, spatter Metallic 14K Gold.

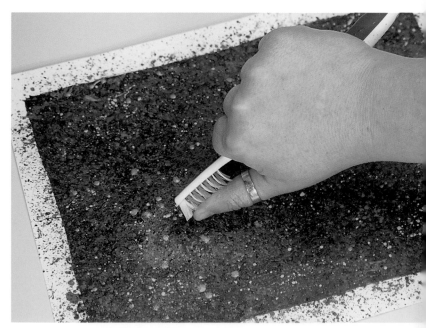

For the colors to truly blend together, spatter a fine mist of water.

Stippling

An alternative to sponging is stippling. Stippling can be done with a variety of brushes from large to small. Like sponges, the different kinds of brushes create different patterns. The softness or stiffness of the bristles and the pressure you use when pouncing down on the surface also affect the pattern. As with sponges, you will need to rotate the brush in your hand each time you pounce to vary the pattern on the surface.

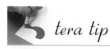 *tera tip*

There are many brushes made expressly for stippling, but you may find that an old scruffy flat brush is a great standby.

In addition to faux effects like stucco, the stippling technique is used to paint hair and fur. Smaller, tighter brushes are excellent for painting shrubbery and flowers.

Stippling is generally a dry brush technique, so do not dampen your brush before you load it with paint. Start by pouring a small puddle of paint on your palette. Holding your brush perpendicular to the palette, pounce your brush directly into the pool of paint and then pounce it on a clean section of the palette. For this technique, you should have very little paint on your brush or you will get blobs of paint, not a definitive pattern, on your surface.

Donna Dewberry
scruffy brush

Ronnie Bringle
blender brush

Winsor & Newton
deerfoot stippler

Fan brush

Pat Wakefield
Bette Byrd
deerfoot stippler

Debbie Mitchell
stippler

Stucco

As trompe l'oeil and European arts become more influential in North America, techniques to create "Old World" finishes are more in demand. This technique quickly produces the look of stucco and works well with trompe l'oeil designs, such as cracked walls, brick, etc.

Stucco is painted with a stippling technique using a dry mop brush. A mop brush looks a lot like a cosmetic brush with a full head and long, loose filaments. Unlike a typical stippling brush, the hairs of the mop hold more paint. This produces a fat, loose pattern on your surface.

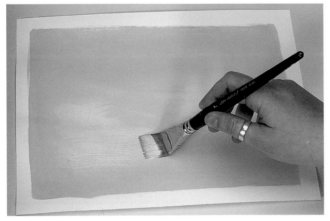

Begin with a basecoat of *Plaid FolkArt* Sunflower.

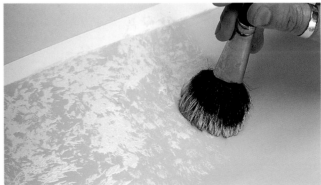

With a dry mop brush, stipple Tapioca in a loose pattern over your surface. Remember to rotate your mop brush in your hand between each downward pounce. Since the bristles of the mop are long, use a very light downward stroke. Do not smash the bristles into the surface. You should get a light and lacey effect from this technique. Wash your brush immediately after stippling to prevent the paint from drying in the bristles.

With a wide, flat brush, mix Buttercrunch with *FolkArt* Blending Gel, then apply it to the surface in a random slip-slap pattern. You should have some sections that are darker, while leaving other sections the original color. This provides depth and texture to the surface. Remember that your glaze should be transparent so that you can see the texture and pattern below.

With a dry mop brush, stipple the surface again with Tapioca to strengthen the lighter areas. (You can gently blow-dry the long mop bristles or blot the bristles until dry.) Do not stipple over the glazed areas. Concentrate on providing contrast to the lighter areas.

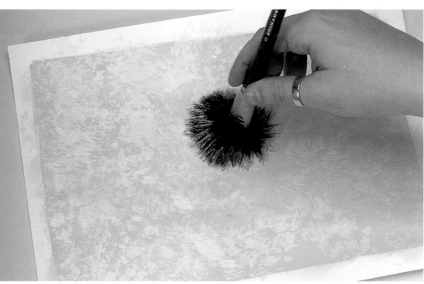

The final step is a heavy spatter of Titanium White over the entire surface. Titanium White is a brighter white than Tapioca and provides the stucco texture. You can use any tool to spatter. The *Loew-Cornell* spatter tool is shown here. Load the tool with Titanium White mixed with water to an inky consistency. Push the wire into the bristles and turn the wood base. Be sure to move above the piece so that you do not get a heavy concentration of spatters in any one place.

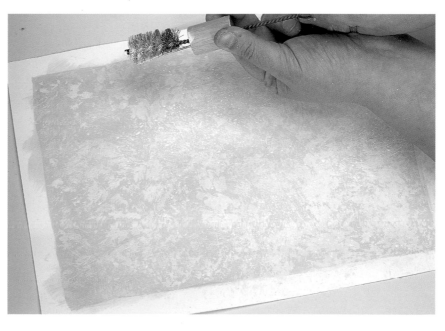

Drybrushing

Drybrushing is used for many effects in painting. As its name suggests, this technique is done with paint loaded on a dry brush. Generally, drybrushing is accomplished with stiffer bristle brushes so that the bristles can create texture on the surface. Smaller bristle brushes can be used to place highlighting and shading for depth in your painting. In the verdigris technique, we will use a large fan brush to achieve a metallic texture effect.

Filbert brush

Rake brush

Fan brush

Verdigris

There are many techniques for painting verdigris. The technique shown here is my favorite, and I have found that it creates a very realistic look. You will paint the copper-colored layer before adding the greenish-colored corrosion typical of verdigris.

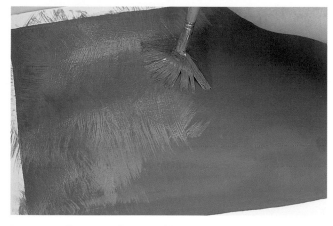

Begin with a smooth basecoat of *Plaid FolkArt* Terra Cotta. A large fan brush is used here. The fan brush has a stiff bristle that gives a distinctive scratchy pattern.

Using a small amount of Pure Gold on your dry brush, apply a random pattern on your surface. Rotate the brush in your hand so that each stroke goes in a slightly different direction.

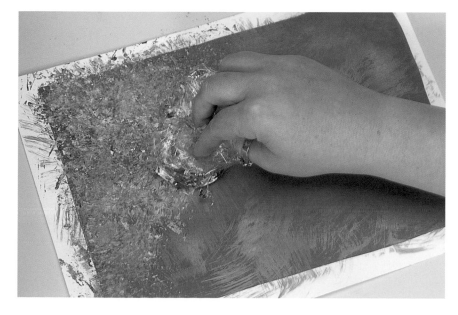

With plastic wrap, a sponge or a crumpled paper towel, swirl blending gel on your palette with Phthalo Green, Poetry Green and a small amount of Icy White as shown in the sponging demonstration. With all three colors loaded on your brush, sponge the surface, allowing the background to show through in some spots while covering the entire surface in others. Remember to rotate the sponging tool in your hand between each downward pounce to avoid a repeated pattern.

Leather

This technique combines stippling and drybrushing with some unusual products for a textured effect. This is a great example of how a bit of experimenting can produce wonderful results.

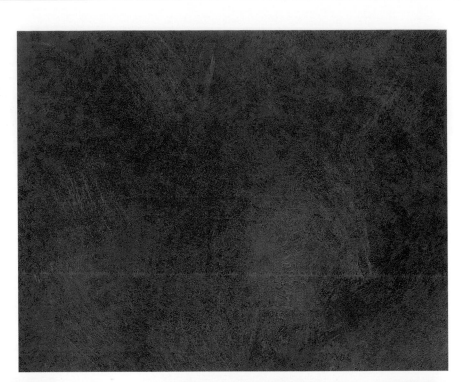

Begin by basecoating the surface with *Delta Ceramcoat* Black.

On your palette, mix a puddle of Raw Umber with texture medium. With a dry mop brush, load your brush by pouncing into this mixture. To avoid getting blobs of paint, pounce on your palette to remove some of the paint before applying it to the surface. Be sure to rotate the brush between each downward pounce. Let this dry.

On your palette, mix a puddle of Burnt Sienna with clear glazing medium, and a separate puddle of Raw Sienna with clear glazing medium. With a dry mop brush, load one side of your brush in each mixture. Pounce your brush on the palette before applying it to the surface in order to avoid getting blobs of paint. Be sure to rotate the brush between each downward pounce. When reloading the brush with paint, watch to be sure that you reload the correct side with each paint color.

Once the glaze has dried, use a fan brush to drybrush Metallic 14K Gold in a random pattern. If the gold is too intense, add water to thin the paint, then blot your brush on a paper towel before applying it to the surface. This is a soft, light application of color. It should not cover the colors beneath, but should be used sparsely to accent the texture.

Using a dry mop brush, stipple satin varnish over the top of the dry painted surface. The varnish will provide additional texture that creates the appearance of the leather.

Smoking

This unusual technique produces a beautifully mellow result. Since it requires you to work with chemicals and fire, be sure to follow common-sense safety precautions. Work in a well-ventilated area and keep any open flames away from flammable materials.

Begin by basecoating your piece with your medium value neutral color. In the example, I used *Jo Sonja*'s Oyster. This technique will work over sand, pink, light green or almost any medium value color. The smoke will be dark gray or black over the base color.

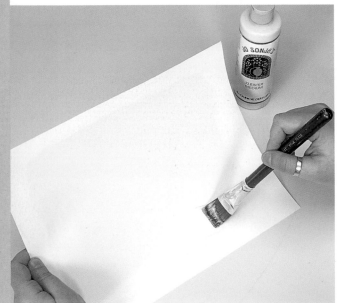

Over the dry basecoat, put an even coat of *Jo Sonja*'s Kleister medium. The Kleister medium will catch the smoke and hold it to the surface.

To provide the smoke, you will need a candle with a medium-to-fat wick. Be sure not to buy a smokeless candle! Less expensive candles tend to provide more smoke. You can also use a kerosene lamp with a one-inch wick—just be sure to keep the flame away from your surface.

Hold a kitchen or palette knife into the flame. As carbon builds up on the knife's edge, it will begin to produce smoke. If possible, keep the candle in a holder on your table and move your piece over it. For furniture and larger pieces, you will need to move the candle. The marble pattern is developed through a combination of the movement of the knife through the flame and the movement of the piece.

For larger pieces, a small fan set on low can be placed nearby. The trick is to direct the smoke without dissipating it into a blur. You may find that simply blowing toward the smoke is enough to help direct it onto your piece. If you get too much smoke, dab

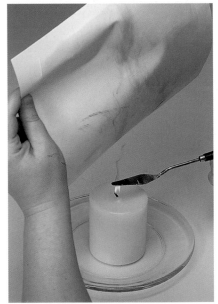

a paper towel over the surface to blot. The Kleister medium will allow you to wipe the surface clean and start over if you are unhappy with the results. Let this dry well, apply the Kleister medium and begin the process again.

Once you have the pattern you desire, let the Kleister medium dry well. You will then need to spray the surface with a clear sealer, such as Krylon. This will set the smoke into the piece. Until it is sprayed, the smoke will be a powdery residue that can easily be smeared if touched.

specialty techniques

How do I antique, crackle & distress?

As a painter, you have an entire arsenal of specialty techniques available to help enhance your painting designs. In this chapter, I'll show you how to use these basic techniques to age, distress and create unique textures on your surfaces. With new products on the market, these techniques have never been easier!

Antiquing

As the name suggests, antiquing is a faux finishing technique that creates the appearance of age on your piece. Antiquing is the same as glazing, whitewashing, pickling and other similar techniques in terms of how you apply the color. You apply a transparent coat of color over a piece to add emphasis to the design or structure. Whitewashing and pickling are generally done before detail is added to your piece. Glazing and antiquing are done after your design is painted to tone the color or, in the case of antiquing, to simulate age. Some designers call for you to antique the piece before and after you apply the design. Antiquing mediums, like glazing mediums, thin

the paint and slow the drying time so that you have more time to work with them. Keep in mind that the purpose of antiquing is to make the piece look older. You should place your darkest antiquing in areas where it would most likely be handled and get dirty. Before you apply your antiquing, be sure to remove all graphite and transfer lines. Your surface should be dry and all paint and mediums should be cured.

When you have finished your design, you will have applied several different products. For example, you may have stained the background, painted the foreground and then glazed over that. Each of these products has its own chemical composition and affects your surface differently. For that reason, I suggest that you varnish your piece before you antique. This will equalize the porosity of the surface so that your antiquing "grabs" evenly over the surface. Otherwise, you might get a blotchiness on your surface. This also provides a barrier so you can wash the antiquing off your surface if you are unhappy with the results.

COLORS COMMONLY USED FOR ANTIQUING
Raw Umber
Burnt Umber
Raw Sienna
Burnt Sienna
Dark Forest Green
Prussian Blue
Barn Red

 tera tip

Antiquing can be messy. Use disposable gloves to protect your hands from staining.

Antiquing, *continued*

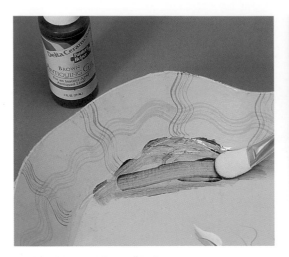

Apply antiquing with your brush.

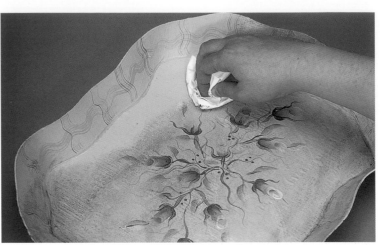

Wipe off the antiquing in sections with a rag or paper towel.

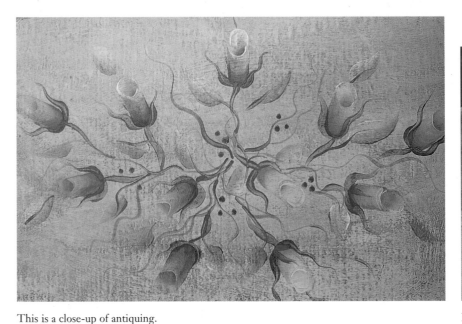

This is a close-up of antiquing.

Here is a close-up of an antiqued corner.

Over your clean and dry varnished surface, apply a thick coat of your antiquing mixture with a large flat brush. Allow the mixture to set for several minutes. With a clean, smooth cloth, begin to wipe off the mixture. The more pressure you apply, the more medium will come off. You will want the antiquing to be darker over edges and places that likely would have been handled. With a clean mop brush, use a light hand to smooth the gradation from dark to light areas. If the mop becomes dirty, wash and dry

it. For larger pieces, you might want to use more than one mop brush to enable you to get through the piece before it dries. On large pieces, antique one section at a time, allowing the antiquing to overlap slightly from one section to another. Let this dry two to three days if you are using oil paint, and one to two hours if you are using an acrylic mix. If the piece looks muddy or has too much of the same color, go back in with a bit of your antiquing medium and fine steel wool to remove antiquing from areas

you want to highlight. Use a light hand and rub in a circular motion. It should take a bit of effort to remove the antiquing at this stage. If it comes off too easily, let it dry another day for oil paints, and another hour for acrylic paints.

Always be sure to varnish over your antiquing unless the product you are using specifies not to. Many of the antiquing mediums will come off over time if not varnished.

ANTIQUING WITH JO SONJA'S PRODUCTS

Prepare your area with what Jo Sonja calls a *barrier coat* of Jo Sonja's Clear Glazing Medium. Dry well with a hair dryer or let the piece sit overnight. With a large brush, apply a thin, even coat of Jo Sonja's Retarder and Antiquing Medium to the surface.

Brush mix a glaze on your palette by adding a touch of color to the retarder and antiquing medium until you have the color you want. Jo Sonja suggests that you keep the color rich and deep in pigmentation by not using too much medium.

Using a slip-slap motion, apply the antiquing to a small area, feathering off the edge so you don't have a distinct line. Soften the color by stroking across the surface with a soft, dry mop brush. Repeat the process until you obtain the depth of desired contrast, letting each layer dry well before you go over it. Once the antiquing dries, finish with a varnish.

There are two product category choices for antiquing. Many manufacturers make premixed antiquing colors that include a medium to slow drying time. You can also make your own antiquing mixture by using acrylic paint and an antiquing medium. Be sure to follow the directions on the medium for the product you choose. To antique with oil paint, use a dot of paint from your tube with oil-based varnish and a couple of drops of linseed oil.

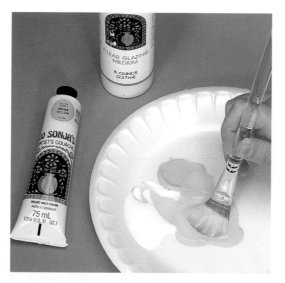

Like antiquing, glazing is a technique that applies a thin coat of color over your surface. While antiquing is used to provide the appearance of age and enhance the structure of your piece, glazing is used to add color to enhance the design. It may be used sparingly on an individual design or on an entire surface in faux finishing techniques.

A glaze is an almost transparent layer of color that will modify the original tone of the area. It is usually a darker color over a lighter color, but almost any color can be used to glaze and tone another color. If you were to take a piece of yellow plastic transparency and look through it, everything would be tinted with yellow. If you held a blue plastic transparency in front of that, the colors would mix for a tint of green. That is the basic idea behind glazing.

tera tip

You may find that adding a bit of a color from your basecoat color helps to pull the design together!

Glazing or Color Wash

A glaze can be created by simply thinning your paint with water (in the case of oil paints, you would use oil), or you can use mediums created specifically for this purpose. Glazing mediums slow the drying time of your paint so it's easier to work with. Each layer of color must be thoroughly dry before the next one is applied.

When used to enhance a design, glazes are applied one over another to slowly build up the color. The glaze increases the color and intensity of the underpainting. The blended effect of this kind of painting creates a mix of the colors with the top color altering the previous color.

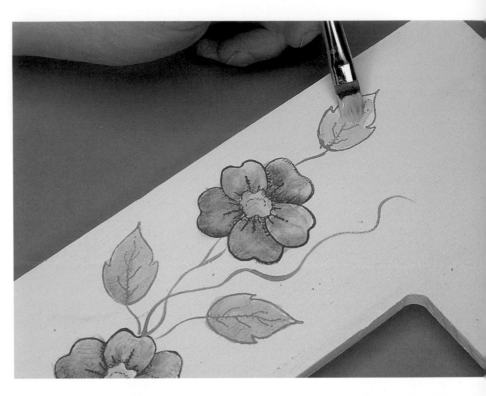

GLAZING WITH OIL PAINTS

Oil paints are transparent by nature. Cadmium and Titanium colors are opaque and do not make glazes as well as transparent and semitransparent colors. Mix the paint with a glazing medium or a mix of turpentine and oil. Due to the slow drying time of oils, you may need to let the glazes dry up to a week before adding the next color.

tera tip

Glazing is sometimes referred to as applying a *wash* of color.

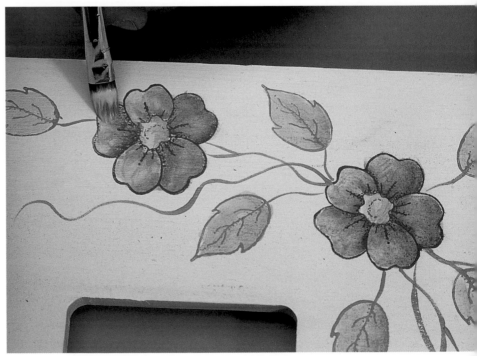

196

Drybrushing

Drybrushing can be used to create visual interest in faux finishing techniques or in individual design elements to add dimension, such as highlighting and shading. As the name suggests, the technique is accomplished using a dry or almost dry brush. For highlighting and shading, use form-following strokes to apply your paint.

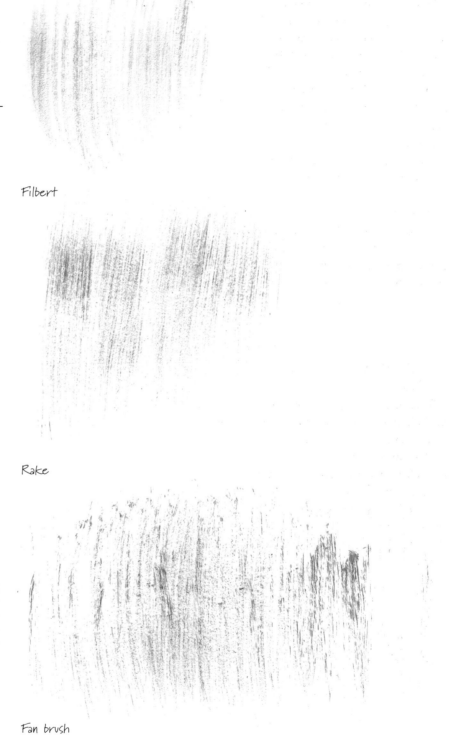

Filbert

Rake

Fan brush

Drybrushing, *continued*

DRYBRUSHING WITH A FILBERT BRUSH

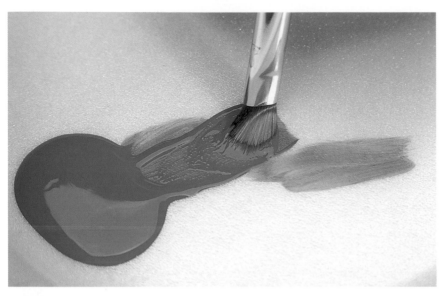

Start by moistening your brush and then blotting it well. You don't want the brush to be wet because the water will thin the paint. Lightly dip the tips of the bristles into the paint and blend it into the tips on your palette.

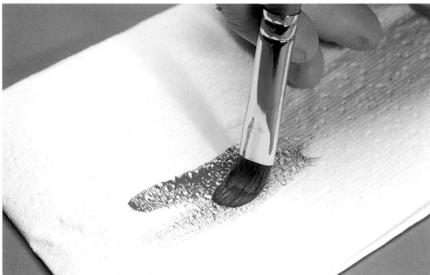

If you find that you have too much paint on your brush, wipe some off on your towel. Then repeat the blending process making sure the paint is just on the tips of the bristles.

With just the bristle tips, lightly brush across your surface.

DRYBRUSHING WITH A FAN BRUSH

Load the brush with paint as you did the filbert.

Wipe off some of the paint and then blend on the palette again to make sure it's just on the tips of the bristles.

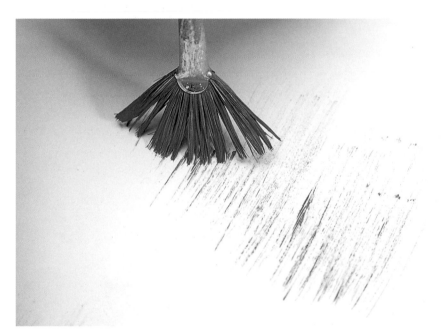

Use a very light hand and only the tips of the bristles to apply the paint. If you push the brush toward the surface, the bristles will clump together and you will get a blotch of paint.

 tera tip

Virtually any brush will work for drybrushing, but filbert, rake, scruffy, stenciling and fabric brushes are favorites. The stiffer brushes work well because the tips stay firm and allow you to dust the surface with paint without applying a lot of downward pressure on the bristles.

You may find that it is best to put a coat of matte sealer over your piece before you start drybrushing so that you can wipe the paint off if you are unhappy with it. Once the piece is finished, you can varnish again.

Spattering

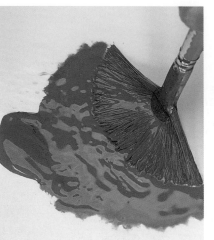

A fan brush works very well for this technique. With a pool of paint thinned with water on your palette, wiggle the fan brush back and forth in the paint so there is plenty of paint loaded on the bristles.

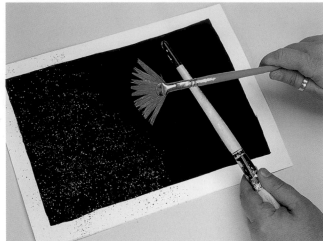

Using the handle of another brush underneath, strike the handle of the fan brush. This will create a fine spray of paint along your surface.

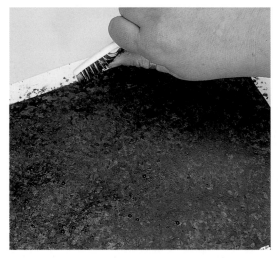

An old toothbrush is probably the most common spattering tool. The size of the fleck you get will, in part, be determined by how far from the surface you are working. In general, you should be three to ten inches from your surface for the most effective spattering.

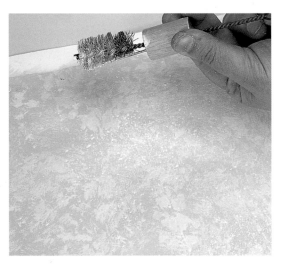

You may also use a spattering tool. Your paint mixture must have an inky consistency. Turn the wood base and be sure to move the tool above the piece so you don't get a heavy concentration of spatters in any one place.

Crackling

Crackling is another faux aging technique. It creates the appearance that the paint on top of the surface has cracked, exposing the paint or surface below. There are many products on the market for crackling, and each works a bit differently. You should read the individual product instructions before using it. I recommend that you use the paint, sealer and varnish recommended by the maker of the crackling product. The most common problem with crackling is using products that do not work well together.

Today there is a category of products that produce tiny cracks. Look for the words *fine, fragile* or *porcelain* on the product label. The size of the cracks produced by crackling products will depend on the number of basecoats applied, the freshness of the uppermost basecoat, the amount of crackling medium applied and how fast the crackling medium dries. The heavier the application of paint and medium, the wider the cracks will appear. With so many variables, it can be hard to predict the exact results you will get with crackling products.

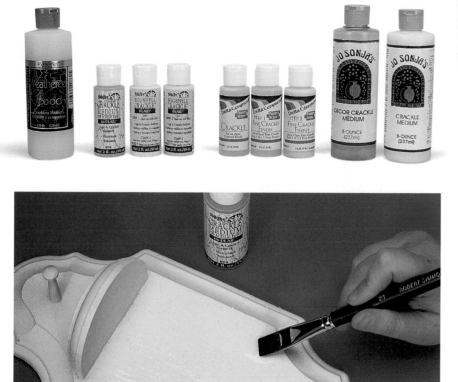

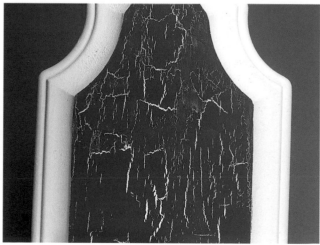

Brush the crackling medium over your basecoat according to the directions. Let it dry.

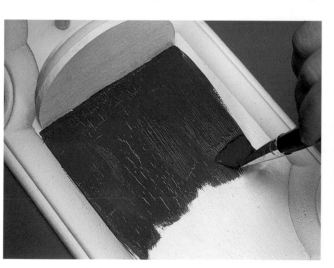

Apply your top color in one direction and do not go over an area where you have already laid down paint.

The completed crackling effect is shown here.

201

Crackling, continued

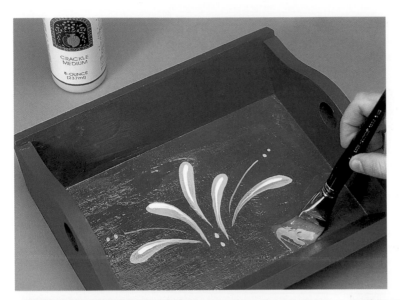

You can also find products which provide a single-step crackle over a basecoat. When dried, you use an antiquing product or a contrasting color of paint for a more subtle crackle effect.

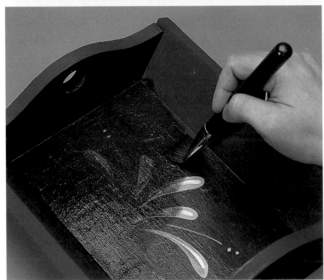

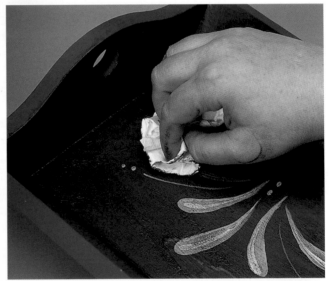

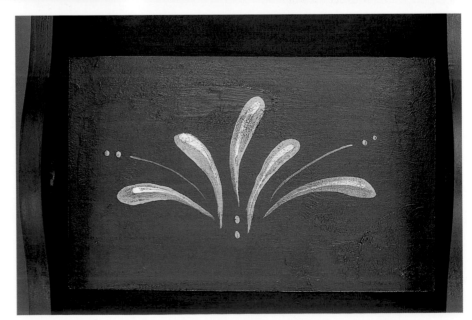

Distressing

Distressing is used to create the appearance of use and age on your piece. Many painters have a hard time distressing their work after they have put a lot of time into it. Nothing will give your piece the appearance of age like well-placed distressing. You will usually want to distress the wood first before you paint, then antique and distress again over your painted area to make it blend.

The key to distressing your piece is to do it where the piece would get the most wear. In other words, choose areas that would have typically been handled or have come into contact with other surfaces. A tray, for example, would have gotten the most wear in the center where things were set upon it, and on the edges where it was handled.

Distressing can be done with blocks of wood, hammers, chains, sandpaper, etc. The more primitive the piece, the more distressing is appropriate. If you just want to age your piece a bit, sandpaper alone might be sufficient.

Another way to distress your piece is to use petroleum jelly or wax to give the appearance of chipped paint. Start by basecoating your piece with the color you want to see peaking

through the "chipped" areas. This might be a stained color or another color of paint, making the item appear to have been painted many times over the years. If the piece is unfinished, a stain will enhance the "aging" of the piece.

When your basecoat is dry, use your finger to smear small amounts of petroleum onto areas you want to appear distressed. Again, remember edges, corners and places that would have received the most use. Basecoat again over the top of the jelly with the topcoat color. Once the paint is dry, use steel wool over the surface. The paint applied over the jelly will come up with light buffing. You may want to use sandpaper to remove additional paint or to smooth selected areas.

Wax may also be used. You can drip candle wax on your surface after basecoating and then paint over it. The wax will chip off after the basecoat dries to reveal the color beneath. You can also rub the waxy part of an unlit candle over your surface.

It will cling to the wood as if you were using a crayon. Make some fat lines and wider areas. Think of the way chipped paint looks. Basecoat over this and, when it is dry, use a credit card or plastic chisel to scrape the wax away.

DRAGGING
Another technique for distressing is called "dragging." This is a variation on antiquing and creates a dirty, grainy look. Over your dried base-coat, apply a colored glaze. This can be an antique color such as Burnt Umber, or a darker version of your basecoat. Starting at one end of your piece, pull a long bristled brush through the wet glaze. You are using the brush to drag the glaze off the piece. Your brush should have at least four-inch bristles and should be used clean and dry. Wipe the glaze off and drag it through again until you have the effect you desire.

specialty brushes

How do I use these strange brushes?

There are dozens of specialty brushes available to decorative painters. Three of the most common and popular, are the stippler, rake or comb and the filbert. Virtually every brush manufacturer makes a variation of these brushes. You should experiment with different brands to find the one that works best for you. You may find that you like different brands in different sizes, or that you want to own a variety of brands because you have uses for all of them.

Stippler Brushes

Stippler brushes are also known as "foliage" and sometimes "teddy bear" brushes. They are commonly used to paint foliage in bushes and trees, and to paint animal fur. However, the brush is quite versatile and is used in several different techniques.

Stipplers come in a variety of shapes and filaments. In addition to brushes made for this purpose, you may want to save your old scruffy brushes and use them as stipplers. As the bristles of a brush begin to splay from use, they can be transitioned into use as a stippling tool. All stippling brushes are used in essentially the same way.

Stippling is usually a dry-brush technique. The brush should be held with the filaments perpendicular to the surface. If you are using a deerfoot brush or one cut on an angle, you should hold the brush by resting it back in your hand. For flat filament brushes, hold the brush with the handle perpendicular to your surface.

Donna Dewberry
Scruffy brush

Ronnie Bringle
Blender brush

Winsor & Newton
Deerfoot stippler

Fan brush

Pat Wakefield
Bette Byrd
Deerfoot stippler

Debbie Mitchell
Stippler

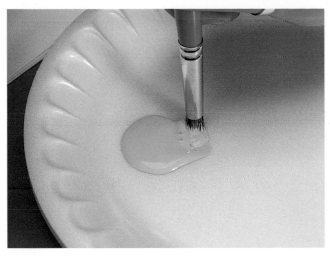

Dip your brush directly into a pool of paint.

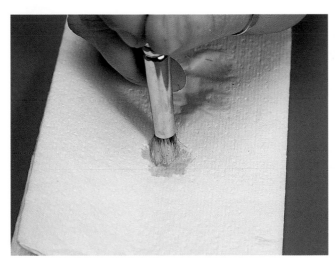

If you get too much paint on your brush, blot the excess on a paper towel.

On a clean portion of your palette, pounce the brush up and down to distribute the paint and remove any excess.

tera tip

The most common mistake in stippling is using too much paint on the brush. You want to allow the bristles of the brush to create a pattern. You will not be able to see this pattern if you have blobs of paint on the brush. For this reason, you should pounce your brush into your paint on your palette, and then pounce it on a separate portion of your palette. This takes the excess paint off your brush and helps spread the paint among the bristles. You should be able to see the pattern of the bristles emerge. When using a stippler brush, the amount of downward pressure you apply will affect the pattern. Experiment with heavy and light pressure to see which effect you like best.

For a softer look, you can slightly dampen your stippler brush, blot it on a towel and then apply the paint as usual. The water will soften the bristles and make the paint a bit more translucent. Experiment with your brush to see the different effects you can create.

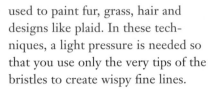

Rake or Comb Brushes

The rake or comb brush can be confusing because each company has its own name for it. Rake and Comb are the most commonly used names. Rake is a registered trademark of the Loew-Cornell Company. Comb is a trademark of the Royal Brush Company. As a result, other companies cannot use those names for their brushes. This brush is also called *wing*, *feather*, *wisp* and other similar names. For the purpose of simplicity, I will refer to the brush as a rake.

The rake brush creates a beautiful wispy look. It can be used both for drybrushing and for painting with an ink-like consistency of paint and water. It is one of the most versatile and underrated brushes on the market.

Each manufacturer has created its own variation of this brush, and I recommend you try a few before deciding on one. Some brushes have a lot more filaments than others. Some have a longer filament and hold more paint. Trying different brushes will help you get the best result from the brush you choose.

Most rake brushes are flat, but some are rounded like a filbert brush. The filaments of the brush have been thinned toward the end. Imagine taking a pair of thinning shears to a flat brush and you will understand what this brush looks like. The thinned filaments cluster together when the brush is loaded with paint. This creates a "rake" or "comb" appearance from which it gets its name.

The most common use of this brush is with paint thinned with water to an ink-like consistency. When loading the brush, apply pressure to take it down to the flat and wiggle the bristles so that you will pull the paint to the tips. Use the very tips of the bristles against your surface, much like you would use a liner brush. The more pressure you apply toward the surface, the thicker the lines will be. If you apply too much pressure, it will simply revert to being a flat brush, because you will use the side of the bristles that are not thinned.

The rake brush is most commonly used to paint fur, grass, hair and designs like plaid. In these techniques, a light pressure is needed so that you use only the very tips of the bristles to create wispy fine lines.

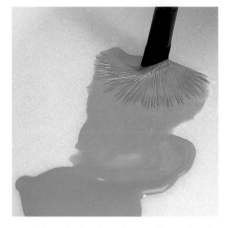

Load the rake brush with paint thinned with water to an inky consistency. Push it down to the ferrule and wiggle to pull the paint to the bristle tips.

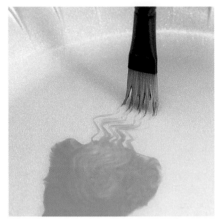

Pull the brush from the pool using only the bristles.

Too much paint on the brush will make it difficult to get a fine line from your rake.

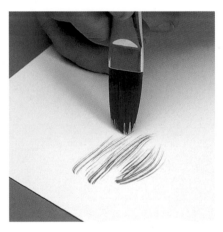

Whether it is round or flat, use only the tips of your rake brush.

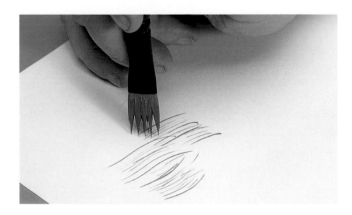

Be sure to brace your hand.

Filbert Brush

The filbert is a flat ferrule brush with rounded bristles at its chisel edge. This creates a versatile brush that can be used for basecoating, varnishing and painting, without the sharp edges created by a regular flat brush. Load the filbert just as you would a flat brush.

The filbert can be double loaded as well to create wonderful effects.

Due to its rounded edges, the filbert makes a great double-loading tool for painting freehand leaves, ribbon and so on.

Blend on your palette just as would a double-loaded flat brush.

Liner Brushes

A liner brush can be challenging to use when you first begin to paint, but once you understand simple fundamentals of how to use this brush, it will become one of your favorites. Liners can be used for lettering, flourishes and embellishment, as well as vines, borders and more.

As discussed in the chapter on tools, liner brushes come in many different configurations. Whether you use a brush with a short- or a long-bristle base and with a certain number of hairs in the brush will depend on your personal preference, as well as the purpose for which you are using the brush. Remember the longer the bristle, the more water and paint the brush will hold.

Liner brushes have a variety of names. Script liners have the longest bristles, spotters have the shortest bristles and liners have medium-length bristles. In addition to holding more paint, longer bristled brushes are best for vines, floral tendrils and loopy lettering. Spotters are great for details in tight spots such as small details like signatures and tiny stroke-work.

Robert Simmons Expressions liner

Raphael Kolinsky quill liner

Donna Dewberry One-Stroke liner

Bette Byrd Aqua Sable 500 scroller

Heather Redick liner 0

tera tip

When you begin to learn lettering, you may want to varnish your piece before you start working. The varnish makes it easier for you to wipe off mistakes.

Liner Brush Techniques

PAINT CONSISTENCY

Especially when using longer-bristled brushes, you will thin your paint with water to an ink-like consistency. The easiest way to do this is to first place a small pool of water on your palette by using an eyedropper, spoon or straw. Then, using your brush slowly, add paint to the water from a separate puddle of paint, wiggling your brush in the paint and water mix to blend. You will waste less paint this way and are more likely to get the right consistency of paint to water.

A more common way to do this is to thoroughly wet your brush and bring it to the side of a puddle of paint. Dip the wet brush into a corner of paint, pull a small amount out and brush blend. Keep going back to the water with your brush until you have thinned the paint sufficiently.

Either way, your paint needs to be thinned more than 50% in most cases. Because paint varies in its thickness, there is no hard-and-fast rule for this. However, most people who have problems with lining have not thinned their paint enough to have it move along the brush evenly. Thin the paint more than you think is necessary. You can always add more paint if the color is too weak.

LOADING THE BRUSH

It is important that a liner be fully loaded, not just at the tip. To load the liner, lay the bristles into the paint puddle down to the flat. You will get paint into the ferrule with this technique, but the paint is so thin it will rinse out well. You may have to stroke through the paint several times to have a fully loaded brush.

Make sure that there are no water droplets on your ferrule! This is important because the water will run down the ferrule as you use the brush and ruin your lining. For some brushes, you may want to twirl the brush handle as you pull away from the paint puddle. If there are any globs of paint on your bristles, your paint is not thin enough.

CONSISTENT DOWNWARD PRESSURE USING THE BRUSH TIP

Keep your brush handle perpendicular to your surface. This is crucial in your ability to use only the tip of the bristles. If you tilt the brush handle, it will force you to use the side of the bristles and you will not get a delicate, thin line.

Use the side of your hand or your little finger to brace your hand. This helps you maintain a consistent pressure on the brush and keeps you from pressing too hard. The more downward pressure you apply toward your surface, the wider the line will be. For most lining, you will use only the very tip of your bristles—making sure that the bristles do not bend—to get the thinnest possible line.

As you paint, move your arm and shoulder, not your wrist. If your elbow is planted on your table or another surface and you are relying solely on your wrist for movement, it is virtually impossible to get a smooth line. Lining requires movement of the entire arm and shoulder.

Liner Brush Techniques, *continued*

KEEPING THE BRUSH STEADY

One of the best tricks I have learned for painting with a liner is to keep your eyes where your brush is going, not on the bristles themselves. This gives you a much steadier hand. Whenever possible, turn your piece so that you can pull the liner toward your body. It is much harder to control the brush if you are pushing away from your body or to the side.

PAINTING STRAIGHT LINES

The best way to paint lines is to brace your hand and keep it steady. The more you practice, the easier it gets.

If you are having problems, an old trick for painting straight lines is to use a wide quilter's ruler. Because these rulers are clear, you can see what you are painting as you work. Place the ruler against your surface, tilting it an angle toward you. Place your brush so that the ferrule is against the ruler and run it along the edge for a straight line. Make sure that, as you do this, you don't put too much downward pressure on the brush. You must also hold the ruler steady.

THE CHALLENGE OF PAINTING CURVED LINES

Completing a circle can be a problem when using a liner brush. If you paint a circle, or a continuous string of circles like a spring, you may notice that you have a tendency to get a break or blotch as the brush comes around. The problem is that, as you bring the brush around, it's on an angle away from your hand. At that point, you must use less pressure to ensure that you are using the very tip of the bristles. The break and blotch comes from using too much pressure. When that happens, you are painting with the side of the bristles as they flip from one side to the other at the curve, creating the blotch.

tera tip

Resist the temptation to hold your breath when doing liner work. Oxygen deprivation to the brain can cause your hand to shake. Try to paint your lines as you exhale, which is when your muscles are more relaxed.

lettering & borders

What's available?

Lettering

Lettering can be done with virtually any brush, but the two most popular are the liner and the flat. I like to tell my students that foibles and imperfections are what makes handpainted art different from mass-produced art. Even the best painters will have some inconsistencies in their lettering from time to time. The best advice I can give you is to practice and relax.

Computers have changed the world, even the world of decorative painting! Word processing programs now allow you to choose a font, determine its size and spacing and print it to use as a pattern. Make sure that you are using copyright-free fonts, which are available in packages at most computer software retailers. More advanced computer programs allow you to create curved or wavy text.

tera tip

Since the columns and lines are evenly spaced, newspapers make an inexpensive practice surface for lettering.

Welcome Welcome Welcome

Welcome Welcome Welcome

Welcome Welcome Welcome

Welcome Welcome

Welcome

Welcome Welcome Welcome

Welcome Welcome Welcome

LETTERING, *continued*

When lettering with a liner brush, use the basics explained on page 207. Lettering involves creating a sustained line with a lot of curves. It is not difficult, but it does take practice and a bit of discipline to use only the tip of the bristles for your letters. Keeping your paint the correct consistency is most important when lettering. Keep in mind the consistency of India ink.

When lettering with a flat brush, refer to the strokework section. Keep your bristles at a 45° angle as you would with a calligraphy nib, and hold the brush perpendicular to the surface. If you have trouble with original work, books on calligraphy will give you wonderful information that you can incorporate into your flat brush lettering in terms of the direction of your stroke and letter spacing.

It can be helpful to use a bridge when lettering. Bridges are made for oil painters and are available from fine art catalogs and stores. You can also make your own by taping erasers to both ends of a ruler or by adding blocks to the ends of a dowel. A bridge is simply a place for you to rest your hand while keeping it suspended over a surface. This can be helpful in lettering so that you don't smear the paint as you work.

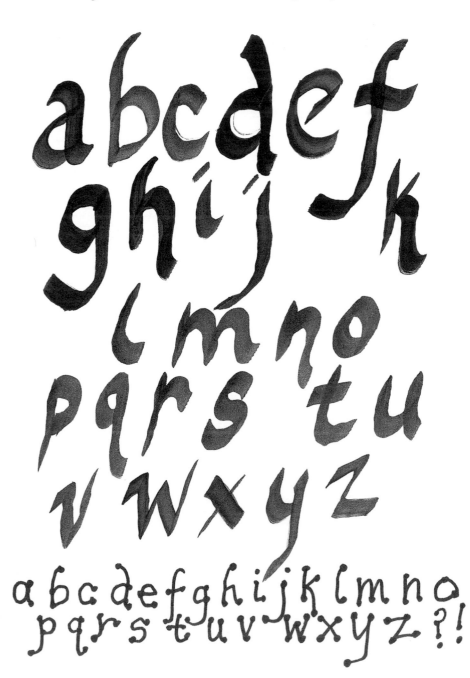

Borders

Liner brushes are often used for free-hand borders. Refer to the section on strokework for instructions on how to paint the strokes used. Borders are painted to provide a frame around a design. Borders vary from a simple, wavy line, to an extremely detailed strokework design as seen in European folk art. As the artist, the type of border is up to you.

A great way to practice borders is to use bookmarks available from craft stores. Keep them handy to paint on while you are watching television or talking on the phone. They make terrific gifts or gift tags when you are done with them!

The biggest challenge when painting borders is spacing. You may find it helpful to chalk off lines around your piece in equal sections. For smaller pieces, simply quartering the design is enough. For larger pieces, mark off every inch or the length of a single repeat of the design so that it matches all the way around.

Like lettering, the foibles in your strokework will create part of the charm of your design. Try to relax and let go of the need for perfection. As a collector of folk art, some of my favorite pieces are those with hair from brushes or other signs of the human involvement in the work of art.

1. Create an inky puddle of water and paint. Pull the paint from the puddle with the rake brush.

2. Vertical lines

3. Horizontal lines

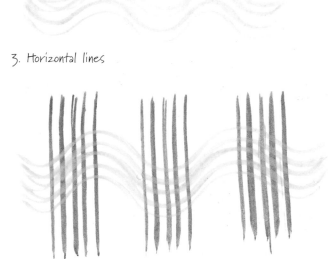

4. Plaid design

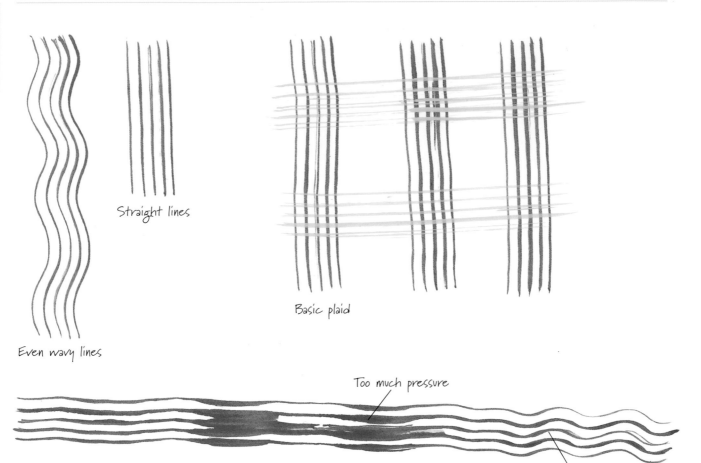

Straight lines

Basic plaid

Even wavy lines

Too much pressure

The key to using a rake is applying even, downward pressure.

Proper consistent pressure

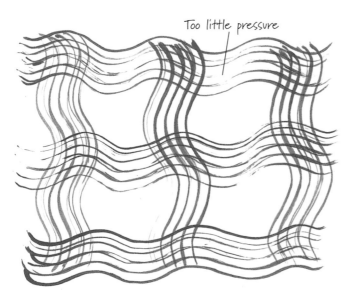

Too little pressure

An example of a wavy plaid with uneven pressure. The problem is that there is not enough water on the brush.

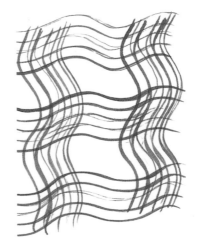

Wavy plaid with more consistent pressure.

Border Examples

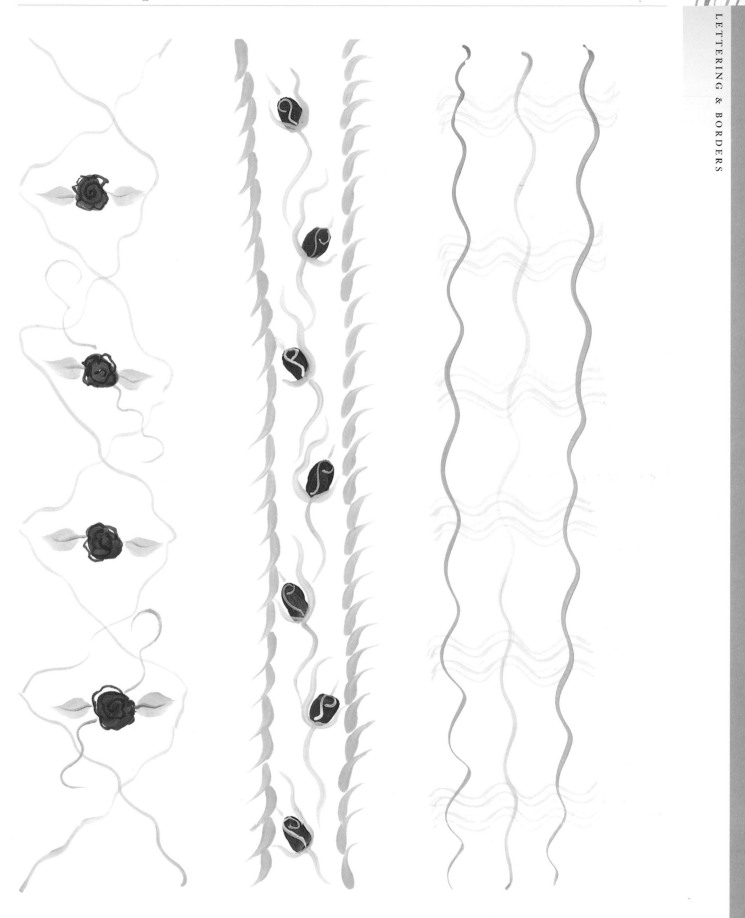

Border Examples, continued

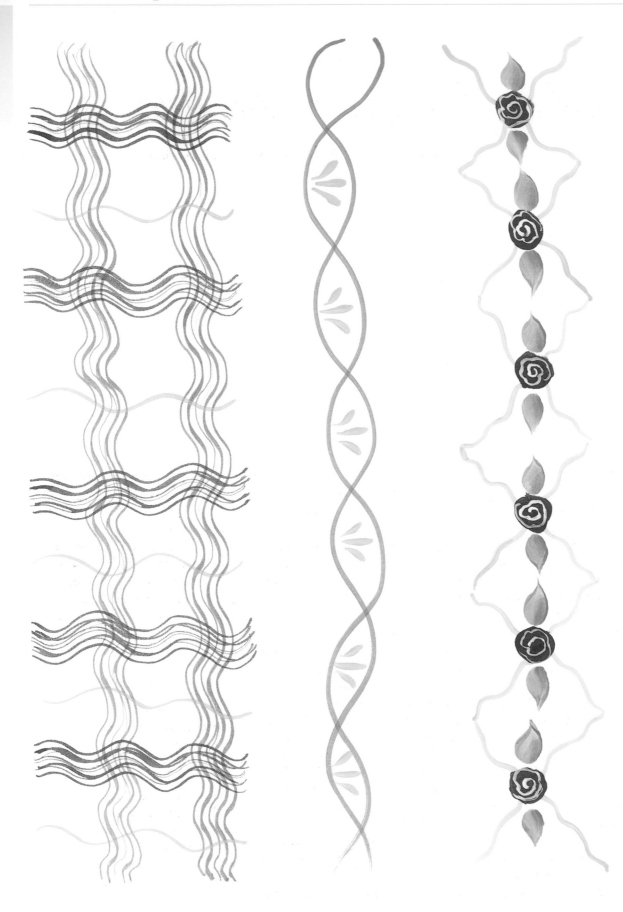

finishes for your project

How do I make it look professional?

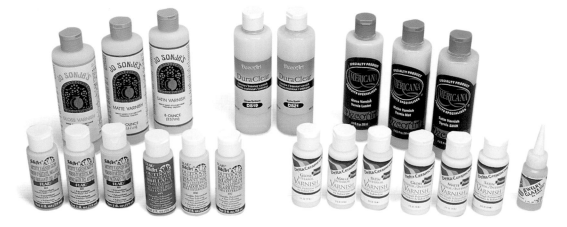

Finishing

Museums and antique stores are filled with decorative art that is hundreds of years old. You may not think your work is good enough to warrant being in a museum, but your family may delight in having something that was handpainted by you. To protect your art, it is important to learn how to finish your piece with a quality varnish.

The varnish you choose also acts as a frame, so it is important to choose the right one. If you've painted a primitive piece with the edges sanded and distressed, then you wouldn't want a high-gloss finish. Conversely, a piece of jewelry or a japanned-style box would look best with a high-gloss finish, rather than a matte finish with no shine.

A good varnish application can make all the difference to a finished work. I have seen mediocre painted pieces with an excellent varnish get more attention than pieces with better quality painting and no varnish. There is something special about a beautiful finish coat. It is important for you to know that acrylic paints do not fully come into their color until varnished. The varnish will give the paint its full glow.

WHAT IS VARNISH?

A varnish is a film or protective layer over your surface. Varnishes come in a variety of formulations. As you become more experienced as a painter, you will likely find that you have specific preferences. I recommend that you stick with the same manufacturer for your sealer, paint and varnish whenever possible. That way, you know that they are meant to be used together.

As a rule of thumb, water-based varnishes should be used with acrylic paints. Oil and specialty paints generally have their own varnishes. There are also special varnishes made for particular purposes, such as an exterior varnish, which is used to protect paint that will be exposed to the elements. Polyurethane is a synthetic and long-lasting varnish. In addition to brands made by craft manufacturers, you can use products made for home use such as Minwax or Flecto Diamond Finish.

tera tip

Before you varnish, use a soft, damp towel over your surface. The water will help you see what the piece will look like when varnished. It will also help you see any mistakes, such as graphite lines that haven't been erased, missed lines or other small flaws, which are easier to fix before the varnish is applied.

Finishing, *continued*

CHOOSING A FINISH

There are three main categories of finish: matte, satin and gloss. Some manufacturers make additional categories such as semimatte or eggshell. You should read their literature as to what this means in comparison with their other products.

Matte has no shine and is only a protection for the paint. It is especially important for matte varnish to be stirred well before use because it contains dulling agents. If these agents are in a clump at the bottom of the jar, your varnish will not be matte. After stirring, let the varnish sit to get rid of the bubbles that will come up from agitating the varnish. Although it doesn't shine, do not give in to the temptation to use a single coat of matte varnish. To achieve full coverage, all varnishes need to be applied in multiple, thin layers, but none more so than a matte varnish.

Gloss gives you a high-gloss finish, and satin gives you a finish somewhere between high-gloss and matte. Satin is the most popular of the finishes, in part because it is the most forgiving in terms of application. Gloss varnish will show fingerprints and brush marks, so it requires wet sanding and more layers than other varnishes.

You should choose the finish that is most appropriate for your design. As a guide, primitive and useful pieces use a matte finish; jewelry and showcase pieces use a gloss finish; and

a satin finish is appropriate for any other piece. In the end, however, it is a matter of personal preference. If you like the finish, it is right.

FOOD-SAFE FINISH

Not every varnish can be used with food. Make sure that your varnish is labeled as "food-safe" before using it on any surface that will come into contact with food. There are also waxes and oils made for wood countertops and bowls that can be used to finish the surface or inside of wood items that will be used with food. You can usually purchase these products at woodworking stores.

tera tip

For items that will be outside, such as mailboxes, take them to an auto painting shop and ask for a clear coat finish. They will generally do this for you for a small charge when they are finishing a car. This is an ultra hard finish that is meant to be exposed to the elements.

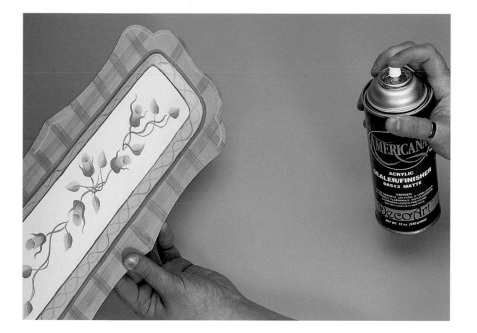

SPRAY VARNISH

Many new painters start with spray varnishes because they are familiar with them. The challenge with using spray varnishes is that you cannot get the same coverage as you would with a brush-on product. However, spray varnishes do have their place in the decorative painter's tool chest. Krylon Matte Finish sprays are invaluable for sealing a piece after antiquing it with oil-based products. They also seal ink so that you can varnish with a brush-on product.

When using a spray varnish, it is important to use it in a well-ventilated area. If possible, do it outside. *Well-ventilated* does not mean in an open room or in a garage. It means a place with outside or fresh air ventilation. Spray paints will damage your lungs if they are not properly used.

Follow the directions on the can for the correct way to use the spray. Generally use sweeping sprays across your piece, holding the spray at least twelve-inches from the surface. Start by spraying outside your surface,

sweep across it and then go past it to the other side so that you don't get a "start blotch" where the spray first hits the surface. It is better to spray three to four light coats than one heavy coat that will drip. When choosing a varnish, try to find one that is non-yellowing.

Shake the can well before using. This is more important than you may realize. The cans have a special design to help you blend the materials inside well, but you must shake them before using. You may also need to shake the can between sprays to keep the product blended. Keep the can moving as you spray because any hesitation will cause a heavier application in that area.

Follow the directions on the can for clearing the nozzle before you use it. If your nozzle is partially blocked, you will get drips and spatters. Some cans have special designs so that you can simply turn them upside down until only the aerosol flows, which will clear the nozzle. You can then resume spraying normally.

Finishing, *continued*

BRUSH-ON APPLICATION

Before using any brush-on varnish, the paint on your piece should be dry and cured. Be sure that it is clean. If your piece has sat in the open for several days, make sure that it is free of dust, animal hair and lint. Varnish will not fix mistakes made in your painting process. It is important to have sealed and sanded your piece before painting and, if necessary, after basecoating, so that the surface you paint on is truly smooth.

Brush-on varnish should be applied with a smooth, large brush. Your varnishing brushes should be kept separate from your painting brushes. It is best to keep them in a box after they dry so they stay clean. Anything on the brush will be transferred to your surface in the varnish.

Varnish should be applied in multiple thin coats. Thicker varnishes, such as polyurethane, may require only three to five coats. Thinner varnishes may require up to ten coats.

You may want to use a dry-it board to rest varnished pieces on as they dry. Another option is to purchase plastic runners from an office supply store. The runners have plastic spikes on the reversed side that are perfect for holding pieces wet with varnish. Each time you reload your brush, run your finger around the edges of your piece to make sure that there are no drips.

Do not go back over a previous stroke except to smooth out a drip. If you must do so, do it immediately and in the same direction you applied the varnish. You will apply multiple coats of varnish, so you can fix mistakes or missed areas. Most varnish sets very quickly and you will get distinct brushstrokes if you overwork it. Some varnishes are "self-leveling," which means that after it is applied to the surface, the product levels itself out, getting rid of brush lines. Flecto Diamond Finish is an example of a self-leveling product.

BRUSHES

Choosing a good brush is as important as choosing a quality varnish. I recommend not using a sponge brush for application because the holes in the sponge trap air, creating bubbles in the varnish. I prefer a rounded-edge filbert-style brush, but flat or wash-style brushes are probably the most popular. The brush should be soft-bristled to comb out bubbles and not leave brush streaks. The brush should also be appropriate for the size of the piece being varnished. In general use a fairly large brush, because using fewer strokes to apply the varnish lessens the likelihood of bubbles and streaks.

Always wash your brush after you have applied the varnish. If you do not get the varnish out, the brush will be ruined. Store the brushes covered, if possible. If dust settles in the brush, it will be transferred to your surface in the varnish and is almost impossible to remove. Some varnishes reactivate when the brush is put back into them, so the brush does not require cleaning in between. However, varnishing products are very hard on brushes, so I suggest cleaning the brushes in-between each application.

tera tip

Some varnishes will become milky if any water is added to them. Always make sure your brush is completely dry before using it for varnishing.

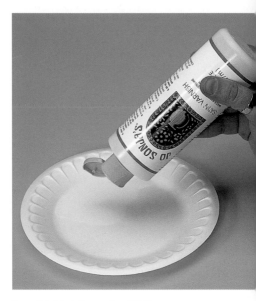

Jean Watkins, formerly of J.W. etc.,-suggests gently pouring a small amount of varnish into a flat dish and applying the varnish from it. This allows you to flatten the brush against the dish and squeeze out excess product and bubbles.

Be sure that you apply your varnish in multiple thin coats, not a few thick coats. The thicker the coat, the more likely it is that you will get bubbles and brushstrokes. When applying the varnish, stroke in one direction across the entire piece, do not move back-and-forth across the piece.

tera tip

Lint and dust will get into your varnish over time. You can remove this by straining your varnish through a piece of nylon, such as panty hose. Pour your varnish into a separate container first, and then strain it back into your original bottle.

tera tip

Even when you are in a hurry, resist the temptation to use a hair dryer or put a piece in the oven to speed the drying time of the varnish. Varnish is likely to crack or yellow if exposed to heat.

Solutions to Common Varnishing Problems

MILKY OR CLOUDED VARNISH

For many varnishes, clouding is caused by water being introduced into the mix. It can also be caused by humid conditions or by applying multiple coats without allowing the bottom coats to fully dry. This can often be fixed. First, allow the varnish to fully dry. Sometimes just allowing it to dry will get rid of the clouding.

Ironically, some varnishes (like Delta Ceramcoat) work better with a little water in the brush. Like most things in painting, you may have to experiment to find out what works best. However it is best not to introduce water into your varnish unless the manufacturer has told you that it is okay to do so.

If it has dried for at least twenty-four hours or more and the clouding is still present, wet sand the piece (see instructions on page 223) and dry well. Then apply a gloss varnish over the top. Allow this to dry and see if the clouding has disappeared. If it has, you then can use a gloss, satin or matte varnish over the top. If not, apply another coat of gloss varnish.

BUBBLES

Bubbles are caused when air is introduced into your varnish. Make sure you are not shaking your varnish bottle before using it. To mix your varnish, gently roll the bottle on its side, but do not shake. Another way to introduce bubbles into your varnish is with your brush. If the varnish has settled to the bottom of the bottle and rolling it is not going to be enough to mix it, use a stick to gently agitate the materials at the bottom. Once that is done, let the varnish set for at least an hour so that the bubbles come back to the top of the jar.

Solutions to Common Varnishing Problems, continued

BRUSHSTROKES

Brushstrokes occur when you apply your varnish too thick or when you work through varnish that has already begun to dry. Also, some varnish products are more prone to brush-strokes than others. Wet sanding (see instructions on next page) will usually soften brushstrokes so that you can apply thinner coats of varnish over the top.

DRIPS

Apply varnish from the center toward the edge and feather off as you reach it. Each time you reload your brush, run your finger around the edges of your piece to make sure that there are no drips. Some painters like to varnish the edges first so that it is easier to wipe off any drips that occur after you apply varnish across the top.

Wet Sanding

Wet sanding is a process that is rarely taught in classes, but that will make all the difference in the quality of your finish. The purpose of wet sanding is to smooth out imperfections in the varnish, such as small bubbles, brush lines or lint.

You must apply at least three coats of varnish before you wet sand or you will sand through your varnish and remove the paint. Apply each layer of varnish and let it dry well.

Using a wet palette or a small bowl, mix a drop of liquid soap and three tablespoons of water. For small surfaces, you can apply this directly to your sanding pad.

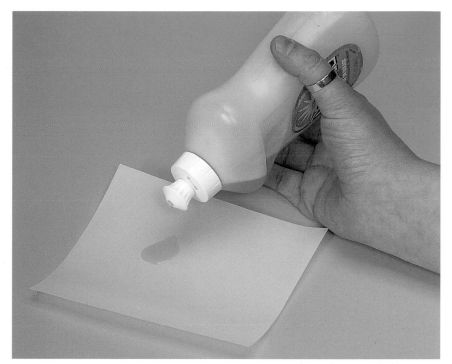

Using super film, a pink sanding pad (backed with vinyl) or a very fine sandpaper, lightly sand the surface. You are just trying to buff out any ridges or imperfections.

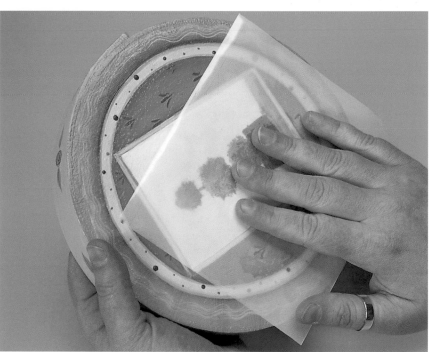

Finishing All Parts of Your Project

Debbie Thyr of the Prairie Sampler in Fullerton, California, once wrote that turning a piece over and seeing that the back is not finished is like accidentally seeing someone's underwear. That image has never left me! Although you might not address it in such dramatic terms, it is distracting to lift a piece and find that the back, inside or bottom is left unfinished.

A great way to finish the inside of a box is with fabric. Measure and cut the fabric to fit. Seal the area to be covered with sealer and let it dry. Lay the fabric on wax paper and coat the front and back with a sealer so that it is wet, not just damp. Recoat the inside of the box and then apply the wet fabric to the surface. Use a brayer or credit card to squeegee out the excess liquid. The fabric will adhere to the surface perfectly. Once it is dry, lightly sand with super film or a fine grain sandpaper and then varnish.

Pick a color used in the main design. If the piece is basecoated in a solid color, then that color is appropriate. The backs of pictures and mirrors can be finished with brown kraft paper.

Something that makes a piece very special is to find a small element painted on the back or inside. I was given a painted piece that has a beautiful strokework design on the back with the artist's signature. I show the back of that piece to everyone who looks at it!

While we are on the topic, sign and date your work. This makes it more valuable to the people who will own it, whether it is purchased or given as a gift. Many artists develop a code for their work. Some artists create an emblem to use with their signature for each year, for example, one year might be a rose, the next might be a bird's nest.

Some artists who sell their work find that older pieces do not sell well, so they create a code. For example, you might track how long you have been painting, the month and year a piece was painted, and the number of items you paint in a year. If you have been painting for five years, the first number is 5; the piece was painted in February, so the next two numbers are 02; the year is 2001, so the next two numbers are 01; and it is the fifteenth piece you have painted that year, so the final two numbers are 15. On your piece, you would paint 5020115.

Waxes

Wax is a final protective barrier and is applied over your varnish. In addition to protection, wax gives an unparalleled shine. There are waxes made especially for use over painted pieces, or you can use a variety of waxes made for furniture. Some artists even recommend neutral shoe polish. It is important to choose a nonyellowing wax for your piece. Experiment to find what works best for you.

Apply the wax like a floor wax. The wax over your varnish can be buffed and cleaned to bring up the shine while protecting the finish underneath.

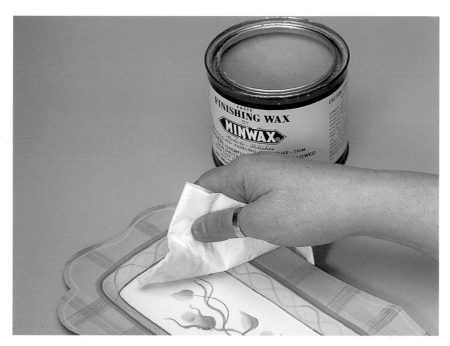

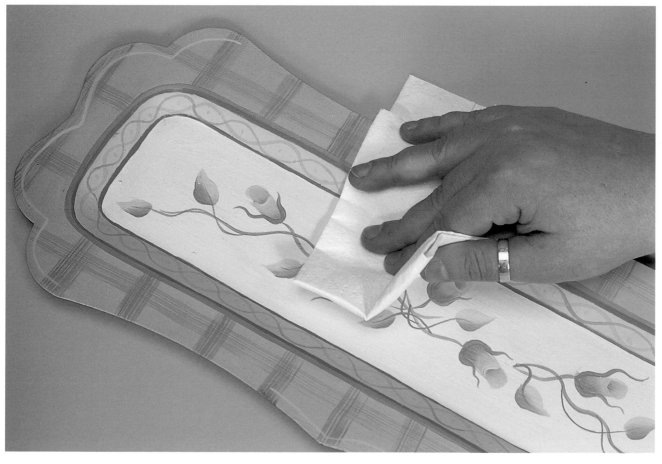

Apply wax with a soft cloth or steel wool in a circular motion. If possible, wax with the grain of the wood. Let the wax set for a few minutes and then buff the wax with a soft cloth until it shines. It is best to use a thin cloth because the heat of your hand through the cloth warms the wax and helps it mold into the nooks and crannies in the piece. If you've never waxed a piece, it is hard to understand what a difference waxing will make until you try it. Finally, be sure to buff out the wax.

Gold Leafing

Gold and metal embellishments date back to ancient civilization. Using gold or precious metals signified the value of an individual piece. Some metals, such as gold, are extremely malleable and can be beaten and pressed into very thin sheets or leaves. Manufacturing processes today makes leafing affordable for crafters and home decorating by providing composition metal sheets. New variegated leafing products cost slightly more. Real gold leafing is still available, but it is substantially more expensive.

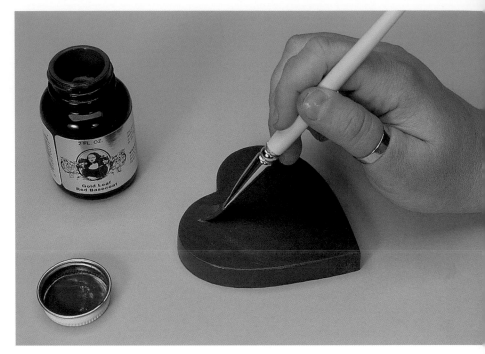

Most traditional leafing products come in "books" of square pieces that are separated by thin tissues. A book typically has twenty-five sheets that will cover up to five square feet of total surface. All leafing should be applied to a clean, smooth, sealed surface. Leafing can be applied to virtually any surface, including fabric. Most leafing manufacturers have their own line of sealers and adhesives for you to work with. For trouble-free application, use the products made for one another rather than mixing brands.

Most gold leafing is applied over a colored basecoat. Gold looks best over a rich red basecoat. Silver looks good over red or a deep blue. There are many colors available to enhance your project, and you should choose the combination best suited for your color scheme.

Apply an adhesive to the area where the leafing will be applied. For smaller areas, brush-on adhesives work best. For larger areas, aerosol adhesives are available. As with any aerosol, be sure to use it in a well-ventilated area with lots of fresh air. Most adhesives have a waiting time of two to thirty minutes before you can apply the leafing. With brush-on adhesives, you simply wait until the adhesive dries to a clear finish and then your surface is ready to leaf.

Keep in mind that you are working with metal, so oils from your fingers can cause the metal to tarnish. Make sure your hands are clean and free of oils before you touch the leaves. It is a good idea to wear cotton gloves if you are comfortable working in them.

tera tip

If you don't use gloves, apply cornstarch or talcum powder to your fingers before working with the leafing products so they don't stick to your fingers.

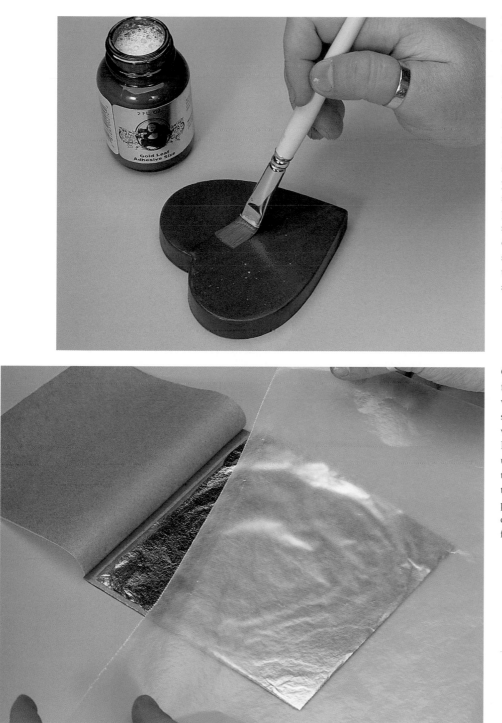

Brush adhesive onto your surface following the directions for the product you chose. (Use an old scruffy brush for this as the adhesive is not good for bristles.) Most manufacturers of brush-on adhesives recommend that you let the adhesive dry from a milky, wet state to a clear dry finish. Since the brush-on adhesive is milky, it is easy to see if you have full coverage of your area. If you find you have a problem with adhesion, apply a second coat of varnish in the opposite direction of the first application after it has dried. Let the second coat dry and then apply your leafing.

Open the book and expose the first sheet of leafing. You may wish to cut ⅛ inch from the spine to free the sheets if you are working on a large surface. Regular waxed paper can be used to "grab" the leafing from the tissue. The leafing is very thin and rips easily. The waxed paper holds it together so you can apply it directly to your surface without having to touch it.

Gold Leafing, *continued*

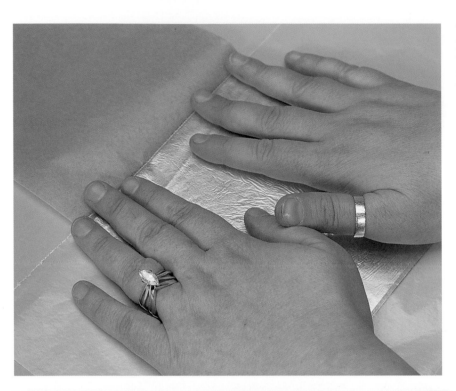

The heat from your hand helps the waxed paper adhere to the leafing. After pressing the waxed paper against a leaf, it should lift effortlessly out of the book when you lift the waxed paper.

With this type of leafing there is no right side to worry about.

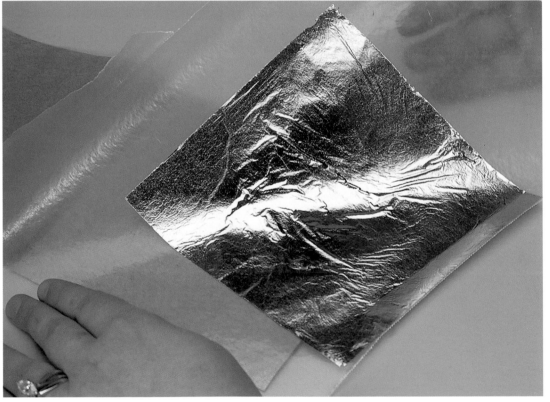

When the adhesive is ready, lift your waxed paper with the leaf on it and apply it leaf-side-down to the surface.

For a large surface, start at one corner and work your way across the piece, slightly overlapping each leaf.

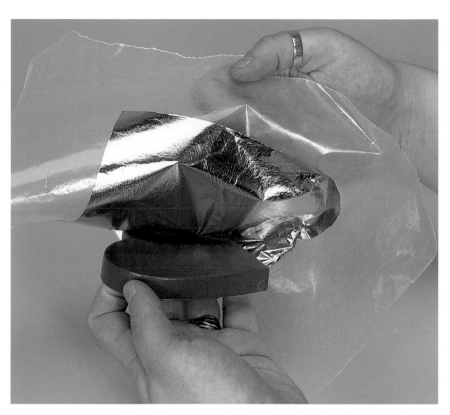

Press the leaf against the adhesive to make sure that the leafing has adhered to the surface. Lift the wax gently and move on to the next section if necessary.

For some projects, you may not want to leaf the entire area or you may want to have the basecoat show through. This is done in modern pieces to have spots of gold leafing over the piece, or to make a piece look antique, as though some of the old leafing has lifted. In this case, do not put adhesive on the areas you don't want to have leafed. For the antique look, you can buff the leafing off in areas, making it look worn.

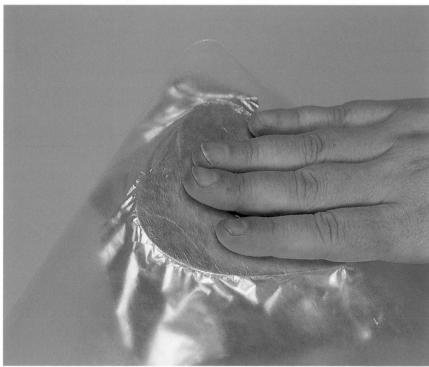

Gold Leafing, *continued*

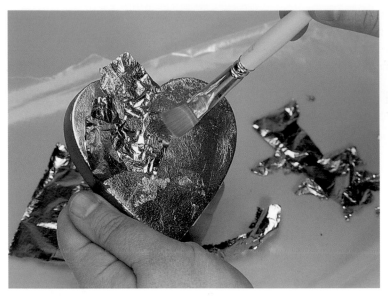

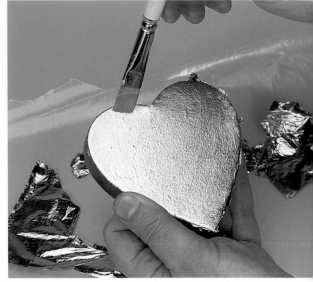

Once the leafing is applied to your satisfaction, use a soft brush to dust off the excess and to smooth the leafing further. Use a gentle hand or the delicate leafing can lift or tear. Running your brush over your TV screen or computer monitor will give it a bit of static, which will help pick up all the tiny fragments on your piece. If you find you missed a section, apply adhesive, let it cure and then apply additional leafing to that area.

A look that I like is to place torn bits of leaf over the top of flat areas, creating a patchwork. I find this to be more visually interesting, and it gives the piece a more antique look. To create this effect, lay the leafing over the leafing that has already adhered to the surface and use your brush to meld the two pieces together.

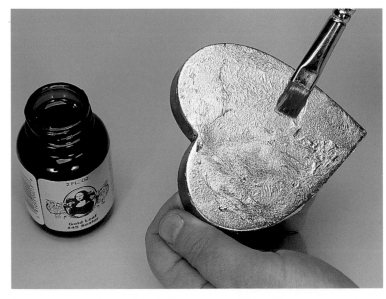

tera tip

Save the bits and pieces of leafing that are discarded when you brush your piece. They can be used in other pieces to fill cracks and crevices, and they make great embellishments for other craft projects such as rubber stamping.

When you are finished, seal the leafing to prevent lifting. If you want to antique the area with a stain or antiquing glaze, do so after sealing and then varnish the finished piece. The sealer will also protect the metal from oxidizing, tarnishing or deteriorating from exposure to oil in your hands and in the air.

Other Gilding Products

Delta has developed its own leafing system that is similar to traditional gold leafing, but is not as hard to use in terms of the delicate nature of most leafing products. *Renaissance Foil* is a bit glitzier and less subtle than traditional leafing, and great to use on ornaments and embellishments that need to be especially shiny. They also have a line of borders and phrases called *Instant Gilded Accents* that make application of these items a breeze.

As with traditional leafing, an adhesive is applied over a basecoat color. *Delta* has its own line of basecoat colors for the *Renaissance Foil* line, but any *Delta Ceramcoat* color can be used. After the adhesive has dried to a clear finish, apply a second coat of adhesive and allow it to dry for about an hour.

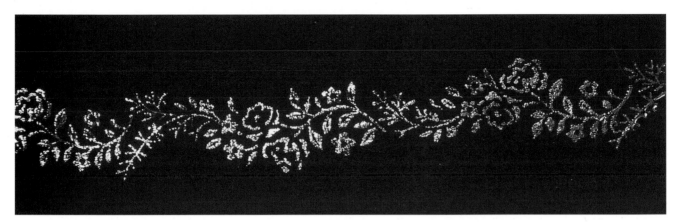

Renaissance Foil has a right side. The shiny side should be up or away from your surface. Apply the Foil and then press it to the surface as you did with the traditional leafing. When you have the Foil the way you want it, apply a sealer over the top.

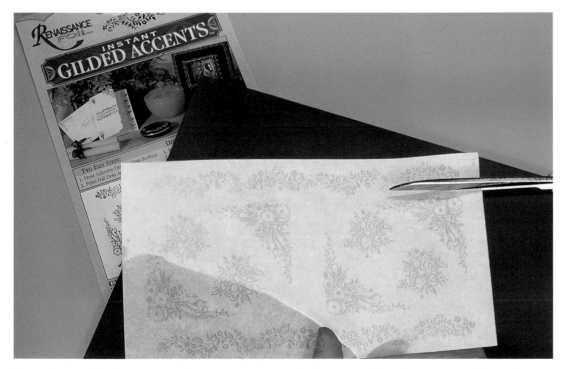

To use Instant Gilded Accents, open the package and choose the design you will use for your surface. The designs come sandwiched between a sheet of plastic and paper. Keep the protective sheets on and cut out the design or designs you will use.

Other Gilding Products, continued

Peel the paper sheet off the back of the design while holding the plastic side firmly in your hand. This is like peeling the backing off a sticker.

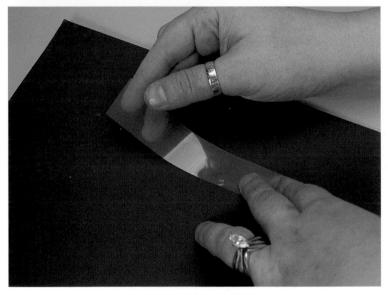

Place the design on your surface. The backing is clear, so you can easily see where the design will sit on your surface. Press down firmly with your finger but do not rub.

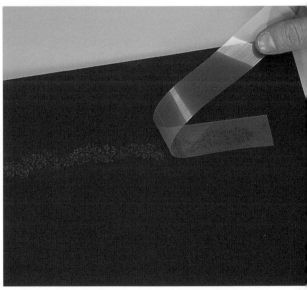

Gently peel the plastic backing away, making sure the adhesive stays in place on your surface. If it begins to lift, press the plastic down again and then lift.

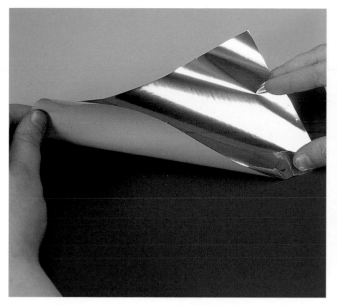

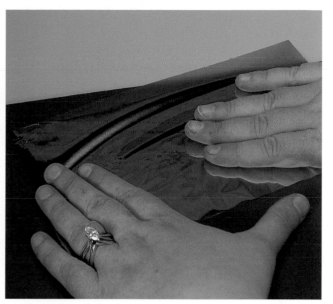

Trim a piece of Renaissance Foil to the approximate size of your design, but large enough so that it is easy for you to hold.

Place the Foil over the design with the shiny side facing up toward you. Firmly press the Foil down onto the adhesive strip.

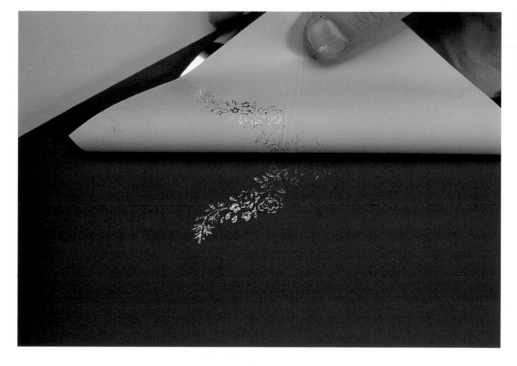

Carefully lift the Foil from the surface. If any part does not adhere, press the Foil back down onto the design until coverage is complete.

Other Gilding Products, *continued*

As gilding has become more popular, a variety of paint pens and products have been developed. One of the best for decorative painters is Plaid's Liquid Leaf. This product produces the most realistic metallic look of any paint products I have found. However, be aware that you should use it only in an area ventilated with fresh air. It contains xylene and should not be used around heat or sparks. Read the warnings on the label before deciding whether this product is acceptable for you to use.

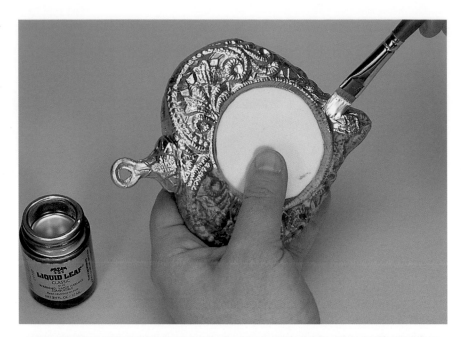

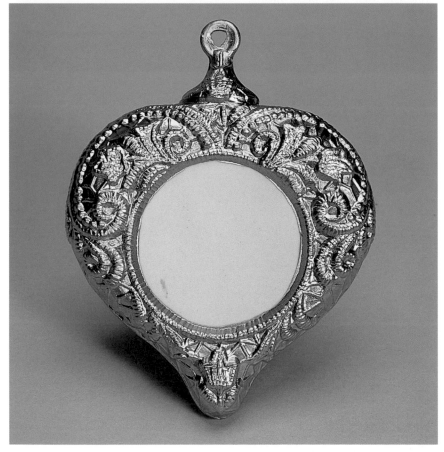

classes, conventions & resources

Where do I get started?

Taking Decorative Painting Classes

As with other industries, many small shops have gone away in the decorative painting industry, but that doesn't mean that teachers are not available. Many teachers work from their homes or teach at community centers. So how do you find a teacher? Start with the yellow pages. Shops are generally listed under the art, craft or hobby section.

If there are no small shops, look to larger craft stores or chain stores. Local teachers will often teach beginner classes at shops and then teach more advanced classes elsewhere. Another place to meet teachers is at craft shows, boutiques and shops. Ask people who are displaying painted items if they teach or know of local teachers.

Also, check out your community's educational resources such as adult education, community colleges and classes at libraries and parks. Look in your phone book or contact your chamber of commerce to see if there is an arts council or a group that may be able to give you a list of local teachers.

Another good source of teacher information is your local chapter of the Society of Decorative Painters. Even if the chapter is not close to

you, they may be able to give you a list of teachers so you can find one in your area. Teachers will often join chapters, even if they do not live nearby, in order to take advantage of seminars by visiting national teachers and to network with other people in the industry. It is a great idea to participate in a chapter because their newsletters will tell you about visiting teachers and national teachers doing seminars at shops.

Once you find a teacher, make sure that person is qualified. Unfortunately, there are teachers who have had only a few lessons themselves. While their hearts are in the right place, it would behoove you to find a teacher who is more experienced. Ask to see a portfolio of the artist's work and get references from some of her students. It is not enough to have a good portfolio. Being a good painter doesn't necessarily make you a good teacher. Call a few students and ask how long they have taken classes with the teacher and what their impressions are.

In 2001, the Society of Decorative Painters is beginning a teacher certification program that indicates the teacher's specific level of skill. In addition, many artists certify teachers in their specific method of painting. Some examples of this are Donna Dewberry, Priscilla Hauser and

Phyllis Tilford. If a teacher does not have certification, it doesn't necessarily mean that she is not a great teacher. Certification just tells you that a specific authority has certified the teacher as to her qualifications.

PROJECT-BASED CLASSES VS. OPEN CLASSES

Each teacher has her own approach to classes. I have met a lot of painters who want to learn how to paint but don't want to take the classes because they don't like a specific project or color palette. Teachers put together projects based upon specific skills that you need to learn. You have to walk before you can run. When you are a beginner, paint anything you get the opportunity to paint. You can give it away or repaint it later in a different color. It's important to get the experience you need.

In open classes, each student works on a project of her choice and the teacher helps the students individually. The challenge with this is that shyer students are liable to get less help if they don't speak out. However, if you learn best in a less structured environment, you may prefer this type of format. Talk to your teacher about the way she runs her class to learn what you should expect from the class.

Taking Decorative Painting Classes, *continued*

WHAT TO EXPECT IN CLASS

Wear comfortable clothes that you don't mind getting paint on. I have a separate collection of clothes with paint on the bottom of the sleeves or torso area where I accidentally bumped into the paint. I didn't notice until the paint was already dry. If you do get paint on your clothes and notice it right away, alcohol or vodka will generally take it off.

Each teacher has her own rules and you should read and follow them. Be aware that you are not the only person in the class, so try to be considerate and turn off your cell phone or beeper. If you can't turn them off, leave class before talking on the phone so that you don't disrupt other students. Some teachers will provide paint or other supplies. These supplies are usually meant to be shared, so don't monopolize the supplies.

Most classes are two to four hours long. Ask for breaks if the teacher does not give one so that you can stretch, use the rest room and so on. Many classes are offered in series of four to six weeks. It is important to be present at all the classes because the lessons build upon one another. If you miss a class, ask for the materials from the class ahead of time and find out if there are any written materials. It is not fair to hold up the students who were present for the class you missed, while you try to catch up. Ask the teacher in advance if she has makeup sessions or what her policy is for missed classes.

There is not a lot of profit in teaching painting. Many shops require you to purchase the kits and wood from the shop or teacher in advance, because they have to buy the stock in case you need it. Although getting started in painting may seem expensive, there is not a high margin of profit for most shops. A shop has many hidden costs, such as rent, staff and utilities, that you may not consider when you think about the materials that you are getting. Many painters will look at a discount catalog and see that they could save a dollar here or a few cents there and think the shop is "ripping them off." Consider the overall cost of your supplies and classes over the weeks and months that you will benefit from them. Many painters never appreciate what a great value a shop can be until they lose it and have to start paying shipping and traveling costs in order to learn!

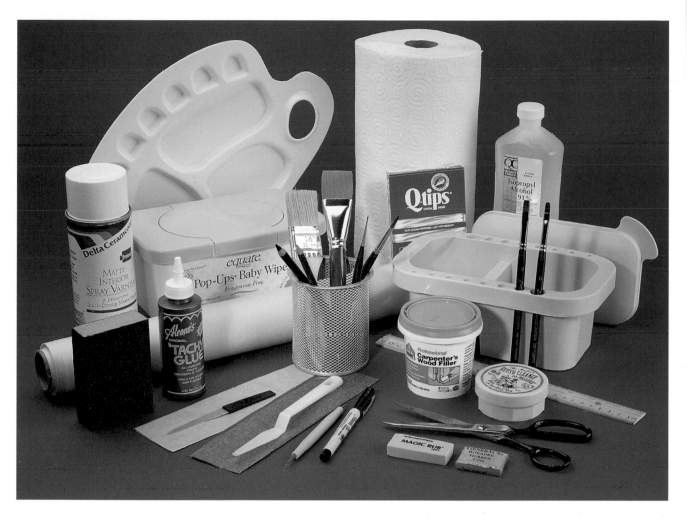

BASIC PAINTING KIT

What you will need for your basic painting kit will vary. Below is a sampling of items commonly used in beginner classes:

All-purpose sealer
Artist-quality eraser
Baby wipes
Basecoating brush
Brush cleaner
Brush holder
Chalk pencil
Cotton swabs
Craft glue
Fine tip permanent marker
Graphite pencil
Nail file

Painting brushes—
 One or two of the following kinds:
 Flats, rounds, filberts, and liners
Paints
Palette knife
Palette or palette paper
Paper towels
Rubbing alcohol
Ruler
Sanding pads—medium and fine grit
Scissors
Stylus
Tracing paper
Transfer paper
Varnish
Varnish brush
Water basin
Wood filler

Worldwide Conventions and Industry Associations

Another way to learn to paint is to attend painting conventions. Industry associations and businesses hold conventions around the world. Below is a list of these groups and how to contact them for information about upcoming events.

■ United Kingdom

BADFA (The British Association of Decorative and Folk Arts)
Brunel University
Uxbridge, Middlesex
1 Bentley Close
Horndean, Waterlooville, Hants
PO8 9HH
England
023-92-356658

■ United States

Creative Painting
P.O. Box 80720
Las Vegas, NV 89180
702-221-8234
members@aol.com/renopaint
members@aol.com/vegaspaint

Heart of Ohio Tole Mini Convention (HOOT)
P.O. Box 626
Reynoldsburg, OH 43068-0626
614-863-1785

New England Traditions
39 Webster Rd.
E. Lyme, CT 06333
518-393-1053
www.newenglandtraditions.org

SALI (Stencil Artisans League Int'l)
526 King St.
Suite 423
Alexandria, VA 22314
703-518-4375
www.sali.org

Society of Decorative Painters
393 N. McLean Blvd.
Wichita, KS 67203-5968
316-269-9300
www.nstdp.org
Note: The SDP has several hundred individual chapters around the world that also have mini-conventions. Contact the society directly to find the chapter nearest you.

Tole Country
Contact: Carol Robbins, Director
4000 Wagonwheel Rd.
Edmond, OK 73034
www.tolecountry.com

■ Canada

C-DAN
4981 Hwy. 7 E.
Unit 12A, Ste. 253
Markham, Ontario L3R 1N1
www.cdan.org

Edmonton Paintarama
Contact: Thelma Maris
P.O. Box 7349
Edson, Alberta T7E 1V5
780-723-3126
www.albertadirectory.com/paintarama

Kaswood Convention
Toronto, Ontario, Canada
Contact: Bonnie Kastner
593 Main Rd.
Hudson, Quebec J0P 1H0
450-458-3355
www.kaswood.com

Southwestern Ontario Paint-In, Paint-In Niagara, Paint-In Alberta
Contact: Audrey or Peter deJong
4442 Mill Crescent, Rt. 1
Ailsa Craig, Ontario N0M 1A0
519-232-9047
www3.sympatico.ca/shades.dejong

TUDAC
Contact: Jayne Todd
P.O. Box 1306
Lakefield, Ontario K0L 2H0
www.tudac.org

Australia

Decorative Folk Artists of Queensland, Inc.
P.O. Box 2326
Brookside Centre, QLD 4053

The Folk and Decorative Artists Association of Australia, Inc.
P.O. Box 80
18 Moore Ave.
West Lindfield, NSW 2070

Folk and Decorative Artists of Tasmania
P.O. Box 550
Moonah, Tasmania 7009

Folk Artists Guild of South Australia, Inc.
P.O. Box 501
Plympton, South Australia 5038

Folk Artists of Western Australia, Inc.
P.O. Box 1134
Kelmscott, DC 6997

Friends Through Folk Art Guild
P.O. Box 176
Penshurst, NSW 2222

Mid-North Coast Folk and Decorative Artists Association, Inc.
7 Alkina St.
North Sapphire
Coffs Harbour NSW 2450

The Society of Folk and Decorative Artists of Victoria, Inc.
P.O. Box 234
Ringwood, Victoria 3134

Sunshine Coast Decorative and Folk Artists Association
P.O. Box 5033
SCMC
Burnside, QLD 4560

New Zealand

Folk and Decorative Artists Society of New Zealand, Inc.
P.O. Box 87-107
Meadowbank, Auckland

Argentina

Fundación Pintura Decorativa Argentina
Venezuela 2169
Capital Federal
Buenos Aires
4262-5853
info@fpda.org.ar

Attending a Convention

Attending a convention to take classes is not a vacation. It can be very tiring going from class to class and walking the trade show floor. The following is a list of items that may be helpful to have with you in addition to your basic painting supplies.

Aspirin or acetaminophen for the headaches and footaches you will get from all the fun.

Binoculars or opera glasses to see the teacher if you get a seat toward the back of class.

Bristol board. If you are tired or not feeling confident, you may want to paint on paper instead of a surface during class.

Business cards with your name and address on them to exchange with fellow painters. Print your own on the computer even if you don't own a business, you may want to keep in touch!

Camera and film.

Canvas apron or book for the signatures of teachers and fellow painters you meet. This is a fun memento from each convention you visit.

Clear film containers with a blank label on the outside of each. If the teacher gives out paint during class that you will need to finish your project, you can store it in these containers.

Comfortable shoes. Forget fashion at conventions. Comfort reins supreme when it comes to painting and shopping.

Convention catalog.

Packing materials and tape in case you want to ship something home. Some painters ship their clothes home so they can take their new goodies with them right away.

Patience.

Pictures of completed projects to share with painters you meet.

Portable Ott Light in case you want to paint in your room after class.

Retarder to soak your brushes until you can properly clean them.

Snacks. There's never enough time to eat well between classes.

Snake light with rechargeable batteries. Most convention classes have lights in the ceiling that are not the best lighting for painters. A snake light can be clipped on the table or wrapped around your neck to give you the light you need.

Sturdy tote bag with shoulder strap for carrying on convention floor. Bags with wheels are generally not allowed on convention floors.

Sweater or sweatshirt. Convention classes are often cold.

Travel alarm.

Learning On Your Own

I cannot recommend anything more beneficial than joining the Society of Decorative Painters or an equivalent group in your area. The society has a magazine called *The Decorative Painter* that provides information about upcoming conventions and seminars, shops and the latest product information. If you are lucky enough to have a local chapter, you can take classes and meet other painters who share your passion for painting.

The National Decorative and Folk Art Painting Society
The Studio
Parson's Lane
Bisley, Gloucestershire GL6 7BB
England

Society of Decorative Painters
393 N. McLean Blvd.
Wichita, KS 67203-5968
316-269-9300
www.decorativepainters.org

■ Reference Books

If there isn't a local chapter or shop in your area or you can't get to one for other reasons, there are some terrific options to use for learning on your own. This book (if I do say so myself) is a good start. There are some other great reference books available that give a more in-depth approach to specific subjects addressed here.

The Complete Book of Basic Brushstrokes for Decorative Painters by Sharon Stansifer (North Light Books)

Conversations in Paint by Charles Dunn (Workman Publishing Company)

Country Painting Projects by Emma Hunk (David & Charles)

Decorative Folk Art by Sybil Edwards, Chris Moore and Lynette Bleiler (David & Charles)

Decorative Painter's Guide to Fruits and Flowers by Andy Jones (Watson-Guptill Crafts)

Decorative Painting Zhostovo Style by Heather Redick (North Light Books)

Donna Dewberry's Complete Book of One-Stroke Painting by Donna S. Dewberry (North Light Books)

Elegant Porcelain and Glass Painting Projects by Carin Heiden Atkins (North Light Books)

Emma Hunk's Country Painting Style by Emma Hunk (David & Charles)

Folk Art Style by Sybil Edwards (David & Charles)

Painting Baby Animal Treasures by Peggy Harris (North Light Books)

Painting Folk Art Flowers by Enid Hoessinger (North Light Books)

Painting Roses With Deanne Fortnam, MDA by Deanne Fortnam (North Light Books)

Realistic Wildlife Painting for Decorative Artists by Heather Dakota (North Light Books)

Sophisticated Surfaces: Ideas and Inspirations From 15 Professional Surface Painters by Karen Aude (Quarry Books)

You can also join book clubs for the artist. This is a great service because they keep you up-to-date on the latest books that are published.

Decorative Artist's Book Club
1507 Dana Ave.
Cincinnati, OH 45207
artistsnetwork.com
631-851-5232

North Light Book Club
1507 Dana Ave.
Cincinnati, OH 45207
artistsnetwork.com
631-851-5232

Artists & Teachers

Each year a large number of artists publish small books with patterns to teach decorative painting techniques. The following is a list of artists you can contact for catalog information.

Susan Abdella, MDA
420 Marilyn Ln.
Redlands, CA 92373
909-335-1046

Vicki Allwardt, CDA
876 Olive St.
Red Bluff, CA 96080
Vallwardt@aol.com
www.busybrushes.com/ToleShoppe/allwardt

Erika Ammann
P.O. Box 3502
Vail, CO 81658
erika@vail.net

Gail Anderson
12822 Water St.
Duluth, MN 55808
www.tolehaven.com

Rebecca Baer, CDA
13316 Marsh Pike
Hagerstown, MD 21742
301-797-1300
painting@rebeccabaer.com
www.rebeccabaer.com

Sue Bailey
2150 McDuffie Rd.
Austell, GA 30001-1826
770-941-5571

Carolyn Ballantine
38 Glover St.
South Melbourne, Victoria 3205
Australia
61-3-9696-2233

Helan Barrick
5805 E. Seventy-Eighth Pl.
Tulsa, OK 74136
918-492-2218
Barrickmda@aol.com

Jane Barrientos, CDA
33 Cooper St.
West Springfield, MA 01089
413-736 8882
jonas18@juno.com

Arlene Beck, MDA
3255 Scotch Ridge Rd.
Duanesburg, NY 12056-0100
518-482-3775

Lynette Bredow
1109 Sixth St.
Ramona, California 92065
760-789-1412
cntrydsnr@netscape.net
www.lynettebredow.com

Ronnie Bringle
1345 W. 530th
McCune, KS 66753
316-632-4218
ronniebringle@ckt.net

Gretchen Cagle
403 W. Fourth St.
P.O. Box 2104
Claremore, OK 74018-2104
918-342-1080

Karen Chase
87 N. 200 W.
Ivins, UT 84738
435-628-3274
kchase4119@aol.com
www.creativeartist.com/kchase

Pat Ciccolella
2971 Blaney
Las Vegas, NV 89121
702-734-7337
www.bearing.com/catsmeow

Aurelia Conway
10285 S. 500 E.
Elizabethtown, IN 47232
812-579-6510
aconway@hummingdhill.com
www.hummingbdhill.com

Dorothy Dent
108 W. Hwy. 174
Republic, MO 65738
417-732-2076
ddent94587@aol.com
www.ddent.com

Donna Dewberry
811 E. Highland Dr.
Altamonte Springs, FL 32701
800-536-2627
dewberry@magicnet.net
www.onestroke.com

Betsy H. Edwards
273 Silver Lake Rd.
Hollis, NH 03049
justbetsys@aol.com

Heidi England
2006 Laurel Hill Dr.
Kingwood, TX 77339
heidi@pcm.net
www.heidiengland.com

Deanne Fortnam, MDA
18 Cambridge Rd.
Nashua, NH 03062-3621
603-881-3579
www.deanneart.com

Scottie Foster
6415 Rivington Rd.
Springfield, VA 22152
703-569-2415
www.bavarianfolkart.com

LuAnn Ginnetti
11826 Thunderbird Ave.
Northridge, CA 91326
818-360-9456

Mary Helen Gould
911 Eastland Circle
Columbia, MO 65201-5563
573-443-4058
maryhelen@gouldcreations.com
www.gouldcreations.com

John Gutcher
1001 Morrison Ct.
Tampa, FL 33629-4912
813-289-4479
JGutcher@aol.com

Priscilla Hauser
P.O. Box 521013
Tulsa, OK 74152-1013
sales@priscillahauser.com
www.priscillahauser.com

Catherine Holman
103 Lakeview Dr.
Excelsior Springs, MO 64024-2552
816-630-5832
www.teantole.com.

Roxanne Jarvis
1763 Stokesley Rd.
Baltimore, MD 21222
410-284-6065
Tolefairie@home.com

Charles Johnson
2357 S. Rogers
P.O. Box 4092 GSS
Springfield, MO 65804
417-886-8052
chasdesigns@hotmail.com

Tricia Joiner
371 Winding Pond Rd.
Londonberry, NH 03053
603-425-7869
TriciaD@aol.com
www.tricias.com

Jo Sonja's Folk Art, Inc.
P.O. Box 9080
Eureka, CA 95501
707-445-9306

Lindy Judd
5 Murev Way
Carrara, QLD 4211
Australia
painting_oz@dingoblue.net.au
www.packet-emporium.com

Julie's White House Originals
2115 E. Edgewood
Springfield, MO 65804

Doxie Keller
127 W. Thirtieth
Hutchinson, KS 67501
doxie@southwind.net

Ann Kingslan
9851 Louis Drive
Omaha, NE 68114-1233
402-397-1239
www.kingslan.com

Yvonne Kresal
18197 NW Pumpkin Ridge Rd.
Cornelius, OR 97113
503-647-5303

Kathy Langdon
10220 Hwy. 41
Madeira, CA 93638
599-432-3908
designs@kathylangdon.com
www.kathylangdon.com

Tera Leigh
923 Oak St.
Lafayette, CA 94539
925-299-2916
tera@teras-wish.com

Mary McCullah
5101 Foxfire Trail
Kingsport, TN 37664
423-288-8573
mtnraptor@aol.com

Linda McFadden
26111 Ynez Rd., Suite B-8
Temecula, CA 92591
909-506-0101
linnymac@aol.com

Maureen McNaughton
Rt. 2
Belwood, Ontario N0B 1J0
Canada
519-843-5648
creativeartist.com/maureen

Debbie Mitchell
304 W. Cheryl
Hurst, TX 76053
817-282-6890
800-282-2836
CozyCubby@aol.com
www.debbie-mitchell.com

Phil Myers and Andy Jones
731 Highland Ave. N.E.
Atlanta, GA 30312
404-222-0348
www.creativehome.com

Sherry C. Nelson, MDA
The Magic Brush, Inc.
P.O. Box 530
Portal, AZ 85632
520-558-2285

Claudia Nice
60906 E. Hwy. 26
Sandy, OR 97055
503-622-3060

Jackie O'Keefe
1290 Saint George Rd.
Merritt Island, FL 32951-6112
407-452-4100
jokeefe@digital.net

Gayle Oram
6090 Hangar Rd.
Tillamook, OR 97141
503-842-2957

Artists & Teachers, continued

Carolyn L. Phillips
23416 Applegate Ct.
Murrieta, CA 92562
909-696-6821
PhillipsPu@cs.com

Jamie Mills Price
112 N. Old Pacific Hwy.
Myrtle Creek, OR 97457
541-863-4466

Heather Redick
19 Goshen St. N.
Zurich, Ontario N0M 2T0
Canada
519-236-4945
heather@hay.net

Cindy Rippe
2305 Desplaines
Blue Island, IL 60406
708-385-1165
Lrippe3699@aol.com

Susan Scheewe
13435 N.E. Whitaker Way
Portland, OR 97230
503-252-9100
www.painting-books.com

Jackie Shaw Studio
Rt. 3
Box 155
Smithsburg, MD 21783
301-824-7592
www.jackieshaw.com

Jo Sonja's Folk Art, Inc.
P.O. Box 9080
Eureka, CA 95501
707-445-9306

Brenda Stewart, CDA
11825 Blandfield
Richmond, VA 23233
804-364-1924

Peggy Stogdill
P.O. Box 4653
Boynton Beach, FL 33424
561-737-3694

Chris Stokes
222 Main St.
Dallas, GA 30132
770-445-8228

Bobbie Takashima
Country Keepsakes
340 West Twenty-Sixth St.
Suite D
National City, CA 91950
619-474-0898
BTFROGS@aol.com
www.BobbieArtStudio.com

Maxine Thomas
822 N.W. Twenty-Third
P.O. Box 613
Camas, WA 98607
306-834-7033
Stippler@aol.com
www.countryprimitives.net

Vi Thurmond, MDA
Box 35394 DP
Des Moines, IA 50315-0304
www.tolenet.com/thurmond

Phyllis Tilford, CDA
1675 S. John Rodes Blvd., Unit C
W. Melbourne, FL 32904
407-724-6988
PTCDA@aol.com
www.tolenet.com/tolemill

Nancy Tribolet, CDA
15219 Stuebner Airline Rd. #5
Houston, TX 77069
281-893-2227

Kerry Trout
P. O. Box 125
Danville, IN 46122
317-745-7296
KerryTrout@juno.com
www.KerryTrout.com

Prudy Vannier
279 Maplewood St.
Northville, MI 48167-1149
810-380-0220
prudy@ismi.net
www.prudysstudio.com

Barb Watson, MDA
20600 Ave. Hacienda
Riverside, CA 92508-2425
909-653-3780
www.barbwatson.com

Marsha Weiser
43 Edgewood Dr.
Brewer, ME 04412
207-989-5439

Shirley Wilson
Ladybug Art Center, Dept. 101
P.O. Box 4159
Springfield, MO 65808
417- 883-4708

Linda Wise, MDA
Linda Wise Designs
P.O. Box 4523
Springfield, MO 65808-4523
417-886-4590

Mary Wiseman
12856 Whitfield
Sterling Htgs., MI 48312
810-264-7328

Susie Wolfe
13260 Tripoli Ave.
Sylmar, CA 91342
swolfe@earthlink.net
www.packetemporium.com
/artists/susie-wolfe

Chieko Yuguchi
1-18-1 Komaba
Toride-shi 302-0027
Japan
297-74-0697
chieko@yuguchi.toride.ibaraki.jp
www.yuguchi.toride.ibaraki.jp/~masa

Jean Zawicki
E2341 Crystal Rd.
Waupaca, WI 54981
715-258-6162

Magazines

Artist's Journal
Jo Sonja's Folk Art, Inc.
P.O. Box 9080
Eurcka, CA 95501

The Artist's Magazine
P.O. Box 2120
Harlan, IA 51593
800-333-0444

Decorative Artists Workbook
P.O. Box 3284
Harlan, IA 51593
800-333-0888

The Decorative Painter
(Magazine of the Society of
Decorative Painters)
P.O. Box 808
Newton, KS 67114

Folk Art and Decorative Painting
Express Publications Pty Ltd.
2 Stanley St.
Locked Bag 111
Silverwater, NSW 2128
Australia
02-748-0599
subs@expresspublications.com.au

Canadian Distributor:
Stonehouse Publications
85 Chambers Dr., Unit #1
Ajaz, Ontario L1Z 1E2
Canada
800-461-1640

U.S. Distributor:
Australian Publications
North Austin Business Center
8711 Burnet Rd.
Suite G-80
Austin, TX 78757-7043
888-788-6572
auspubs@aol.com

Painting
P.O. Box 5007
Des Plaines, IL 60017-5007
800-444-0441
www.clapper.com

PaintWorks and
PaintWorks Quick & Easy Painting
U.S. Distributor:
Kable News Co.
641 Lexington Ave.
New York, NY 10022
800-877-5527

Distributor outside the U.S. and
Canada:
Worldwide Media Service, Inc.
30 Montgomery St.
Seventh Floor
Jersey City, NJ 07302

Tole World
308 E. Hitt St.
P.O. Box 455
Mt. Morris, IL 61054-7685
510-671-9852, ext. 1202

Wood Strokes
1041 Shary Circle
Concord, CA 94518

Videos

Another excellent way to learn how to paint is through videos. Videos enable you to watch the teacher up close and to replay sections that you are confused about. Many published artists produce their own videos. These are available through their cat alogs and at conventions. The following companies also produce painting videos:

The Joy of Painting
P.O. Box 946
Sterling, VA 22170
800-EASY-ART

Perfect Palette Videos
P.O. Box 25286
Milwaukee, WI 53225
800-839-0306
www.perfectpalette.com

Royal Brush Manufacturing, Inc.
6949 Kennedy Ave.
Hammond, IN 46323
800-247-2211

Finding Supplies

If you don't have a local shop or can't get to conventions, finding supplies can be challenging. The following is a list of retail suppliers. The listing below should not be construed as an endorsement of one company over another. This is just an attempt to help you find the materials you need.

Full Service Suppliers

Afonwen Craft & Antique Centre
Afonwen
Caerwys
Nr. Mold
Clwyd CH7 5UB
Wales

Annie Sloan España
La Aldea S/N
18697 La Herradura
Granada
Spain
0034-958-640552

Artist Club
P.O. Box 8930
Vancouver, WA 98668-8930
800-257-1077
360-260-8900, ext. 133
www.artistsclub.com

Arts & Crafts Canada
P.O. Box 1870
83 Queen St. E
St. Marys, Ontario N4X 1C2
Canada
877-565-ARTS
www.artsandcraftscanada.com

Bailey's Paint
Griffin Mill Estate
London Rd.
New Stroud
Thrupp, Gloucester GL5 2AZ
England
01453-882237

Belinda Ballantine
The Abbey Brewery
Malmesbury
Wiltshire SN16 9AS
England

Bradshaws
11 Park St.
Ninehead
Somerset TA24 5NQ
England

Bristol Decorator Centres
456 Enoggera Rd.
Alderley 4051
Brisbane QLD
Australia
07-536-1044

The British & Columbian Trading Co.
The Silver Thimble
Rt. 1, Site 10 b, C. 18
Kaleden, British Columbia V0H 1K0
Canada
250-497-6167

Brodie & Middleton, Ltd.
68 Drury Ln.
London WC2B 5SP
England
071-836-3289

Carmichael Components, Ltd.
26 Pield Heath Rd.
Uxbridge Middlesex UB8 3NG
England

Catalina Cottage
125 N. Aspan #5
Azusa, CA 91702
800-787-6685
www.catalinacottage.com

Cheap Joe's Art Stuff
374 Industrial Park Dr.
Boone, NC 28607
800-447-8192
www.cheapjoes.com

Cotswold Epicure
5, Oxford Rd.
Moreton-in-Marsh
Oxon GL56 0LA
England
01608-652999

Cottage Folk Art
7 Church St.
Beaminster, Dorset DT8 3BT
England

Craig & Rose, PLC.
172 Leith Walk
Edinburgh EH6 5EB
Scotland
031-554-1131

Cranberry Creative Finishes
Bee's Barn
Fulbeck Lowfields
Grantham, Lincolnshire
England
01636-626562

Creative Decorating
Maranatha, Whitbrock
Wadebridge, Cornwall PL27 7ED
England
01208-814528

Crick House Interiors
Weston Business Park
Weston on the Green
Oxon OX6 8TJ
England
01869-343007

Daler-Rowney, Ltd.
12 Percy St.
London W1A 2BP
England
071-636-8241

The Decorative Arts Co., Ltd.
5 Royal Crescent
London W11 45N
England

De Vergulde Kwast
Westerkade 19
3511 HB Utrecht
Netherlands
0031-0-303-40615

Dick Blick
P.O. Box 1267
Galesburg, IL 61402-1267
800-328-4548
www.dickblick.com

Do-It-All, Ltd.
Falcon House
The Minories
Dudley
West Midlands KY2 8PG
England
0384-456-456

Duller and Co.
Van Oldenbarneveldstraat 82
1052 KG Amsterdam
Netherlands
0031-0-2068-42332

E. Milner Oxford, Ltd.
Glanville Rd.
Cowley, Oxford OX4 2DB
England
0865-718-171

Effects of Honiton
Plympton House
59 High St.
Honiton, Devon EX14 8EU
England
01404-44971

Erika Ammann
P.O. Box 3502
Vail, CO 81658
erika@vail.net

Fanny's Antique Centre
1 Lynmouth Rd.
Reading Berks RG1 8DD
England
01189-50-8261

Folk Art Enterprises
73 Marsh St.
P.O. Box 1088
Ridgetown, Ontario N0P 2C0
Canada
800-265-9434

Foxell and James, Ltd.
57 Farringdon Rd.
London EC1M 3JB
England
071-405-0152

Greystone's Antiques & Interiors
High St., Lechlad
Gloucester GL73AE
England
01367-253140

Hearthspun Decorative Arts
1170 Burnhamthorpe Rd. W., #26
Mississauga, Ont. L5C 4E6
Canada
905-949-1888

Herrschners, Inc.
2800 Hoover Rd.
Stevens Point, WI 54492
800-441-0838
www.herrschners.com

Hobby Lobby
7507 SW Forty-Fourth St.
Door 038
Oklahoma City, OK 73179
405-745-1100
www.hobbylobby.com

Hofcraft
P.O. Box 72
Grand Haven, MI 49417
800-828-0359
www.hofcraft.com

Holly's
90 King St.
Woodville, Ontario K0M 2T0
Canada
705-439-1198
www.sympatico.ca/hoolyivens
/holly.htm

Homebase Ltd.
Beddington House
Wallington, Surrey
England
081-784-7200

HomeCraft Express
P.O. Box 24890
San Jose, CA 95154-4890
800-301-7377
www.homecraftexpress.com

Hudson Gool Heirloom
Pells Farm
Pells Ln.
West Kingsdown
Kent TN15 6AU
England

Jerry's Artarama
P.O. Box 1105J
New Hyde Park, NY 11040
800-827-8478
UArtist@aol.com
www.jerryscatalog.com

J. H. Ratcliffe and Co.
135a Linaker St.
Southport PR8 5DF
England
0704-537-999

Jo-Ann Fabrics & Crafts
841 Apolla St., Ste. 350
El Segundo, CA 90245
(800) 525-4951
www.joanns.com

Jocasta Innes
2 Milk St.
Shrewsbury SY1 1SZ
England
01743-341682

John Jones Art Centre
4 Morris Pl.
Off Stroud Green Rd.
Finsbury Park
London 4N4 3JG
England
0171-2815439

Finding Supplies, continued

J. W. Bollom
13 Theobalds Rd.
London WC1X 8FN
England
071-242-0313

Kristina Bulat
5 Anne's Ct.
Halifax, West Yorkshire HX3 9RS
England
17775-735151

L. Cornelissen & Son, Ltd.
105 Great Russell St.
London WC1B 3RY
England
0171-636-1045

Le Mani
Grolmanstr. 20
10623 Berlin
Germany
0049-30-315-07682

Leo's Decorators (VIC) Pty, Ltd.
119 McKinnon Rd.
McKinnon 3204
McKinnon VIC
Australia
03-578-4465

Linova
Laarstraat 74-76
7201 CG Zutphen
Netherlands
0031-0-575-42300

Luxbros
NV Lerrekenstr. 32b
2220 Heist op den Berg
Belgium
0032-0-15245555

Marlow Antique Centre
35 Station Rd.
Marlow, Bucks SL7 1NN
England
01628-473223

MercArt
Mexico City, Mexico
Av. San Antonio 339 esq. Periferico
Col. San Pedro De Los Pinos
516-8645

Michael's Arts and Crafts
8000 Bent Branch Dr.
Irving, TX 75063
www.michaels.com

Miller's Art Shop
28 Stockwell St.
Glasgow G14 RT
Scotland
0141-553-1660

Opus Framing and Art Supplies
1677 Second Ave. W.
Vancouver
British Columbia V6J 9Z9
Canada
604-736-7535
800-663-6953

Paint and Paper
Hellesdon Park Ind. Est
Drayton Rd
Norwich, Norfolk NR6 5DR
England
01603-400777

Paint Magic
59 High St.
Holywoood Co. Down
Northern Ireland BT18 9AQ
01232-421881

Paint Magic/Jocasta Innes
412 Pebble Creek Ct.
Pennington, NJ 08534-1945
609-730-0445

The Paint Pot Decorating Centres, Ltd.
636 Goodwood Rd.
Daw Park 5041
Adelaide SA
Australia
08-276-9828

Paris Paint Techniques
Valerie Traynor
91 Rutland St.
Carlisle, MA 01741
978-369-3440

Paul's Paint & Decor Centre
57 Dixon Rd.
Rockingham 6168
Perth, WA
Australia
09-592-3440

Period Effects
4 Church St.
Lutterworth
Leicestershire LE17 4AW
England
01455-553049

Practical Style
117 London Rd.
Oxford
England

Pulchalski Woodcrafts
Rt. 1
P.O. Box 1656
Moscow, PA 18444
800-923-9663

Pure Country Pine & Folk Art
Rt. 4
Limberlost Rd.
Huntsville, Ontario P1H 2J6
705-635-3506

Rag `n Roll
41 Adams Ave.
Abington, Northampton NN1 4LQ
England
01604-624-624520

Relics of Witney
35 Bridge St.
Witney, Oxon OX8 6DA
England
01993-704-611

Robinson's Woods
1057 Trumbull Ave.
Unit N
Girard, OH 44420
330-759-3843
www.robinsonswoods.com

Sax Arts and Crafts
P.O. Box 331
9515 Montrose Rd.
Niagara Falls, Ontario L2E 6T3
Canada
800-884-3963
www.artsupplies.com

Serendipity
12 Devonshire St.
Penrith, Cumbria CA11 7SR
01768-895-977
www.edirectory.co.uk/serendipity

Settler's Cabin
Rt. 1
(Baxter) Angus, Ontario L0M 1B0
Canada

Shapes
Wester Inches Farm House
Inverness 1V2 5BG
Scotland
01463-230378

Stan Brown's Arts and Crafts Inc.
13435 N. E. Whitaker Way
Portland, OR 97230
800-547-5531
www.stanbrownartsandcrafts.com

The Stencil Shop
Eyam Hall Craft Centre
Eyam, Hope Valley
Derby S32 5QW
England
01433-639001

Stonebridge Collection
Rt. 4
Pakenham, Ontario K0A 2X0
Canada
800-ART-TOLE
www.stonebridgecoll.com.

Texas Homecare, Ltd.
Homecharm House
Park Farm
Wellingborough
Northants NN8 6SA
England
0933-679-679

Upstairs at Trend of Worcester
14 Friar St.
Worcester WR1 2RZ
England
01886-880810

Viking Woodcrafts
1317 Eighth St. S.E.
Waseca, MN 56093
800-328-0116
www.vikingwoodcrafts.com

Webbs of Tenterden
51 High St.
Tenterden, Kent TN30 6BH
England
01580-762132

Welcome Home
18a Warwick St.
Worthing, Sussex BN11 3DJ
England
01903-215542

Wickes
120-138 Station Rd.
Harrow, Middlesex HA1 2QB
England
081-863-5696

Wrights of Lymm
Millers Lane
Lymm, Cheshire WA13 9RG
England
01925-752226

Zana Anne Designs
Mountfield, Staple St.
Hernhill
Faversham, Kent ME13 9TY
England
01227-752606

Zoe Rogers
47 Woodland Rd.
Kenilworth
Warwickshire CV8 2FT
England

■ **Brushes**

Art and Craft Supply
Carroll Rd.
P.O. Box 5070
Slidell, LA 70469-5070
800-642-1062

Daler-Rowney USA/Robert Simmons
2 Corporate Dr.
Cranbury, NJ 08512
609-655-5252

Dove Brushes
280 Terrace Rd.
Tarpon Springs, FL 34689
800-334-3683
www.dovebrushes.com

Expressive Arts and Crafts Supplies
12455 Branford St.
Unit 6
Arleta, CA 91331
800-747-6880

Jack Richeson & Co., Inc.
P.O. Box 160
557 Marcella St.
Kimberly, WI 54136-0160
800-233-2545

Loew-Cornell
563 Chesnut Ave.
Teaneck, NJ 07666-2490
201-836-7070
www.loew-cornell.com

Raphael Brushes
Cottage Folk Art
7 Church St.
Beaminster, Dorset DT8 3BA
England

Finding Supplies, continued

Royal & Langnickel Brushes
6707 Broadway
Merrillville, IN 46410
800-247-2211

Scharff
P.O. Box 746
Fayetteville, GA 30214
888-SCHARFF
www.artbrush.com

Silver Brush Limited
92 North Main St.
Bldg. 18E
P.O. Box 414
Windsor, NJ 08561-0414
609-443-4900
www.silverbrush.com/

SUN-K Co., Ltd.
Higashi-Nihonbashi 1-11-15
Chuo-ku
Tokyo, Japan 103

Winsor & Newton/Colart Americas Inc.
11 Constitution Ave.
P.O. Box 1396
Piscataway, NJ 08855
732-562-0770

Winsor & Newton
51 Rathbone Pl.
London W1P 1AB
England
071-636-4231

■ Canvas

Artist Dream Kanvas
T/C Art Supply
P.O. Box 320
Groveland, CA 95321

BagWorks
3301-C. S. Cravens Rd.
Ft. Worth, TX 76119
800-365-7423
www.bagworks.com

■ Clothing

Advantage Apparel
P.O. Box 490
Market St.
Moundville, AL 35474
800-959-6134

Artistically Inclined
463 Commerce Park Dr.
Suite 10
Marietta, GA 30060
800-878-6018

Diamond Apparel, Inc.
1115 Independence Blvd.
Suite 201
Virginia Beach, VA 23455
800-388-7171
www.diamondapparel.com

Goodbuy Sportswear
2400 Thirty-First St. S.
St. Petersburg, FL 33712-3307
800-282-0974

Predot
P.O. Box 13804
New Orleans, LA 70185
800-535-7803

Sunbelt Sportswear
P.O. Box 791967
San Antonio, TX 78279-1967
800-531-5916

■ Cut Wood Supplier

B & N Woodcrafts
31234 Wheel Ave
Unit 105
Abbotsford
British Columbia V2T 6G9
Canada
604-854-5501

Boulder Hill Woodworks
HC 61
P.O. Box 1036
St. George, ME 04857
800-448-4891
www.midcoast.com/~rewco

Cape Cod Cooperage
1150 Queen Anne Rd.
Chatham, MA 02633
800-479-0788

Cherry Tree Toys
P.O. Box 369
Belmont, OH 43718-0369
800-848-4363
www.cherrytree-online.com

Designs by Bentwood, Inc.
170 Big Star Dr.
P.O. Box 1676
Thomasville, GA 31792
912-226-1223

Meisel Hardware Specialties
P.O. Box 70
Mound, MN 55364-0070
800-441-9870

R & M What Knots
23406 Ninety-Fourth Ave. W.
Edmonds, WA 98020
206-542-1592

Sechtem's Wood
533 E. Margaret Ave.
Russell, KS 67665
785-483-2912

A Touch of Dutch
15970 N.W. Davidson Rd.
Banks, OR 97106
503-674-2423

Unique Woods
400 N. Bowen Rd., #114
Arlington, TX 76012
800-353-9650

Walnut Hollow Farm Inc.
1409 State Rd. 23
Dodgeville, WI 53533
608-935-2341

Wayne's Woodenware
1913 State Rd. 150
Neenah, WI 54956
920-725-7986

White Pine Design, The Box Co.
3877 Christytown Rd.
Story City, IA 50248
515-388-4601

The Wood Cellar
Rancocas Woods
114 Creek Rd.
Mt. Laurel, NJ 08054
609-273-1117

York River Trading Store
90 Rt. 1
York, ME 03909
207-363-7734

Zim's Inc.
P.O. Box 57620
Salt Lake City, UT 84157
800-453-6420

Cypress Knees

Louisiana Cypress Products
HC 76
P.O. Box 220
Olla, LA 71465
318-495-5450

Tom's Cypress, Inc.
Hwy. 301 N.
P.O. Drawer L
Waldo, FL 32694
904-468-2357

Fabric Suppliers

Jaquard
Rupert, Gibbon & Spider
P.O. Box 425
Healdsburg, CA 95448
800-442-0455

Wimpole Street Creation
955 North West, Bldg. 6
North Salt Lake, UT 84054

Glassware

Christmas by Krebs
P.O. Box 5730
Roswell, NM 88202-5730
505-624-2882

Gold Leaf

Stuart R. Stevenson
68 Clerkenwell Rd.
London EC1m 5QS
England
0171-253-1693

Gourds

The American Gourd Society, Inc.
P.O. Box 274K
Mt. Gilead, OH 43339
419-946-3302

The Gourd Farm
1089 Hoyt Braswell Rd.
Wrens, GA 30833
706-547-6784

Sandlady's Gourd Farm
Rte. 4
P.O. Box 86
Tangier, IN 47952
765-498-5428
www.bloomingdaletel.com/~sandlady

West Mountain Gourd Farm
Rt. 1
Box 853m
Gilmer, TX 75644
903-734-5204

White River Gourds
P.O. Box 443
Muncie, IN 47308-0443
www.gourds.com

Leather

Pigmentation's
2056 300th St.
Odebolt, IA 51458
712-668-2625

Metal/Tin

Barb Watson's Brushworks
P.O. Box 1467
Moreno Valley, CA 92556
909-653-3780
www.barbwatson.com

BFB Sales Limited
6535 Millcreek Dr., Unit 8
Mississauga, Ontario L5N 2M2
Canada
905-858-7888

Colonial Tin Works, Inc.
P.O. Box 8827
Greensboro, NC 27419
800-433-5054

Craft Catalog
P.O. Box 1069
Reynoldsburg, OH 43068
800-777-1442

The Tin Angel
2274 King James Ct.
Winter Park, FL 32792
407-339-8872

Tin Originals
P.O. Box 64037
Fayetteville, NC 28306
919-424-1400

Paint Manufacturers

A. P. Fitzpatrick Fine Art Materials
142 Cambridge Heath Rd.
London E1 5QJ
England
0171-790-0884

Binney & Smith, Ltd.
599 Blackburn Rd.
Clayton North 3168
P.O. Box 684
Glen Waverly 3150
Victoria
Australia

Finding Supplies, *continued*

Binney & Smith, Ltd.
Toronto Sales & Distribution Office
40 E. Pearce St.
Richmond Hill, Ontario L4B 1B7
Canada

Binney & Smith, Ltd. (Liquitex products)
Amphill Road, Bedford MK42 9RS
England

Chroma, Inc.
(Jo Sonja's Acrylic, Archival Oil)
205 Bucky Dr.
Lititz, PA 17543
800-257-8278
www.chroma-inc.com

Chroma Acrylics Pty Ltd.
P.O. Box 3B
Mt. Kuring-Gai
NSW 2080
Australia

Chroma Colour
Cartoon House
16 Grange Mills
Weir Road
Balham
London SW12 0NE
England

DecoArt
P.O. Box 386
Stanford, KY 40484
800-367-3047
www.decoart.com

DecoArtistic
Studio House
Rotherwick
Basingstoke, Hampshire RG27 9BG
England

Delta Technical Coatings
2550 Pellissier Pl.
Whittier, CA 90601-1505
800-423-4135
www.deltacrafts.com

Genesis Artist Colors
4717 W. 16th St.
Indianapolis, IN 46222
317-244-6871

George Weil & Son, Ltd. (Delta Ceramcoat)
The Warehouse
Reading Circle Rd.
Redhill, Surrey RH1 1HG
England

Koh-I-Noor
(Accent Acrylics, Max Oils, Grumbacher)
100 North St.
Bloomsbury, NJ 08804
800-877-3165

Majestic Paints
3090 Southwest Blvd.
Grove City, OH 43123
614-871-1777

Maple Ride Paint Co.
(1837 Legacy Acrylic)
P.O. Box 14
Ridgetown, Ontario N0P2C0
Canada
888-214-0062
www.folkartenterprises.org

Martin/F. Weber Co. Paints
(Prima Oils and Acrylics)
2727 Southhampton Rd.
Philadelphia, PA 19154-1293
215-677-5600
www.weberart.com

Paint Service Co., Ltd.
19 Eccleston St.
London SW1 9WX
England
071-730-6408

Plaid Enterprises, Inc.
(FolkArt, Apple Barrel)
P.O. Box 7600
Norcross, GA 30091-7600
800-842-4197
www.plaidonline.com

Potmolen Paint
27 Woodcock In. Estate
Warminster, Wiltshire BA12 9DX
England
0985-213-960

Stulb's Old Village Paints
P.O. Box 1030
Fort Washington, PA 19034
800-498-7687

Tomas Seth & Co.
(Jo Sonja products)
Holly House
Castle Hill
Hartley, Kent DA3 7BH
England

■ Papier mâché

Catalina Cottage
125 N. Aspan #5
Azusa, CA 91702
800-787-6685

J and R Industries
P.O. Box 4221
Shawnee Mission, KS 66204
800-999-9513

■ Porcelain

Auntie M's Porcelain
P.O. Box 1122
Salina, KS 67401-1122
785-823-3893

Decorative Porcelain Ltd
1515 Evergreen Pl.
Tacoma, WA 98466-6436
206-565-3051

JC's Pour `n More
407 Main St.
Spearville, KS 67896
316-385-2627
www.ucom.net/~dustzone

Porcelain by Marilyn
3687 W. Rt. 40
Greenfield, IN 46140
317-462-5063

Pottery/Stoneware

The Creative Cat
512 Mammouth Rd.
Londonderry, NH 03053
603-437-5947

Masterpieces
11A Loudoun St., S.W.
Leesburgh, VA 22075
800-771-1303

Robinson Ransbottom Pottery
P.O. Box 7
Roseville, OH 43777
740-697-7355
www.ransbottompottery.com

Yesteryears Pottery
P.O. Box 460
Marshall, TX 75671
903-935-7481

Slate

Cape Cod Cooperage
1150 Queen Anne Rd.
Chatham, MA 02653
508-432-0788

Capozzolo Brothers Slate Co.
1342 Ridge Rd.
Bangor, PA 18013
800-282-6582
www.regiononline.com/capozzolo

Penn Big Bed Slate Co., Inc.
8450 Brown St.
Slatington, PA 18080
610-767-4601

Shoreline Slate
779 E. Main St.
Branford, CT 06405
www.shorelineslates.com

The Slate Works
72 Iron Bridge Rd.
Millnocket, ME 04462
207-723-9745

Watches

Bee Wearables
45 Aliany St.
Oshauna, Ontario L1H 2Y9
Canada
905-579-5143
www.bee-wearables.com

Quartz Concepts, Inc.
21352 Nordhoff St., Unit 114
Chatsworth, CA 91311
818-718-0271

Wood Bowls

Weston Bowl Mill
P.O. Box 218
Weston, VT 05161
802-824-6219

Woodturner
Classic Form by Dick Carlson
7477 N. Wayland
Portland, OR 97203-4705
503-289-6280

index